ADVANCE PRAISE FOR
STOP TELLING WOMEN TO SMILE

"Tatyana's art does what all great art does: tells the truth about our times. Her portraits of women are not only beautiful, they give women a space to have their truths heard. She is formidable and strong in her art, and our society is better for it."

—Spike Lee

"Tatyana Fazlalizadeh has done what so many artists wish to accomplish. She has combined her tremendous talent for producing beautiful images with a forthright critique of the world she inhabits. Stop Telling Women to Smile is the most consequential street art campaign of the last decade, and we owe that to Tatyana's honesty, intelligence, hustle, and unmatched artistic talents. Her commitment to this project has challenged the way we discuss women and women's bodies in public space, and we are better for it."

—Mychal Denzel Smith, *New York Times* bestselling author of
Invisible Man, Got the Whole World Watching

"Tatyana Fazlalizadeh's work wrestles the knot between cultural codes and the bodies of women with spectacular artistry. Her intersectional feminism lights the fire we need to see a way forward. She is unflinching and glorious."

—Lidia Yuknavitch, bestselling author of *The Book of Joan*

"Tatyana Fazlalizadeh's work makes me smile. Provocation brings joy and Fazlalizadeh's images startle and prod with their delicate ferocity, reminding us that women are human. She treats us to what is seldom seen: woman as subject, woman as agent, woman as free human being."

—Myriam Gurba, author of *Mean*

"Tatyana Fazlalizadeh is the political artist of our time. Her walls burn, laying plain oppressions both buried and overt with beauty, power, and courage."

—Molly Crabapple, author of *Drawing Blood*

STOP TELLING WOMEN TO SMILE

Stories of
Street Harassment
and How
We're Taking
Back Our Power

STOP TELLING WOMEN TO SMILE

Tatyana Fazlalizadeh

SEAL
PRESS

New York

Seal Press
Hachette Book Group
1290 Avenue of the Americas, New York, NY 10104
sealpress.com @sealpress

Printed in the United States of America

First Edition: February 2020

Published by Seal Press, an imprint of Perseus Books, LLC, a subsidiary of Hachette Book Group, Inc. The Seal Press name and logo is a trademark of the Hachette Book Group.

The Hachette Speakers Bureau provides a wide range of authors for speaking events. To find out more, go to www.hachettespeakersbureau.com or call (866) 376-6591.

The publisher is not responsible for websites (or their content) that are not owned by the publisher.

Print book interior design by Amy Quinn

Library of Congress Cataloging-in-Publication Data
Names: Fazlalizadeh, Tatyana, author.
Title: Stop telling women to smile: stories of street harassment and how we're taking back our power / Tatyana Fazlalizadeh.
Description: New York: Seal Press, [2019]
Identifiers: LCCN 2019038649 | ISBN 9781580058483 (hardcover) | ISBN 9781580058476 (ebook)
Subjects: LCSH: Sexual harassment of women. | Sexual harassment of women—Prevention. | Sexual abuse victims.
Classification: LCC HQ1237 .F39 2019 | DDC 305.42—dc23
LC record available at https://lccn.loc.gov/2019038649

ISBNs: 978-1-58005-848-3 (hardcover); 978-1-58005-847-6 (ebook)

LSC-C

10 9 8 7 6 5 4 3 2 1

CONTENTS

INTRODUCTION

I was still a girl when my body began to change. When it started to be ogled, stared at, whispered to, touched, followed. No sooner had I begun to understand my own developing body than it began to no longer feel like my own. It felt like a *thing*. A thing that men wanted.

That was when I started to feel uncomfortable, and unsafe. It seemed as though my body existed for men's pleasure, and it became something I was forced to dress myself in for others' enjoyment.

I started to cover up.

I was very conscious of the clothes I wore, of not wanting to be seen. Not wanting to wear anything that was too tight or that would reveal this *thing* I had to carry. I wanted to hide my body so I could keep it to myself, learning and exploring and growing into it in my own time and space.

When I think about how early sexual harassment began for me, and how early it begins for so many girls, I am infuriated by the idea that before we can define ourselves within our own bodies, someone else has already determined what they are: sexual objects.

Street harassment is sexual harassment that happens in the public space. It can take the form of anything from a misguided and unwelcome comment from a passerby—"Hello, sweetie"—to cruder catcalling or explicit, often denigrating sexualization. It includes physical encounters that cross the line into assault. It can happen anywhere.

For the last several years, I have made it my mission to understand street harassment. I have asked women around the country for their definitions and the ways they've experienced it. I've learned from their answers that it can be defined by any behavior—commenting, leering, or touching—that is sexual and unwanted.

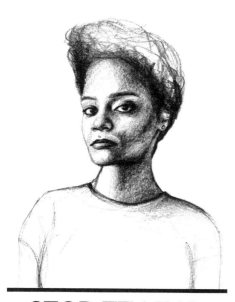

STOP TELLING
WOMEN
TO SMILE

Women have described being grabbed by the hands or wrists. Having their paths blocked as they were walking. Having men whisper in their ears, standing too close, leveraging their power. Being touched on public transportation. Having kissing noises made as they pass, being followed, getting yelled at. Many women have told me that men have grabbed their genitals. Many said they had been followed while out for a run and had to stop jogging in public places.

Like so many of us, I started to experience these things when I was a child, probably around eleven or twelve years. Walking down the sidewalk or even from my mother's car to the entrance of a grocery store left me open to leering looks; some men would even try to pick me up if my mother wasn't by my side. Still, I was born and raised in Oklahoma City, which isn't a pedestrian-friendly place, and most people there don't get around by walking. That limited the opportunities for men to harass women and girls, and me. It was when I moved to Philadelphia at age seventeen that street harassment became an everyday part of my life.

Walking around in that unfamiliar city as a teenager was an entirely different beast than walking down the street in Oklahoma City. Of course, I was already familiar with the idea that my body was a thing that would be sexualized by men. The difference was that in Philadelphia, a city where walking and public transportation are common, strangers were in close proximity to my personal space and my body every day. I was struck by the sheer quantity of harassment I experienced in a single day, walking to and from school. In the fifteen-plus years since then, street harassment has continued to be a part of my daily life.

That's why, in 2012, I started a street art series called Stop Telling Women to Smile (STWTS, for short).

Stop Telling Women to Smile is a series of posters featuring drawings of women captioned with text that speaks directly to street harassers. I created this street art series to challenge gender-based harassment in the public space. The idea is simple: I make posters I can paste onto public walls in large numbers across New York City and other cities across the country. I'm a portrait artist, so I wanted the work to show the faces of women, and I wanted the women to speak directly to men who harass women on the street. I wanted the work to speak out for women when we couldn't speak up for ourselves.

Because it's not easy to talk back. Sometimes I speak up for myself when I am harassed, and other times I don't. With this art project, I could take the words that swirled in my head that I didn't say aloud and put them out into the world.

The project began with three posters: one that showed a drawing of myself, the other two featuring friends of mine. The posters showing my friends' faces each displayed a single sentence:

**MY NAME IS NOT BABY, SWEETIE, SWEETHEART,
SHORTY, SEXY, HONEY, PRETTY, BOO, MA.**

WOMEN ARE NOT SEEKING YOUR VALIDATION.

The poster with my self-portrait showed the text "Stop Telling Women to Smile." I put that poster in Brooklyn one night, and the very next day on Tumblr I came across a photo that someone had taken of it. By the end of the day, the photo had thousands of likes and reposts. Soon after, I pasted two posters on a corner in Bed-Stuy in Brooklyn. A reporter from NPR lived on that block. He sent photos of the work to his friends at other media outlets, and pretty quickly, a reporter from the *New York Times* contacted me to discuss the work. The NPR reporter covered the project by coming out with me one night while I put up the work. As soon as I put up the first piece, a cop car stopped and police officers caught me. It was great footage for the reporter, who recorded the entire interaction. The police officer let me go. In New York, the police are usually pretty stern on vandalism. I've known artists who have been arrested for wheat-pasting. It's always alarming, any time that I'm confronted by the police, whether I am in the wrong or not. As a Black woman, it is always a charged interaction. This night, I told the officer I would take the work down, that it wasn't permanent. He let me go. From there, the media coverage continued and the project grew a large following online.

Before then, I had not considered the important role the internet would play in this work. The posters are not meant to last forever, but once someone posts a photo of my art, it gets a new life online, and the idea and meaning are transported to people around the world. Amazing.

As the project expanded to include more women, many of whom I hadn't previously known, my process changed. I interviewed each woman about her experiences of being harassed in public. Each piece depicts a woman I have come to know, and the text that is paired with her portrait is inspired by the woman's experiences. I turn these pieces into black-and-white posters, print multiple copies of each, and glue them to outdoor walls.

> My body was ogled, stared at, whispered to, touched, followed.

Sometimes I make them bigger—sometimes I have the opportunity to paint them as murals. The project is about taking back space in public, reclaiming authority over our bodies and the street.

Over time I met all kinds of women—women from cities and small towns, immigrants and students and professionals, creatives and sisters and mothers. As I recorded their interviews, I found myself wishing I could share their stories, the stories behind the posters and behind the lives that inspired them, with a broader audience. Their stories enable us to delve deeper into the dynamics of street harassment. I have gained so much, both personally and as an artist, from speaking with all these women and girls, and now I'm so happy that, here in this book, other people can access the same insights, information, wisdom, clarity, comfort, and inspiration I've had over the years, and commiserate, too.

People have asked if one particular moment or incident sparked this project, and my answer has always been no. There was not *one* moment, there were *hundreds*, cumulating over the years; the project grew out of the utter enormity of experienced street harassment. It arose from the exhaustion and frustration of enduring years of sexual harassment and abuse from strange men. No, not just one moment. Rather, the simple fact that it happens all of the time.

I've been told the crudest, most disgusting things.

I've been called *baby, sweetie, sweetheart, sexy, mami, beautiful, lovely, cutie, bitch*—all by strange men who do not know me.

Men have grabbed me, followed me.

I've been told to smile.

And I've been in cursing matches with men after they've harassed me.

These moments have been unrelenting and are inescapable, a constant in my life. And even when street harassment does not happen, the possibility of it is always there.

A fundamental element of street harassment is that there's more to it than the harassment itself. The threat of sexual violence is often implicit in the things men say to women on the street about their bodies. This danger always hangs over our heads. We don't know if any given interaction will stay within the realm of harassment or tip over into violence. It is something we guard against with awkward smiles at work, keys held between our fingers when we walk down the street, and constant vigilance over our drink cups at parties. The threat of sexual violence is one that begins when we are young and seems never to abate.

That is what prompted this work. I want to chop away at that threat.

The profound impact of street harassment is something that men typically do not understand. Often, their ignorance is willful, because understanding it would interrupt their way of life. But it is important for everyone to acknowledge the complexities of it. It is important to realize that women have been experiencing this behavior and all of its nuances for years and that it shapes our lives and identities.

For example, a woman I know told me about a time when a man, a stranger, said hello to her on the street. When she didn't respond fast enough—or loudly enough, or nicely enough, and just kept walking—he cursed her out. Now, a well-meaning person might respond to that story with a wave of the hand, saying, "Oh, it's not that big of a deal. He's just being an asshole." But the point they'd be missing is that it isn't just about that one incident. It's about the millions of instances, every day, everywhere.

It is mentally, emotionally, and physically exhausting to walk down the street without peace. To wear earbuds, to take a different, inconvenient route, to put on a scarf or sweater when it's eighty degrees outside—all the types of precautions we take to avoid being harassed—and we are still, constantly, harassed. Hassled. Badgered. Accosted.

It's rage-inducing, and that rage was the catalyst for Stop Telling Women to Smile. Not because one man did one thing to me in the street. But because

it seems all men feel like they have the right to say anything they want to me about my body. And I'm tired.

Street harassment is not an isolated issue; it sits on top of all of the other forms of sexual harassment and abuse. For many women and girls and femmes, it follows on a long history of aggressive sexualization—everything from sexism and discrimination in the workplace, at school, and at home, to sexual or domestic abuse, to sexual intimidation and assault.

Sexual harassment, in particular, happens in so many places, so many times. So, when you leave one space where you're being treated badly because you're a woman—maybe your supervisor has asked you to go out for a drink, and it doesn't seem work-related—and get outside into the street or onto public transportation, where you are likely to be harassed, it can feel like there is no safe space to be truly free from gendered mistreatment.

I have always wanted my art to be a reflection of my experiences as a Black person and a woman. Identity has long been an important part of my work because our sense of identity has very real consequences in our lives. For Black people, queer people, trans people, people of color, and many other groups, claiming our own identity is an act of self-determination in a society that constructs identities for us and attaches them to us like labels, as a way to other us. More than that, it's an act of survival.

A defining fact of my life is that when I walk out my door in the morning I am read as a woman and therefore am mistreated in very specific ways that are part of a long history of violence against women. My work is about that: how women are treated in these real, everyday moments simply because we are women.

Street harassment is the most direct and visible form of mistreatment in my life. It's the first thing that greets me each day. It's in my face, undeniable and inescapable. I also experience other microaggressions, particularly racism, in my daily life. But public sexual harassment is the constant and has been the constant for so many years.

When I moved to Philadelphia to go to art school, three things were happening at the same time: I was becoming an artist, I was coming into my womanhood, and I was experiencing ever more sexism. That was when I really became subject to the emotional, mental, physical, and economic consequences of daily street harassment.

Plenty of sexism happened in the classroom, too, where the male voices of my classmates were heard over mine, and where my male professors came on to me—some aggressively, others insidiously. As I explored and expanded my skill and voice as an artist, my artistic development and the weight of sexism began to converge.

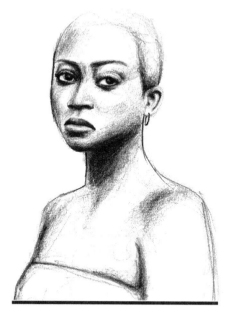

WOMEN
ARE NOT SEEKING
YOUR VALIDATION

I made the first pieces of the Stop Telling Women to Smile series a few years after graduating from college. They came from very real thoughts and reactions that I've had to men in the streets over the years. It was my voice speaking back in a way that I didn't always do in person, often out of fear of retaliation in the form of verbal abuse or violence. I wanted these posters to become a part of the environment, a voice and defense for the women trying to exist in those places, a voice telling men to stop, to leave us alone.

One of the earliest pieces reads "Women Are Not Seeking Your Validation" under a portrait of a short-haired woman who looks out at viewers with an expression of combined fatigue and defiance. This portrait was a response to men giving women "compliments" in the street—as if we are looking for their approval. As if we get dressed in the morning and walk outside hoping that strange men will validate us by telling us we have nice lips, or great legs, or that they like the way we walk.

We do not.

Whenever men say things like that to me, I wonder, *Do you really think I care what you think about me? Do you really think I'm waiting for your approval? These "compliments" you think you're giving me, as if you are* rating *me, as if I'm here to please* you—*I don't care about any of it. I don't want it.*

In the early years, I had not considered just how much the sentence "Stop telling women to smile" would resonate with others—or how controversial

it would be. It raises questions I'm often asked and have been called upon to answer, such as, "How is telling a woman to smile street harassment? How is complimenting a woman sexist?"

It's sexist because women are told to smile as a way of controlling their bodies, their appearance, and their presentation. A man telling a woman to smile dismisses her autonomy over her own body, emotions, and self-expression. It assumes she has an emotional responsibility to always present as happy, pleasant, and approachable—whether or not that is how she feels or what she wants to express.

I've always believed that men who tell me to smile are trying to create a mood in which I seem more approachable to them. The problem is that my own wants and needs are not considered. In these encounters on the street, I do not want to be approachable, because I have no wish to talk to these men. By telling me to smile, men are centering their desire, and forcing me to do the same, even when I don't comply.

My desire, meanwhile, is decentered, erased even. This type of street harassment turns me into an object that will function either in service of what men want or in opposition to it.

"Smile for me."

"You're too pretty not to smile."

"Why aren't you smiling?"

"Can I get a smile?"

Everything within these statements and questions is about my physical appeal to this unknown person and what he wants from me. I am not interested in any of it. I am just trying to go about my day.

But that doesn't matter, because what I want isn't in the picture at all. Instead, women are expected to assume that every man who speaks to us on the street has good intentions; we are expected to accept their "compliments," to smile on demand, and to interrupt our day to interact with them in a way that pleases them.

And what happens when we do not smile or respond in a way that feels light and positive? We are often punished with insults, cursing, shouting, or physical violence.

The Stop Telling Women to Smile project is about pinpointing the everyday occurrences of sexism and sexual harassment that women experience and making them visible. It is not enough to say that sexism is wrong and should be dismantled. We have to interrogate the sexism that occurs throughout

our lives—even the seemingly small, trivial instances. Because if we do not challenge those moments—being told to smile, being called sweetie, being touched, even gently, without our consent—they pave the way for even worse behaviors to be normalized and accepted.

In 2013, about a year after beginning the Stop Telling Women to Smile art series in New York, people around the country and around the world started asking me to visit their cities, saying that they needed the work in their own neighborhoods. I decided to travel with the project. That's when the personal became political.

Until that point, I had not understood just how much of a problem street harassment was for women everywhere. I was about to discover that, by using my artwork to speak about my own experiences, I unknowingly was speaking for so many other women and had created a platform for their voices to be heard, too. I launched a Kickstarter campaign to fund my travels to cities across the United States, to places where I could interview all kinds of women and create new work that was specific to their lives and communities.

I wanted to hear from the women who were reaching out to me and to let their stories inform this project so that I could tackle the problem from a wide, varied, and inclusive perspective. What I experience on the street is different from what a sixteen-year-old Latinx girl in Miami experiences, or a forty-year-old trans woman in Omaha, or a sixty-year-old Black woman in South Los Angeles.

To really fight this behavior, not just a single narrative but many must inform us. The experiences of a diversity of women must help us understand that sexism does not work alone and that, when most women experience sexism, they are experiencing it through their layered identities.

When I interview women for this work, I try to understand and then reflect back to the public just how such mistreatment based on the simple fact that they are women and based on their racial identity, gender presentation, size, personal style, ability, age, and more affects their lives.

So many factors contribute to how a person is perceived and treated in the street. For most women, sexualization is only one element in their harassment. Racialized women face racist comments, trans women face transphobia, LGBTQ women face homophobia—and the list goes on to include women with disabilities, women who are poor, women facing homelessness,

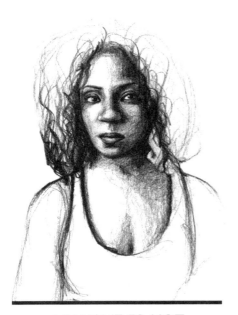

MY NAME IS NOT
BABY
SHORTY, SEXY, SWEETIE, HONEY
PRETTY, BOO, SWEETHEART, MA

sex workers. One oppression usually works in tandem with others.

It's important to stretch the conversation to include the faces and voices of many people so that the narrative moves beyond street harassment as something that happens only to young white women. Like most media we consume, white people are usually the face of it. A part of white supremacy is to make the lives of white people the dominant story, the normal story. It happens in most parts of our society, and you see it within feminism. "White feminism" is feminism from white women that centers the experiences of only white women, excluding the way race is inextricably tied to the experiences of Black women and women of color. It is why feminism was long led by white women, prioritizing their experiences, their sensibilities, their stories. When I entered into the mainstream conversation on street harassment with Stop Telling Women to Smile, most of the stories and media I saw online about street harassment were from white women. On this issue, and most other issues surrounding sexism, it is not that Black women are not telling our stories or doing the work. We are and have been. We, instead, have had to fight for our stories to be actually heard and valued. So, with this work, I am consciously centering the experiences of diverse women.

That said, in reality I'll never be able to feature the voice of every woman who has experienced harassment. Important perspectives are not included here. But I believe this project does work with intention to hear from and represent numerous and various women.

This book tells the stories of women and nonbinary persons from a range of backgrounds. What is especially fascinating are the ways in which sexism and sexual harassment have permeated each person's life. Whether in small moments or in larger, more tragic events, each person has had numerous

experiences with sexism and harassment, usually beginning in childhood, that have affected them forever.

Through this work, I have learned more than I could have imagined when I first began it: How the women's various identities influence how they experience the outdoor space. How so many women experience trauma, and how that dovetails with the harassment they receive on the street. I have learned about the power in telling your story and how speaking about who you are and what you have experienced is an empowering and political act. I have also learned a lot about myself. (More on that later.)

For this book, I interviewed nine new women and one nonbinary person, and just as for the STWTS series, I spoke with each person one-on-one. I explain a little more about my process in a few pages, but, simply, I spoke with each person, photographed them, and drew their portrait. Near the end of each interview, I asked each person the same question I've been asking women and femmes over the years since I began the project: What do you want to say back to your harassers in the street?

Their answers—many of which are included in this book—were enlightening, entertaining, sharp, brave, proud, and as varied as the people themselves.

This book, just like the street work, wouldn't have been possible without the participation of the women and people who shared their lives with me. I'm sharing these interviews with you in the hope that you'll find them as illuminating as I have. I'm sharing these people's stories with you because, in addition to offering visual portraits, I'm eager to present their voices in their actual words. Think of their chapters as verbal self-portraits, to complement the drawings.

The conversations I am privileged to have had with these people are far-ranging and fascinating. They each speak about various aspects and angles of street harassment, and it has been invaluable in broadening my understanding of the problem. Each person has some things in common with the others and some things that distinguish them. Taken all together, they reveal the infinite ways we are all connected and the equally infinite ways we are each unique.

I want to take a moment to address a few questions and arguments that people sometimes raise in response to the Stop Telling Women to Smile series.

People often ask whether it is possible to legislate a solution to street harassment. The media have been covering the topic more and more, and

recently, following a violent incident in Paris where a man forcefully slapped a woman after throwing an ashtray at her outside of a restaurant, France banned street harassment, levying fines for catcalling.

Numerous factors prevent such laws from being a good idea in other countries. Here in the United States, such legislation would likely mean an increase in the criminalization of men in already criminalized areas. For that reason, Black and brown women would be reluctant to call the police on harassing men in their neighborhoods in addition to the fact that Black women and women of color themselves risk being harassed by the police when they encounter them.

Racial bias is another consideration. White women may be more likely to perceive harassment as coming from Black and brown men and may be quicker to call the police on them than on harassing white men. In other words, I believe that an anti–street harassment law would become yet another means of sending Black and brown men into the legal system and promoting the prison-industrial complex.

Laws in some states already ban certain forms of harassment in public spaces. Stalking, groping, and indecent exposure are illegal in most states. In New York City, gender-based harassment in public places like restaurants, schools, and subways is illegal. But there is no federal ordinance specifically against sexual harassment in the streets. Because laws against harassment vary by state, and sometimes by city, it is difficult to understand just where we stand as a country on what behavior toward women is punishable.

It's also important to acknowledge that women and feminine-presenting people are not the only ones who experience sexual harassment: it occasionally happens to cisgender, heterosexual men as well. But not nearly as often as it happens to women, and not to the same degree, and their experiences are not what my art series and this book are about.

And while we're at it, not all harassers are men. Yes, women can sexually harass and abuse other women. Most of us have ingested some forms of sexism and misogyny, and that includes from women, whether cis or trans, straight or queer. It is difficult not to in a society permeated by rape culture. (You can see this, for instance, in how some feminists condemn sex workers, attempting to police how another woman uses her own body and sexuality.) In any case, because most harassment and violence against women and LGBTQ people is perpetrated by cisgender, heterosexual men, that is where I focus my work.

One aspect of street harassment is common for all of us who experience it: even though it occurs in public, it still feels like a private moment, an experience that each of us carries alone. By bringing these experiences into the light, I'm trying to change the way we think about this problem—not as a private issue that falls to the woman to solve but as a public one for which we all share responsibility.

People are used to living with these everyday oppressions, as if they are just the way of the world. But, in fact, we can change it. Cultures do shift. Even if we currently live in a toxic, sexist, violent society that dictates what women should and should not be, we can slowly and gradually change into a society that treats women better. I believe this begins with breaking the silence around everyday violence and calling out the behavior we are not willing to take anymore.

A Note on Process

Before you read further, I'd like to share with you a little about my process for creating the posters and this book. When I choose to feature a woman, the first thing I do is talk with her. These conversations happen either one-on-one or in group settings. Sometimes I talk with women online or through organizations. When I want to hear from a specific group of people—say, teenage girls or college students or queer women of color—I set up meetings through organizations that service these communities.

Over the years, I have collaborated with many groups, organizations, galleries, schools, artists, and activists to help bring the work to life in their cities, from Boston to Los Angeles, Oakland, San Francisco, Mexico City, Philadelphia, and Miami. The project grew in just a year from an idea in my head to a collaboration with dozens and dozens of people across the country.

Once I'm in a city, I want to learn about how street harassment happens there, taking into account the city's cultures, traditions, and geography. Each city has its own distinct harassment culture, and it's based in part on street life at large. A key piece involves how pedestrians travel through the city.

I want to know how women experience public mistreatment based on who they are in their particular locale. In 2014, I went to Oakland, then to Los Angeles, then Atlanta, hearing from people about how they experience harassment in different neighborhoods. In Los Angeles, I spoke with students

at Santa Monica College one day, and the next day with a group of older Black women laborers in South LA. The stories I heard from them, living only a handful of miles apart, were vastly different.

When I talk with women, I ask them questions to open up the conversation and allow them to speak candidly about their experiences. I want to have an exchange, but I also want them to feel they can speak freely and share whatever they want. I want the conversation to move as naturally as it can. I've found that women who show up to these group discussions and one-on-one conversations often are not artists or activists but regular people who want the space to tell their story.

We all want to tell our story. We all want to be heard. But we also want to be believed. So many times when we tell our stories, our words are discredited and the lives, jobs, behavior, and reputations of men are positioned above our experiences. That aspect of this work is critical: I listen to women, they tell me what they want to say to the public, and then I use my art, my talent, my skill to insert their voices into the street.

After the conversations, I photograph each woman, and from the photograph, I draw her portrait. When I started the project, the first few designs did not include drawings—I simply worked with photographs and text. But I shifted into black-and-white graphite drawings because I didn't want to abandon my natural inclination to draw and paint. There's something about creating a drawing of a person's face that emphasizes their humanity. It comes in part from the simple act of looking at someone so closely, which is not something we usually do.

The women's humanity comes through in these posters. The viewer can not only read the words but also see that someone took the time

to draw these portraits of lovely human beings who are not necessarily looking happy or pretty or pleasant. The women's expressions are real, direct, in-your-face. I want to show images of women in the streets not looking agreeable to the viewer in the same way that we do not need to look agreeable to men in the street. Instead, I want them to look like themselves. Like regular human beings who are tired of dealing with harassment.

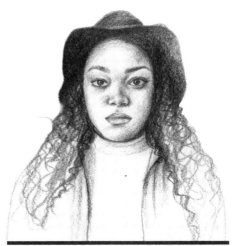

MY WORTH EXTENDS FAR BEYOND MY BODY

I use a black-and-white color scheme for a couple of reasons. One is that the work is printed out in high numbers and is placed in various sites across a city, and that's easier to do when color isn't a factor. I also love the look of black-and-white drawings against the colors of the street: a red brick wall, gray concrete sidewalk, a blue painted door. The black-and-white poster stands out and keeps the texture and color of the original graphite drawing intact.

Once I complete the portrait of a woman, I compose the design by adding text to the drawing. I pull the text from our conversation, from their answer to the questions, "What do you want to say to harassers in the street? What have you wanted to say that perhaps you never felt safe enough to say? What do you simply want the public to know about who you are, what you go through, the treatment that you have experienced?" Their responses become a part of the public service message embedded in the art.

When the poster is finished and replicated, I put wheat paste in a bucket and use a large paintbrush to attach the posters to outdoor surfaces. Wheat paste is a type of adhesive that is made by heating flour and water, and I learned to make it by watching videos on YouTube, though you can also buy it. It's a common medium in arts and crafts. It's easy to make and easy to use. I carry my bucket of paste to wall after wall, corner after corner, city after city. Sometimes alone, sometimes with friends or volunteers, I put these women's images out in the streets.

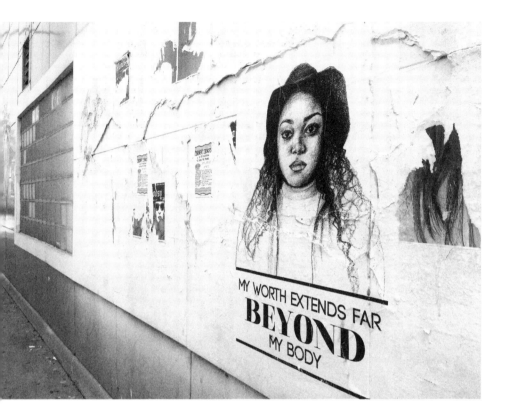

Art and words. A simple pairing, and a powerful one. When people see my posters, they aren't just seeing a woman's face but also hearing her voice, and knowing her truth.

A Note on Language

One last note before I introduce you to the people featured in the following chapters: I'd like to explain a couple of terms I use throughout the book.

First, you'll notice that I capitalize the word *Black* when describing people or culture. This is a deliberate choice in order to recognize Blackness as an ethnicity and not a color. It makes sense to me to do it that way, not just for the purposes of the book but in all areas of my life. I have always preferred the term *Black* over *African American*. My father was Persian, from Iran, and my mother is Black, a descendant of Africans who were enslaved in the United

States. I consider myself a mixed-race Persian and Black woman. But more succinctly, I'm Black.

The terms *women of color* and *woman of color* also appear in the book. I have never really liked using *people of color*, though I understand that it is the common label for people who are not white. But that is precisely my issue with it: as if white people are the norm, and anything other than white must be qualified as such. It, to me, is an othering all on its own that seems to exempt white people from the issue of race, which is what the concept of whiteness is all about: leaving white people, as a people, unmarked and unbothered. But it is the common term, and it's how a lot of the women in the book describe themselves. Because I don't have any better words to use at this time, *women of color* shows up here.

Second, I want to make clear that when I use the word *men* in this book, I am mostly referring to cisgender, heterosexual men. I do not want to promote the gender binary or to implicate trans men and masculine-leaning people. Masculinity does not belong only to cis-heterosexual men, and I think we can and should challenge how we think of it. In the lives of most people—including cis and trans women, gender-nonconforming people, children, queer folks, and transgender men—straight cisgender men have been historically and statistically the most violent. So, when you read *men* in the book, that is who I am referring to. There will be some places where I feel it is necessary to specifically point out cis-heterosexual men, and so you will read *cis-het* in those places. When I use the word *women*, which I use often, I am including both cis and trans women. However, not all of the people featured in this book identify as women. Sonia (Chapter 10) is nonbinary.

PART ONE
THE WOMEN

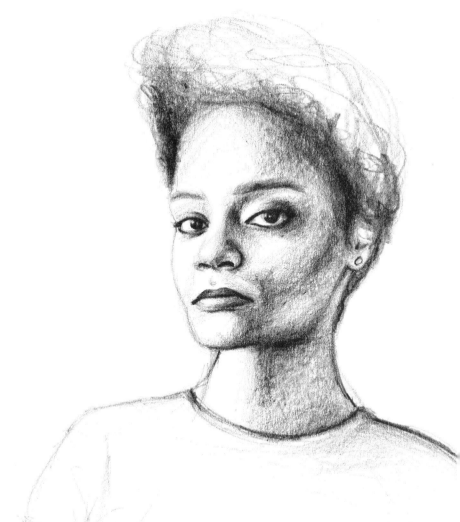

Chapter 1

<u>TATYANA</u>

Making Political Art

Age: 33
Identifies as: Black, woman, queer

knew from a pretty young age that I wanted to make political art. Growing up in Oklahoma City, I incubated in my mother's political consciousness about race and racism. Oklahoma is very white, but I grew up in a neighborhood and in schools that were predominantly Black, so most of my world, and my influences and role models, were Black. And though I didn't experience overt racism daily, I was very aware of the systemic racism in our society.

My mom is definitely my biggest and best role model; she's had a huge positive influence on me as a person and as an artist. She is confident, even bold, in her politics and in general. She taught art and math at a nearby high school and middle school, so everybody knew and respected her. She also made art. Over the years she has worked in pastels, charcoal, clothing designs, and screen printing. She's had her own silk-screening business for over twenty years and creates T-shirts featuring her own designs and commissioned shirts for local Black businesses, organizations, and families.

As far back as I can remember, she was exploring and presenting her Blackness in her everyday life. Her politics infused everything she did. She peppered her art and math classes with lessons about Black history and Black pride, teaching her students to be proud of their heritage and themselves. She talked about race and politics with me, and I'd listen to her conversations with other people and pick up the books that lay around our house and watch her walk down the street, commanding respect in her African garb and head wraps (which no one else in Oklahoma City was wearing, as far as I remember).

My mother was a Black woman who was into Black things. We ate at the local Black-owned fish and BBQ spots. We listened to Black music radio stations in the car when we weren't listening to her cassette tapes with a mix of old school R&B songs. We celebrated Kwanzaa. The art she made, from T-shirts to clothing designs to drawings, amplified Blackness.

In 1991, when Rodney King was brutally beaten by four Los Angeles police officers, my mother made a T-shirt in response to the event. Under a drawing of King's face, she included the basic facts about the violent beating, the gross acquittal of the officers, and the riots that followed. Art and words. I was in the first grade at the time, and she had me wear the shirt to school. This was typical of how my mother raised me, and it forever shaped how I look at the world.

My mom was always encouraging and supportive of me, telling me I could be and do whatever I wanted. The emphasis wasn't on being female

in a male-dominated world but on being Black in a white supremacist world. That's what she was passionate and political about, and how she framed things. And though she didn't openly identify as a feminist or talk about women's liberation with me, the fact that she was this strong, hardworking, widely respected woman, and the head of our household, meant that I had a powerful female role model.

I absorbed it all, as if by osmosis. I was a quiet kid. People assumed I was shy, and maybe a part of me was. But I never fully felt like I was shy in the sense of being afraid to speak. I was observant, but I kept my thoughts and observations to myself. I've since learned the importance of speaking, of expressing your thoughts, of being bold and taking up space, especially for Black girls and women. But I also still value my quietness, my habit of taking in the things and people around me.

When I wanted to move to Philadelphia for college, my mother was the main person in my family who was enthusiastic about the choice. Everyone else was concerned that it was too expensive and too far away from home. My mother told me that when she was a teenager, she was offered the opportunity to travel with her poetry. She was crushed when my grandmother wouldn't let her go. That was one of the reasons she supported me going away to pursue my dreams of being an artist.

As a kid, it was engaging and even fun to soak in her knowledge and ideas and observations; it didn't feel like boring grown-up talk. My mom and I spent a lot of time together and were really close. Before she married my step-father, it was mostly just her and me in the house after my brother moved out. I have cousins close in age to me, and I spent time with them at my grandmother's house. But at home, it was my mother and me. We'd sit in the beautiful home she'd made for us. I'd help her silk-screen T-shirts, and we'd talk about almost everything. She was open with me, even about things like sex.

But one thing that nobody, not even my mom, talked to me about was street harassment and sexual harassment at large; it was ever present, but invisible. I first started to experience it when I was about eleven or twelve, when I suddenly developed a very curvy body seemingly overnight: one morning I woke up and the bra I'd been wearing didn't fit me anymore.

I was in middle school. The school bus would drop me a few blocks from home and I'd walk the rest of the way. It happened pretty regularly that men in cars would slow down to talk to me. I can remember the sensation of walking next to the street, having a car pull up alongside me, and bracing myself

because I knew, before I even turned my head, that it was a man and that he was looking at my body. Through their car windows, men would tell me I was pretty and ask me questions about myself, especially how old I was. When I said twelve or thirteen, they might have said, "Oh, really? You look older," but they never drove off when they learned my age. They'd always continue talking to me in that sly way. These were grown men.

I had been conditioned to be polite, so I'd respond to harassers as briefly as possible without being rude. That conditioning is a Southern thing. Oklahoma is strange in that it's not thought of as the true South because it's too far west, but neither is it part of the Midwest. It's considered part of the Southwest, but not in the same way Arizona or Nevada is. Geographically, it is right in the middle, and so it sort of falls between the regional cracks. But Oklahomans feel and act like Southerners in many ways, including putting an emphasis on friendliness and courtesy.

I learned early how to smile and nod even when the situation was unpleasant for me. I didn't know any alternative. I hadn't been taught I could end an interaction if I didn't like it; that it was okay to be impolite to people who were making me uncomfortable.

It was constant, the ogling by men, even by family friends and men in our community. I can remember plenty of times standing there while my mom was in conversation with a man, and he'd be talking with her and meanwhile looking my body up and down. Even then, I understood that men were no longer seeing me as a whole person, as my full self, as Tatyana who is talented, who is quiet, who has her specific personality. Instead, the focus was on my body as a separate thing from me as a person, and in their eyes, it was the most noteworthy thing about me.

In the grocery store or at the post office, when I was next to my mom, men I didn't know would look at me, but not say anything; but then if I went off alone to get something in another aisle, they would approach me and make comments. That showed me that they knew talking to me like I was a sexual object was wrong; they just didn't care.

I still sometimes feel pain and anger when I think about just how wrong it all was. To have adults—even some I'd grown up around and to whom I looked for guidance and safety—suddenly start to regard me that way, to be treated literally as a thing put there for their viewing pleasure, was deeply unsettling and confusing. I believe that, at least with many of these men, if they had been able to pause from their ogling to consider my humanity and my

feelings, they'd have seen that prioritizing their desire over my preteen uncertainty and naivety was a gross exploitation of their power over me.

But that's the thing: the normalization of these dynamics and behaviors is so thorough and so ancient that men are never asked or told to pause and consider the truth of the situation, and so they don't even recognize that they are treating us as objects.

Coming into My Sexuality—a Tainted Experience

Speaking of my uncertainty and naivety—in the years after my body developed quickly, the new hormones ushered in a budding sexuality, and I was pretty well in touch with it, and pretty enthusiastic. I wasn't ready to actually do anything sexually with anyone else for a long time, but in private, I devoured romance novels, developed desperate crushes on celebrities, and daydreamed elaborately about falling in love. That was how my sexuality first expressed itself, as an urgent longing to fall in love and to be fallen in love with. It was exciting and fun and more compelling than anything that had ever happened to me.

But from the beginning, my sense of my sexual nature was colored and tainted by men constantly asserting their own sexuality and inserting it into my experience and my space. As a result, my sexuality was forced upon me when I was a child, before I was ready to claim it for myself. Men were perceiving me as a sexual person before I perceived myself that way. My body felt like a thing that was there to be consumed by men, without the whole me being a part of it. I know for sure this feeling deeply affected my developing sexuality and sense of myself, but it's impossible to know exactly how, because I cannot imagine my childhood and adolescence without the presence of those leering men.

Luckily, though, the insidious violation didn't send my sexuality into hiding or keep me from exploring it myself. I hear from other women that, as girls, in the face of being sexualized from the outside, and with all that male desire asserting itself so unrelentingly, for a long time they couldn't decipher what they themselves wanted. Part of that indecision is just being a teenager, for sure. But another part of it comes from having your sexual agency taken away from you the moment it arrives. This is especially true for queer youth.

Men sexualizing girls not only prescribes the girls' sexuality before they are ready but also pushes a heteronormativity that isn't in line with who queer girls might be.

But even while I longed for romance, the unwanted male attention made me want to keep my sexuality to myself. I kept my body hidden in baggy clothes and carried myself protectively to preserve some claim over myself and my body. And there was another reason to cover up: that was the clear message I received from the adults in my life. I didn't necessarily always want to cover up, but I felt like I had to. Even back then, I noticed how I was being held responsible for the problem. Even back then, I felt like my body was just growing and doing what it was going to do, and I didn't understand why I should have to hide myself when I wasn't trying to be sexual or attract attention—I was simply wearing shorts.

I still feel that way: I'm a sexual person, and I want to be sexualized by certain people who also see me as a whole person. But I don't want to be up for grabs to any person, let alone any strange man who feels entitled to my body and sees me only as that.

When I was a teenager, the conversations my mom and I had around my sexuality generally had to do with keeping myself safe from boys and men, not doing certain things or going certain places, not dressing or behaving in certain ways or staying out late. I was her only daughter, and like all parents, she was desperate to keep me safe. From her and from everyone, I received that familiar message girls get that boys are going to behave badly, and we girls bear the responsibility for not letting them treat us badly.

On top of being freaked out by leering men, I also started to notice other kinds of gender inequity. For instance, I wasn't allowed to date until I graduated high school, whereas my male cousin, who was exactly my age, was out dating much earlier than that. And in general, my extended family was much more lenient with him. He would talk back to the grown-ups and get away with it more than I would have if I'd tried that. Because we were the same age, I could see the double standard really clearly.

I could see sexism at school, too, especially in middle school, when the boys made a game of teasing us girls about our bodies and groping us. Though I was generally pretty quiet, I stood up for myself—I'd get furious about harassment, even though it definitely felt different coming from my peers than it did from adult men. Once, a boy came up to me, grabbed my breast, and then took off running. I chased him through the hallways, caught him, and we got

into a fight. I snatched his glasses and made him get down on his knees and apologize before I'd give them back. I'm glad I did that, though I shouldn't have had to.

But I did have to defend myself in such ways because no one else was going to. I don't remember any of my teachers or school administrators ever addressing bad gender-related behavior. It just wasn't seen as a problem that all through middle school we girls were being harassed and had to actively fight off the boys. To me, though, it felt like a big problem. I hated middle school because of it; it was awful there.

Another related reason I hated middle school was because I was bullied in a very specific, very common, very gendered way. There were always rumors going around about certain girls having sex with boys, and I was one of the girls who people talked about in that way. The ironic thing is I was so far from having sex at that point; I never did anything even close for years—but because my body looked the way it did, kids made assumptions. And that experience made me aware of how girls are not only sexualized but also accused of inviting the sexual attention and inappropriate behavior they receive. We were told we shouldn't be doing that and that's why he's looking at you and treating you that way. This is particularly true for Black girls.

> Nobody, not even my mom, talked to me about street harassment and sexual harassment at large; it was ever present, but invisible.

Back then, I didn't talk about any of the harassment or bullying with my mom; I doubt if any of my friends talked with their parents either, out of embarrassment, even though we weren't the ones behaving badly and in reality had nothing to be ashamed of. At the time, my mom was in this kind of hypervigilant mode of making sure I didn't mess around with boys or have a boyfriend. But that was so far from what was actually happening—I didn't start fooling around with boys until later—and, in fact, something really different was happening, something intense and relentless and, in a way, the opposite of what she was afraid of: she didn't need to worry about what *I* was doing but about what was being done *to me*. But because boys were a sensitive subject, and I was embarrassed, it didn't occur to me to tell my mom about what was happening at school, and I'm not sure I would have known how. At that age none of us knew how to name it.

In my head, I questioned this male behavior—the comments and staring from men, the middle school grabbing, the ways men and boys sexualized me—though, like many girls, I didn't talk about it. At least not until later in high school, when my female friends and I would commiserate about being harassed. I think that was when I actively began to question why men and boys believed they could treat us in these ways and why nobody said or did anything to prevent it.

My best friend from the time I was twelve, who is still my closest friend, is brilliant and observant, and back then we started a conversation about sexism that we are still carrying on today. (Don't get me wrong, it's not all so lofty and political; we talk about everything, from pop culture to sex to how our bodies are changing with age and everything else.) My friends and I would vent to one another about the way we'd been treated by boys or men on a given day. Those conversations gradually started to go deeper and wider, into our experiences with sexism in general, and sexual abuse, and all of the ways our bodies had been treated at the hands of men since we were children.

Turning Anger into Art

I started to make art around that time when I was developing my own political ideas. My politics and concerns grew very naturally out of the politics my mom had raised me on. Everything I'd learned from her about society and racism had a direct influence on my decisions around what kind of art I wanted to make, especially once I got to college. Even now, my work comes all from that place: What do I have to say about things that are relevant to who I am, my community, the groups I'm a part of, how I experience the world as this particular type of person that I am?

During college, I started thinking a lot about gender-based injustice. Identity and identity politics have always been central to my outlook, and that came from my mother and the household she created. In adulthood, I decided to identify as a feminist.

I held off on claiming the term for myself for that long for a couple of reasons. First, though I've always held the ideas and beliefs of feminism, I didn't feel able to actualize those beliefs until I started to intentionally address sexism in my art and everyday life.

Second, like some other Black women, I felt excluded from feminism, which had disregarded the realities of Black women's lives and how race directly impacts our treatment as women. Feminist movements up to that point were led by white women and seemed only to include white women.

I'm also interested in, and certainly influenced by, Womanism, a term first coined by Alice Walker. Among other descriptions of the concept, she once said, "womanist is to feminist as purple is to lavender." Black women embraced Womanism as a distinction from white women's feminism.

My identity and how I choose to label myself have evolved and hopefully will continue to evolve over my life and will continue to have an effect on the art I make. Kimberlé Crenshaw's theory of intersectionality has heavily influenced how I understand my experiences as a Black woman. As important, I could apply the theory to my understanding of other people's experiences as well, which ultimately influences how I can tell their stories in my work.

The theory of intersectionality is that racism and sexism do not work independently and must be looked at as overlapping varieties of discrimination to fully recognize the experiences of Black women. I feel very strongly about this idea and always keep it close in my thoughts. It's partly thanks to this intersectionality theory that I view my feminism as distinctly Black feminism.

As I mentioned, moving to Philly was a big culture shock, especially encountering the street culture and the rampant public harassment of women. Even though I'd been fighting for and in defense of my own body since I was a child and had been having adult men tell me what they wanted to do to my young body for years, I was still caught off guard by the frequency of this behavior in the new city.

After moving off campus sophomore year, I walked a mile every day to and from classes, and the constancy of the ogling and commenting was unbelievable. I guess young women get it more because they're viewed as vulnerable and because their bodies often conform more to societal beauty norms. Transitioning into womanhood is such an exciting and precious and confusing time in a girl's life. It makes me sad and furious that, at precisely that transformative, raw, uncertain, powerful moment, we receive this onslaught of harassment, not to mention the constant judgment about how we dress and carry ourselves.

I can't believe that, still today, girls who like sex are called promiscuous and slutty, whereas boys are encouraged to like sex and are called studs when

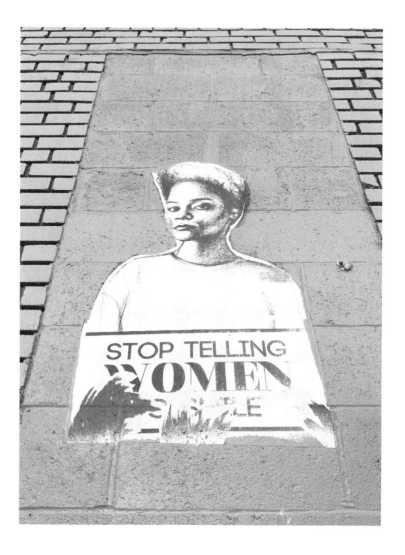

they "get" a lot of girls. When will girls and women be free to explore and express our sexuality? And when will boys and men stop being taught that sex is about achievement, and conquest even? Today, when I interview teenage Black girls, I'm excited to see how they are owning their own sexuality even in the face of harassment, in ways that perhaps I wasn't able to when I was younger.

I said earlier that I didn't create the Stop Telling Women to Smile art because of any one particularly terrible episode of street harassment. But like many women, I've had a few bad ones that brought me to tears. One time in my early twenties, I was walking down the street in Philadelphia, dressed

nicely for the opening of an art show, when a guy biked by and slapped my butt so hard it hurt. For a few moments while I was stunned, he rode along next to me, slowly looking my body up and down. It took me a second to fully register what had happened. Then I got angry.

Remember how, back in Oklahoma as a kid, I felt compelled to respond politely to many of my harassers? In Philly, that changed, partly because the tenor of the comments was different, uglier. But also because the frequency made me that much more sick of it. I figured out how to respond more appropriately, and I would sometimes snap back at men when they said unwelcome things to me.

So, I chased this dude, shouting and cursing, as he biked off. I was infuriated, and very shaken. But I had to hold back my tears, pull myself together, and go to my own art opening and pretend I was fine. It happened in my neighborhood, where I knew and recognized a lot of people, but I didn't know him. That episode stayed with me, and for the next weeks and months I kept an eye out for him, warily, but also hopeful that I'd see him so I could scream at him some more.

Another time, also in Philly, I was slowly walking down the sidewalk, texting with my boyfriend, when I passed three guys leaning against a car. One of them asked if he could put his number in my phone so that I could text him. I rolled my eyes, which offended him enough that he started saying overtly insulting stuff, suggesting I was lucky he was interested in me. I got mad and said something back to him, and it escalated until we were shouting at each other.

This really upset me. When it was over, I called my boyfriend crying, and he was sympathetic, but I felt like he didn't really get the seriousness of what had just happened and why it was affecting me so strongly. I tried to get across just how angry I was and why. I'd been in a good mood before the guy inserted himself into my day by being aggressive and insulting, and I wanted my boyfriend to understand my rage and frustration. But he didn't really understand and that made me even more frustrated.

It's possible that at the time I wasn't fully able to articulate why I was so upset. I'm not sure I recognized until later in my life the fundamental feelings I experience when a man verbally or physically accosts me on the street. Partly that's because the anger immediately floods in, as it should, and that tends to obscure other feelings in the moment. My other frequent initial reaction is

disbelief at the absurdity of such behavior; it is just a bizarre way to approach another person.

But when I look below the anger, I see shame and humiliation, which still makes me shake my head at the terrible irony of it: Why do we women feel ashamed and embarrassed when this happens to us? We have done nothing wrong, and yet there is this impulse not to draw further attention to ourselves and the situation. It's the harassers who are behaving badly and who should feel ashamed. But they never seem to, while we usually do.

I also often experience a strong feeling of bewilderment: *Why would you treat me like that? I did nothing to you. Why would you treat another human being so inhumanely?*

And there is something else. I feel, simply, hurt when men treat me this way. Somehow, that can be a hard thing to explain to someone else. It can compound the feeling of vulnerability to acknowledge that we are wounded. But I think it's often a part of our response to any unprovoked harassment.

It's important to look at our underlying emotions in reaction to harassment. But I also really value the anger that I feel, even if it can be exhausting in its own way. Mostly, it energizes me and enables me to channel that energy into my work.

Indifference Is Part of the Problem

Stop Telling Women to Smile came from my anger at being harassed on the street. Every woman I've spoken to about it is also angry. So, why is there so much silence around this thing we all suffer through? We've named some of the reasons: fear of retaliation by the harassers, embarrassment, fatigue. Sometimes, later, long after the moment when we were accosted, we might mention what happened to someone we know will be sympathetic.

But we've also been taught over and over that what happened to us doesn't matter. After being dehumanized on the street, our concerns are then dismissed by friends, colleagues, spouses, our broader social circles. We know that our anger at being harassed will be met mostly with indifference. All of society is so accustomed to men engaging in these behaviors that we have somehow come to believe it isn't a real problem.

Still, women are often enraged by how we're treated, even if we don't talk about it much. So, where does all that anger go? I'm very grateful to have

found an outlet for my own rage. The work allows me to feel the anger, and to express it, and it allows my subjects the same outlet. More, it allows us to express it there where it happens, on the corner, in the street.

And yet, I still regularly walk around mad about being harassed, and I know that many thousands, probably millions, of women around the world do, too. We keep our pain and fury leashed inside us. For me, largely this is because of how women, and especially Black women, are received when we express our anger. In all sorts of implicit and explicit ways, women are told not to express it. That's what men telling women to smile is about, in fact. The message we receive again and again is that our emotions, particularly anger, are unattractive.

For Black women, though, it goes beyond that. White supremacy has taught our society that Black anger is frightening and intimidating. The stereotype of the angry Black woman is widespread and deep-seated. It is a powerful deterrent to us getting mad, especially in public, where a white person may well call the police on us. Often, we are seen as angry and aggressive

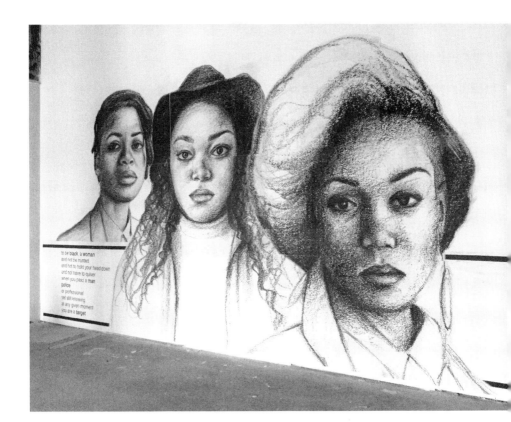

even when we are not. Black women's emotional expression is often read as threatening by non-Black people. It adds a layer of danger to how we are able to emotionally express ourselves in public spaces. For their part, white women who get mad out loud are generally seen as ridiculous: hysterical, out of control of their emotions, shrill.

I wish we were allowed our rage, because it's justified. I wish men didn't do things to us on the street/office/home/subway that enraged us. I wish we could exist in peace and freedom. But for now, I'm going to keep making my art and talking with women about their experiences. And I hope that by putting our reactions back out onto the street, I can help lighten the weight of that anger we each carry around inside us, at least a little bit.

Representations of Race

A big piece of street harassment that I explore in my art is race. I mentioned the general misperception that street harassment happens mostly to young white women; this is not true. White society seems to have no idea how much harassment women of color receive. I have heard from white women who have been stunned to learn how much more intense and relentless it is for Black and brown women.

I believe this lack of awareness stems partly from the fact that men of color tend not to harass white women as often or as aggressively as they do women of color. This has to do with several things: the fact that white Americans have always viewed Black men as violent; the fact that they have always feared and believed that Black men were out to get white women; the fact that white people call the police on Black people for no good reason; and the fact that it is dangerous for Black people to interact with the police. It goes back half a century to Jim Crow, when Emmett Till was accused of flirting with a white woman and was murdered for it, and his murderers went free. And further still, all the way back to the origins of this country.

White society has always had a delusional fear of Black men. Black people have always known this, and finally, the rest of the culture is starting to see it. In 2017, researchers at Montclair State University conducted a series of seven studies about this phenomenon and published the results in the *Journal of Personality and Social Psychology*. In showing dozens of photographs of white and Black men to white participants, the studies found strong evidence that

white people see Black men as physically bigger and stronger than white men with the same physique. The researchers wrote, "Americans demonstrated a systematic bias in their perceptions of the physical formidability imposed by Black men." Along with this bias comes a knee-jerk inclination to bring violence, "legal" or otherwise, down on the heads of Black men perceived to be a threat.

I get a lot of street harassment from Black men, and I also get plenty from white men. The harassment I receive from white men is the type that I'm most fearful of. If I am walking past a bar where drunk white men have spilled out onto the sidewalk, my first hope is that they don't notice me. But if they do, I'm worried that they will not only harass me sexually but racially, too. Again, as a Black woman, I am not just navigating sexism but also racist sexism. My chances of facing violence in the public space from white men are compounded by the chances of them being violently racist and sexist.

On the occasions when I have spoken back to white harassers, they've sometimes said racist things in return, calling me "black bitch" or something similar as I walk away. But other Black women have told me of far worse racist sexual harassment they've experienced. More than one woman of color has been approached by white men, in various settings, especially in places like Wall Street, who assume they are there for solicitation. This is especially true for Black and brown trans women. It makes me wonder about the extent of the sexual harassment and violence faced by sex workers when their bodies are assumed to be up for even more consumption by entitled men.

Again, most white people seem unaware of the frequency with which white men harass women of color, and of the racist component of that harassment. This ignorance speaks to the larger problem of the silence around and invisibility of public harassment and of white women's experiences being the dominant narrative. The lives and experiences of Black and brown women are largely absent in the media compared to the lives of white women. Because it's generally Black and brown women and women of color who receive the most street harassment, that experience isn't seen by the broader culture.

White women, historically, simply do not listen to Black women. It is why Black women have felt excluded from feminist movements led by white women. It is not that we have not been telling our stories and fighting for our lives for all these years; it is that white women have not heard us.

I'm hoping to help rectify that situation with both the street art series and the book. I'm also invested in simply portraying Black and brown women in

art in general, in ways that are truer for us as human beings than the usual media representations (or lack thereof).

At some point during college, the lifelong focus on racial justice joined forces with my anger from years of being sexualized, heckled, and intimidated in public, and I decided I wanted to make art about those experiences. I tried a few different approaches and media. I have always done a lot of work in oil paint, and I made one painting of a woman being grabbed by multiple hands. But it wasn't the right medium, and I wasn't satisfied with it or with any of my other attempts.

I finally got the idea for Stop Telling Women to Smile in my late twenties, some years after I graduated from college, when I was working as a freelance illustrator and budding muralist in Philadelphia. Gradually, my various realities began to make sense and work with each other. I was a woman, I was an artist, and I found myself spending time outdoors as a muralist. For one mural project, I collaborated with an art collective made up of all men. I remember very clearly painting the wall outside and men would walk by and whistle at

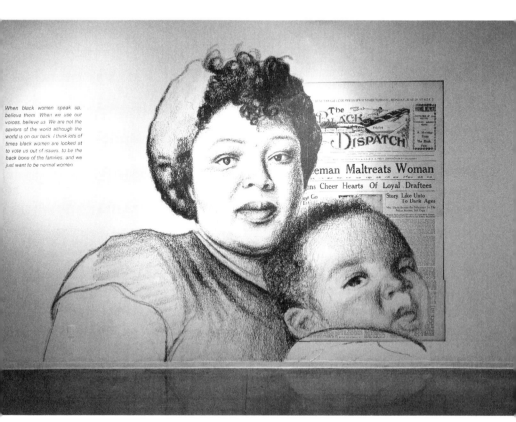

When black women speak up, believe them. When we use our voices, believe us. We are not the saviors of the world although the world is on our back. I think lots of times black women are looked at to vote us out of issues, to be the back bone of the families, and we just want to be normal women

me, or yell to me, or ask me to come down off the scaffolding to talk to them. These were not things that my male colleagues experienced. They were free to work and make their art on the street in peace, and I was not.

I always had to think about what to wear while I worked. In the summer, I worried about whether my shorts were too short (they were not) and would bring unwanted attention (they did). I was preoccupied with trying to avoid being sexualized while performing manual labor outdoors. Meanwhile, my male colleagues sometimes took their shirts off while they worked, and nobody objectified them.

The five or six men in the collective were good guys, but it was a really male space and group they created, and I wish they'd thought about what it might be like for me to be the only woman and to be getting harassed while I worked. They never said anything to me or the harassers when it happened. They just seemed not to notice or not to think it mattered that I couldn't work in peace. I was accustomed to nobody talking about street harassment, but the silence and indifference were so pronounced in that situation.

It was around that same time that I encountered the large-scale street art of the artist JR and learned about wheat paste. That's when I got the idea to create a public art project that would address the very thing that I was experiencing, had been experiencing for years, and was tired of experiencing—in the very setting where it happened. Wheat paste seemed perfect for artwork about street harassment. Not having to ask for or receive permission to put up the posters and the immediacy and temporariness of them felt like the right way to respond to street harassment, which is in the moment, off the cuff, constant. Posters can be printed and put up quickly and in multiple places.

Also during this period, I started to feel strongly that the private conversations I'd been having with friends for years, though incredibly important and formative for me, were not enough. It seemed really clear that the conversation needed to be public. Again, visibility is key. But beyond that, opening up the conversation in a public space has allowed for so much more understanding of the origins of sexism, of the infinite small, daily ways we live it, and of the bigger, more dramatic and violent treatment women receive. Spaces like Tumblr and Twitter mean no one is excluded from the conversation, and therefore we all benefit from getting a much more complete, complex, nuanced picture of the world.

I got onto Twitter early and was active and vocal from the start. I immediately experienced what a powerful force it could be. It gave me access to all

sorts of other people who shared my concerns, even if we came from really different experiences and places. Further, it helped me develop my own approach to conversations about society and race and gender.

One aspect that cannot be emphasized enough, because it's something many men and some women don't seem to understand, is how street harassment is on a continuum of inhumane treatment that women regularly experience or live in fear of, for our entire lives. This continuum includes everything from being underpaid and overlooked at our jobs, to sexual harassment at work and in social settings, to stalking, rape, domestic abuse, child abuse, and murder. And while each instance of harassment is fleeting, the cumulative impact on women's emotional lives and mental health is far from it.

I've already described the ways that street harassment is privately wounding, both in the moment and for a long time afterward. For me and many other women, another lasting response to being harassed is anxiety. I experience it on a low level almost constantly. The general, evolutionary purpose of anxiety is to protect us; it often leads us to take precautions against danger. Likely that anxious, self-defensive response occurs deep inside, on a level we're not even aware of. But it also happens in very conscious, obvious ways.

Before I leave the house, I always consider how far I am walking, what I'm wearing, what route to take. Recently, I was about to head out for a date wearing a mini dress, but I couldn't find my headphones, which are my primary defense against harassment—to block it out. I panicked because I was running late but I was absolutely not going to walk to the train in a dress that would surely elicit comments from men without having the protective barrier of listening to music. I finally found them, to my great relief.

But even deciding to wear headphones sometimes prompts a slightly anxious internal debate: Is it safe to obstruct my hearing on the street? What if I can't hear an attacker running up behind me? Most of the time, that fear is outweighed by the peace of mind the earbuds bring by blocking out the unwelcome things men say to me in public.

One experience in particular has left me with a very specific lasting effect. Ever since the guy slapped my behind as he rode by on his bicycle, I've been worried about people biking up behind me as I walk down the sidewalk. If I hear a bike coming from behind, I still have an automatic fear response, nine years later.

What Works?

About five years ago, my mom was in the hospital for surgery, and during her recovery she had this one nurse who was really kind, but he kept addressing her with names like "sweetie" and "sweetheart." It was coming from that Southern ethic of friendliness and politeness, lots of people call each other by little endearments like that, and he was clearly trying to be comforting. But it didn't sit quite right with my mom. There she was, trapped in a hospital bed with him coming in and out of her room at will and calling her these very familiar little names. After about the third time, she addressed it in the most graceful, gracious way possible. She asked him his name, then said, "I'm Sandra. Would you mind calling me that instead of sweetheart?"

He responded well, it was not a big deal, things moved on, and he called her by her name from then on. I was so impressed with how my mom handled it. She spoke up for herself, and he changed his behavior. It was kind of momentous. It's so simple but so powerful to ask someone to call you by your name instead of by those pet names. I'm all for using anger to make change when it feels necessary or right, and I absolutely believe women are not and should not be held responsible for

> My coming of age was tainted by men constantly asserting their own sexuality and inserting it into my experience and my space.

men's feelings when we are calling them out about their misogyny. But these gentler, quieter ways of addressing sexism can also be really impactful.

Sometimes they're actually more immediately effective than anger, especially in individual, intimate interactions like my mom's. Because she knew he wasn't calling her these things maliciously, but rather from a place of kindness, she met that intention with her own kindness. As a result, he didn't get defensive and instead was able to hear her. Not only did he happily do as she asked, but he might have even learned something from it. Maybe he thinks twice now before addressing women with those words.

For me, it's still tricky navigating those small moments. I can get really annoyed, really quickly. And for sure, annoyance is often warranted. Still, my mom's approach struck me, and I think about it periodically as I go about my day trying to fend off harassment and other kinds of sexist treatment.

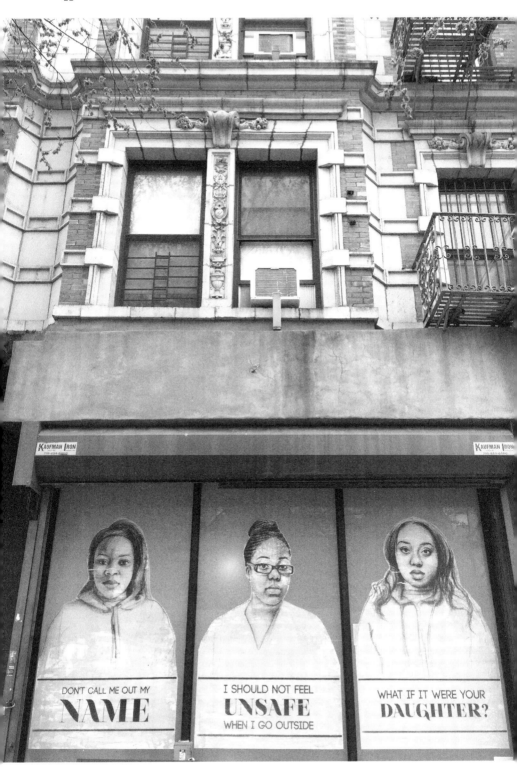

So, yeah, my mom, my best friend, these are the people who have done the most to shape me, to help me determine my life choices, to bolster and sustain me throughout my life. It makes sense that they're both women. My mom is really proud of me for creating STWTS, which obviously makes me happy. Over the years, we have started to talk about sexual harassment and other feminist issues. At lunch with a friend recently, we discussed how both of our mothers seemed to hold feminist ideas, particularly Black feminist ideas, but they never outwardly identified that way, at least not to us. We each sent a text to our moms asking for clarification. Both responded with yes, I'm a feminist.

In addition to the positive female influences in my life, I also think about how negative influences have actually led me toward making this art, too. My bad experiences with men and boys over the course of my life so far—those pushed me to become more of a feminist. In a way, it was recognizing the very conditioning that told me to stay quiet that prompted me to speak about sexism and to assert myself with my words and my art.

It's what made me want to do this work for other women and girls. I think about being in elementary school or middle school, and how the boys used to treat me, and knowing that the girls in that same neighborhood or that same school are probably being treated that way now. It makes me want to do work that makes those spaces better and safer for them.

What Would You Say?

When I meet women and talk to them about their experiences, I always ask what they want to say to the world about themselves and their experiences with harassment. Someone turned it back at me recently, and I realized what a big question that is. I'm constantly learning more about myself, what it is that I care about, what I'm passionate about, what I want to say, what I want to be, my purpose—all these really large questions I'm continually asking myself, both as an artist and as a person. For a lot of my life, it's been a lot about identity—about being Black, about being a woman, about being a mixed-race Black woman.

Lately, I've been trying to push that even further. What would I want to assert about myself that doesn't necessarily have to do with the oppression prescribed to those identities? When I think about what I might say to the public these days, it would be about who I am as a person, with a humanness much

larger than the perceptions projected onto my Blackness or my womanhood. For now I'll just go with: I'm here, I am who I am, and I am not here for anyone else. I am not here to please anyone, to teach anyone, to entertain anyone.

This work is about capturing instances of our everyday lives that we don't talk about, that are normalized, unquestioned, accepted. With the work, I'm trying to isolate those moments, and highlight them, and blow them up big. In the moment when we're sexualized and harassed in public, there's such a disconnect between how publicly it occurs and how private our reactions to it are. Most of the time, because it's the appropriate reaction, we feel angry. But we don't express it—we are not supposed to—so we just carry it around within ourselves every day.

I pinpoint those moments, enlarge them, show that we're angry about them and are allowing and accepting that anger. Instead of having to carry it ourselves, this art reflects it back to the public in the space where it takes place—on the corner, in the street, in the park, where it actually happens. Sometimes we contain our anger because we don't want to be seen as the stereotypical angry Black woman or the hysterical woman. Other times we keep it in from fear for our physical safety.

The STWTS project started not as an attempt to find a solution to street harassment or change laws. It was really just this simple: *Stop telling me to smile; it makes me angry and I owe you nothing.* I'm saying publicly, this is something that happens to me.

Here in this book, though, I go beyond the moment when harassment happens and beyond our immediate reactions. When I sit down with women to ask them to break down their experiences of street harassment, it's another way we can reclaim some power over it. The interview process is deliberate and in-depth. The women are usually really thoughtful and eager to get at the heart of the experience and its effect on our lives. This book shows readers more than that single, dramatic moment of conflict.

The work I put up in the street is about highlighting and enlarging that moment so we can all see it more clearly. But the process of making the art is slow and steady: I ask women questions, they consider them, their answers sometimes come slowly and incrementally and other times in spurts. For the street art, I sit with their answers, winnowing their words and feelings to capture a single strong, succinct statement. Here, I can show you what it's like to hear in detail from all of these women who come from so many different

places, backgrounds, cultures, and experiences, and what it's like to make the work.

The experience of making art from talking to so many women over the years has been like weaving a tapestry of experiences and voices and insights. The tapestry is an important touchstone in my life, a resource for when I doubt myself, a comfort for when I am especially discouraged by the onslaught of harassment and violence against women. The women's commonalities and their individualities make me feel less alone. I want the voices presented in this book to provide you with that same tapestry, that same deep understanding, and that same sense of connection and comfort.

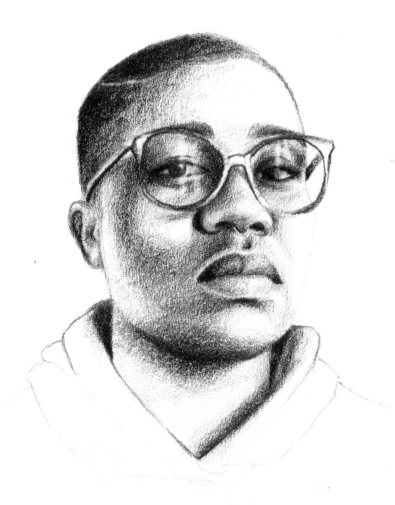

Chapter 2

<u>CANDICE</u>

Compounded Traumas

Age: 30
Identifies as: Queer, Nigerian American, woman, androgynous

Candice, a thirty-year-old writer and former teaching artist in Brooklyn, has used visual art to prompt conversations with her students. She shared some of the pieces from the Stop Telling Women to Smile series, and they told her that street harassment is something they know very well. The girls in her class, young teens, were already jaded by the experience of street harassment—it no longer surprised them.

I ask Candice how she defines street harassment and when it first began for her:

> I would define it as unwanted advances in public spaces or as general comments directed toward someone based on how they look. So, the minute someone realizes you don't want them to be saying that thing to you or looking at you in that way or following you or walking with you, they should stop. It's murky, but I feel like anything that you haven't consented to, or invited, that is directed at you based on your appearance in a public space, I would define that as street harassment.

For Candice, identifying as both a woman and as androgynous means that she varies her presentation between more femme and more gender nonconforming. Of course, her gender presentation on a given day determines the sorts of street harassment she receives. I wanted to know: How would she describe the different treatment she receives when she is looking more feminine versus when she dresses in (so-called) masculine clothes?

> I would say most days I'm pretty androgynous—I've been a tomboy my whole life. I get hit on when I'm more femme presenting, and then the comments are snarkier when I look more androgynous or like a tomboy. In my everyday life, I'm just always thinking about how the way I'm presenting is going to invite this or that. I don't think I steer away from being feminine because of the fear of harassment on the street or anything like that, but when I present more femme I do think more about being a woman and what that means in terms of safety.

It's interesting that even though Candice is not presenting as masculine but, in her words, as a "tomboy," it automatically changes the type and tone of the comments she receives. But I'm relieved to hear that her androgyny doesn't make her feel unsafe, because I've heard frightening stories from other gender-nonconforming people.

This may come as a surprise, but men are particularly likely to harass masculine women. Some have told me that men in the street point to their masculinity to insult them. These men take a woman's masculinity as an affront to their own; accosting them is an attempt to reassert their manhood and regain a sense of power.

One woman in Atlanta who identifies as "a stud/ag/dom/butch/masculine of center lesbian woman" offered this insight: "The men mistake my gender-appearance as symbolic of my desire to be a man," she said. "One man said to me, 'I think you dropped your dick on the floor' as I was walking with a girl on a date. Not only does my gender presentation say that I am unavailable to them, but it clearly symbolizes that I am a woman who does not want or need a man, and I believe men take this personally."

Several masculine-presenting women have spoken of regularly facing physical danger. Tragically, it doesn't always stop at threats. In 2003, a fifteen-year-old, masculine of center Black girl named Sakia Gunn was murdered by a stranger when she told him she was gay. After sexually harassing her and her friends as they waited for the train, he took offense when she didn't respond to his "advances." Some cisgender, heterosexual men feel their masculinity is threatened by any diversion from the gender binary, which puts all trans people, masculine of center women, and nonbinary people at greater risk of violence. This behavior is also representative of behavior that gay and queer women generally face on the street by men who feel like they have some ownership over these women's bodies and sexuality. For a couple composed of two women, walking and holding hands or showing any other sign of affection with each other, the street harassment they face will likely be layered with homophobia.

As we continue talking, Candice touches on several different aspects of women's fear, all of them significant. I ask her to describe the fear she feels on the street.

> The prevalence of street harassment and the fact that witnesses often remain silent come from the same phenomenon: this treatment is seen as a normal thing women just have to deal with.

Sometimes when I'm frightened of men on the street it's like experiencing sexual trauma again, that has happened twice in my life. As a woman who

lives by myself in Brooklyn, I think about it a lot. It's kind of ridiculous how much I think about it. Every time something happens in my neighborhood and it's on the news I think about how vulnerable I am living alone. I don't like that feeling of, "Oh, there's no man in this apartment, there's no masculine person to protect me."

I don't keep any weapons in the house; I don't have a knife by my bed, I don't have a bat, I don't have a gun, and as I get older, and because I'm living by myself, I think about it more and more, and wonder, "should I have that?" Or if I got weapons, would that just attract more violence?

I hadn't considered getting a weapon till a year and a half ago when I started living by myself. That's when I started taking all these precautions, thinking about the number of locks on my door, all that stuff. Sexual violence is something that's always in the back of my head. This thing is so common it really could happen again. And it's even true among my students, so many of them wrote about it this year. It's as common as walking down the street.

Every woman knows deep in her bones what Candice is talking about. Sexual assault is an ever-present force, an always-on-the-horizon encounter. For so many women, it is a constant, daily fear. It's a threat many of us dread more than other forms of violence. And though men can also be the victims of sexual assault, the fear of the body that Candice speaks of—the awareness that at any point someone might attack you—is not something men typically live with. Women have these fears not because of irrational paranoia but because one in five of us will be raped at some point in our lives.

We live in a society that has cultivated a rape culture in which sexual violence against women is presented as entertainment on TV and in the movies, where misogynistic language is normalized, where women are blamed when they are assaulted, and where sexual harassment is accepted and tolerated. All of these things and more create an environment where women feel unsafe and vulnerable. Rape culture means a man can brag about sexually assaulting women, be accused of sexual harassment and/or assault by sixteen women, and still be elected to the presidency of the United States.

In bringing up past sexual traumas, Candice points to another central experience for many women. I've been a part of several group conversations throughout my life when the subject of sexual assault came up. Every time, the overwhelming majority of the group had experienced some form of abuse or assault. According to the nonprofit Rape, Abuse, and Incest National

Network (RAINN), nine out of ten rape victims are female, and approximately 70 percent of rape or sexual assault victims experience moderate to severe distress, a larger percentage than for any other violent crime.

The fact that a lot of women have experienced sexual assault or abuse puts the experience of street harassment in another context: being sexualized and verbally abused in the street triggers memories of past traumas and compounds the effect of the earlier abuse. It bears reiterating what Candice said—that in certain instances, being harassed can be like reliving the original assault. This phenomenon of reexperiencing a past trauma is a common aspect of post-traumatic stress disorder.

WHAT WOMEN WANT TO SAY TO STREET HARASSERS

"MY APPEARANCE DOESN'T DEFINE MY GENDER."
—INGRID, SAN FRANCISCO

The fear women feel is that much more intense, that much more constant, for women who have been raped or assaulted before, because for them, the fear comes from actual experience. Candice, who is a writer and performer as well as someone who works with youth, tells me that all her creative work is about navigating the world while dealing with and healing from her past traumas.

Taking precautions against sexual assault is another very familiar part of life for most women. We learn these measures almost automatically over the course of our lives, from things that we're taught as children—*watch what you wear, stay away from that uncle*—to those we figure out as adults, like not going to the restroom alone at a party, making sure we know where the exits are in any new space we enter, and walking in the street if the sidewalk is dark and deserted.

These precautions are all in response to our very realistic fears for our bodies. Fears of men. We are always aware of the everyday dangers of simply existing as a woman because of the violence put onto us by men. I ask Candice about how she keeps herself safe from it all. What steps does she take to protect herself from harassment and violence?

I always think about what I'm wearing and at what time of day. I know that if I lived in a different neighborhood I may not think that way. In my neighborhood to walk out of the house with too much of my skin out means I'm going to get a lot of comments. There's a lot of women in my neighborhood who do it but I'm noticing a difference between me and straight women. I may be more sensitive to the comments that I receive if I dress a certain way. If I'm wearing less, I'm going to take a car. I'm not taking the bus, I'm not getting on the train, and I'm not walking anywhere but right outside my building.

Lots of women, including me, reroute ourselves, redress ourselves, and avoid being on public transportation in efforts to avoid harassment. Aside from the mental strain of having to think about how to protect ourselves, having to pay for cabs home at night instead of taking the bus or train is a significant economic impact of street harassment.

Bystanders and Allies

Next, Candice talks about how she experiences harassment differently in different spaces. I ask if she carries herself in certain ways depending on where she is.

Friends who have run into me when I'm walking down the street always say I look like I'm in the zone. That's because I don't look around too much. I don't want to make eye contact with the wrong person. I know that if I make eye contact with the wrong guy he's going to think that it's some type of yes; yes to talking to me, to getting physically close to me, to touching me. And the trains make me really, really nervous because it's a space where someone could harass you and you can't get off until it stops and the doors open.

I ask about her experience of the ways bystanders respond (or don't).

I've had a lot of friends tell me about being harassed on the train and no one defending them. It happens regularly. I've seen it and I've experienced it; where you're on the train or on the bus and you just know because you're in New York City no one's going to say anything, they're going to act like it's not

their business. Wherever I am in public, I'm always thinking about whether or not I'll have defense or support.

Being harassed on a crowded subway is humiliating and makes you feel trapped and powerless. Many women in New York City have stories of being harassed, groped, flashed, even followed on the train. I have heard many stories of men masturbating on public transportation. Moreover, when you're harassed and stuck in a bus or train car with your harasser and bystanders, and no one speaks up for you, it makes you feel very alone in your fear and vulnerability.

WHAT WOMEN WANT TO SAY TO STREET HARASSERS

"I DO NOT EXIST FOR OTHERS' APPROVAL— MY PRESENTATION IS ONLY FOR ME."
—MARGARET, ATLANTA

Both the prevalence of street harassment and the fact that witnesses often remain silent come from the same phenomenon: this treatment is seen as a normal thing women just have to deal with, an annoyance of living in a big city and being a woman. Of course, it isn't at all normal behavior and shouldn't be seen that way. Instead, it should be viewed as antisocial. And rather than being allowed to continue, there should be aggressive social pushback until it stops.

Speaking of pushback, I wanted to hear whether Candice had ever experienced a man defending her against harassment. She tells me about a time she was doing a photo shoot for a T-shirt line and she was harassed on the street as the crew walked from one location to another. One of the men, a photographer, spoke up for her.

It was the first time I'd ever had a man defend me. Two of us were women, and the photographer was a guy. This other guy started talking to us and walking with us. The photographer was like, "She said no! What is wrong with you? She said no!"

It felt so great. It was a different experience than me and my female friends saying, "Stop, I don't appreciate that." I feel like I'm never with my guy friends when it happens. But if I was with them, I would expect them to stand up for me or we probably wouldn't be friends anymore. I feel like men listen to each other, they don't listen to us a lot of times.

It is frustrating but true that some men, especially harassers, are more likely to pay attention to what a man says than what a woman says. And, of course, there's the fact that when she is being harassed, a woman may not feel safe or comfortable voicing her objection. For these and many other good reasons, any and all bystander interventions are key to ending street harassment, and male allies are an essential facet of that. Intervention by anonymous bystanders is just as important and effective as intervention by friends. But witnesses sometimes find it difficult to find the presence of mind or courage to intervene.

> **For so many women, sexual assault is a constant, daily fear.**

Hollaback!, an anti–street harassment organization, suggests interventions it calls the Five D's: direct (directly responding to the harasser), distract (derailing the situation by interrupting, ignoring the harassers, and engaging with the person being harassed), delegate (finding a third party to help intervene), delay (checking on the person after the fact to make sure they are okay), and finally, document. Of course, with any of these, it's essential to consider your safety and the safety of the person being harassed.

If talking directly to the harasser seems unsafe, you can turn all your attention to the woman he's targeting. Just making your presence and concern known, and letting her know that she is not alone, can hugely decrease her discomfort or fear. In the best-case scenario, it can also stop the harassment. If it feels safe to do so, you can approach it directly and simply by asking her if she is okay. But even just interrupting the harassment to ask the woman for the time or for directions can distract the harasser and halt the whole interaction.

Feeling alone, and as if no one around is willing to help, makes women feel even more unsafe and vulnerable. Everyone, and men especially, can do something in the moment to help protect someone from being harassed and possibly assaulted.

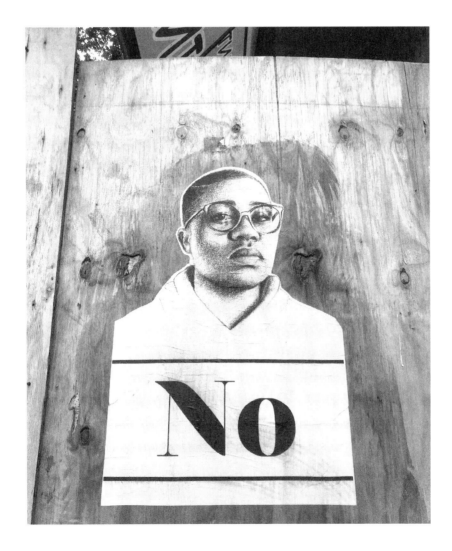

Teaching Kids About Respect

Luckily, as someone who works with youth, Candice is in a position to make a difference. Noting that misogyny shows up early in young men, she discusses trying to combat it in the classroom.

What does she say to her students about street harassment, and sexism in general?

I just want [the boys in my class] to hear women talk about this stuff as much as possible. There's been times where a lot of the young women in

my class will write about something important to them, and they'll share it out loud. And then I get to the boys and they say they weren't listening, or they didn't participate in the writing exercise today because they didn't feel like it.

I turn and ask the girls, "How does it make you feel that they just didn't have to participate today?" I have them talk directly to the boys about it. Which has been really fruitful; the boys feel bad when that happens. Teenage boys are reachable. They just need it to be in their face consistently.

I love to imagine Candice bringing up these difficult and uncomfortable subjects in a classroom full of teenagers. They are lucky to have her. Even though sexism is much more in the public conversation recently, it's still not something that most people discuss in any depth. Simply by raising the issue and making sure that the boys listen directly to the girls about their experiences, she is having an impact. I'm sure at least some of those teenage boys will go on to become allies who intervene to defend their friends, family, and even strangers against harassment and worse.

Reactions and Responses

I'm always curious about if and how women respond to harassers on the street. How, when, or whether we respond to street harassment is up to each of us as an individual.

I ask Candice if she ever talks back to men who make comments to her.

I'm actually extremely confrontational. [*laughs*] A lot of times I say things back when I'm harassed in the street. Lately, when I'm being stared at a lot I usually say, "I don't like being stared at like that. That makes me really uncomfortable. Can you look over there?" I did that maybe a few days ago, and he stopped. They usually do if I'm really explicit about it.

I usually lead with my feelings. I'm strategic about it. I don't curse people out in the street because I always feel really unsafe when I do that. If I'm in a bar setting and someone's making comments to me, I sometimes engage in more conversation, if I have the energy. I'll ask things like, "Does that work for you? Do people respond to that?" The conversation usually doesn't go much beyond that.

WHAT WOMEN WANT TO SAY TO STREET HARASSERS

"MY BODY IS NOT COMMUNITY PROPERTY."
—JUBIE, NEW YORK

There is no one right way to respond to harassment. Sometimes, cursing and screaming is safe and effective (and satisfying), and other times, not responding at all is the right move. It's often difficult to know what to do in the moment, especially because, even if you don't respond at all, there is no guarantee that the man will not get violent. I really admire Candice's example of responding by stating her feelings. Her words firmly and directly point out the harasser's behavior and the effect it has on her. In moments when we have the patience and wherewithal to do that, I imagine it could actually make some men pay attention.

Finally, I ask Candice what broad message she might like to deliver to harassers.

I just want to say "No." Because I feel a deep offense and discomfort from men when I say no about anything.

Sometimes, the most succinct response is the most forceful. On a fundamental level, Candice is refusing to explain or attempt to educate harassers (as opposed to teenage boys); she is simply stating what she feels and knows. Just hearing Candice say it so firmly fills me with resolve, and with a kind of clarity: with every fiber of my being, I, too, just want to say "No," loud and clear.

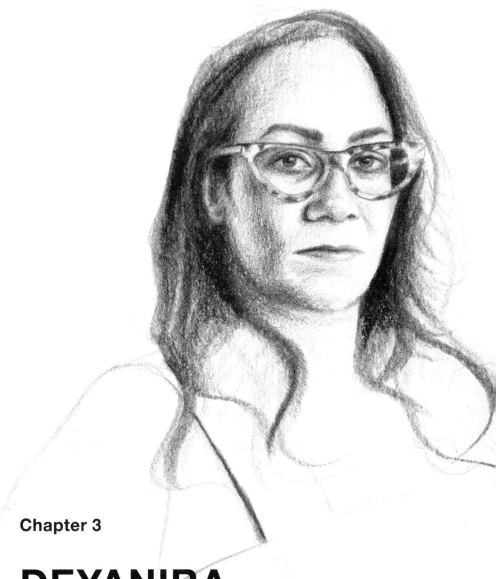

Chapter 3

DEYANIRA

Motherhood and Middle Age

Age: 48
Identifies as: Cis female, Afro-Latina, mother, social worker, and writer

Deyanira is a lifelong New Yorker, a social worker, a mother of four. Raised by parents who came from the Dominican Republic, she speaks both Spanish and English. When we meet, she is recently single. She tells me that she left the relationship happily and says, "I feel very blessed to have been able to do that because I recognize that a lot of women are unable to." It's great to hear. I can see right away that she's a confident, optimistic woman.

I begin as I always do, asking Deyanira for her personal definition of street harassment:

Street harassment is when I'm walking down the street and men feel free to make any type of comment, whether it's something crass, or something some might say is flattering, without my asking for it or expecting it or welcoming it.

Then I want to hear about her earliest memories of it.

I developed very young, unfortunately—well, fortunately, because it's my body. But I was a brick house at eleven and the first experience of it that I remember was going into a bodega in my neighborhood. The biggest treat of my day was that my mother would give me twenty-five cents and I'd go to the bodega and buy myself a bag of chips. This man who worked in the bodega would always smile at me. Even though I didn't know what it meant, it made me feel uncomfortable in a way that my child mind couldn't define.

I remember one day I went there and I was wearing this navy blue dress, I literally had my hair in two braids in a blue beret and I was feeling myself. I walked in there smiling and feeling good and the man tried to touch my face. I remember ducking and running out and telling my mom what happened, and my mom laughing and saying, "Oh, that's nothing."

I remember knowing within myself that something about it was weird and gross. I knew I didn't want him to touch me. And in general, grown-ass men would be talking to my eleven-year-old breasts. I know my face looked like an innocent kid, but there were my booty and my breasts, and they just felt free to say whatever they wanted.

As often happens during these conversations, I feel a rush of recognition, this time at hearing Deyanira talk about developing so young. I suppose that

our different responses to harassment at that age can be attributed partly to where we lived, the density, anonymity, and very direct culture of New York versus Oklahoma City's spread-out population, small-town feel, and Southern courtesy. But also, my general reticence at that age played a role for sure. In any event, although our external reactions to being sexualized as young girls were very different, our interior experiences of it were similar.

WHAT WOMEN WANT TO SAY TO STREET HARASSERS

"MY DAY IS NOT ANY BETTER BY YOU TRYING TO COMPLIMENT ME."
—SHONGRETTA, ATLANTA

I know that for me and my women friends, the internal struggle against body-image messages we receive from the outside has been lifelong and constant. I'm curious to hear Deyanira's take on this seemingly universal phenomenon. Have her feelings about having a curvy body changed over the years?

When I was a younger woman, I was almost ashamed of my body and its gift. I remember wearing big giant shirts and baggy clothes just because I didn't want the attention. Only very recently, in my late thirties and forties, have I kind of gotten out of that mind-set and started to feel like, well, this is what it is. I'm proud of it, it's my body, it works, it's getting me where I need to go, and it's a beautiful thing. I don't want to hide it because you can't control yourself.

If that sounds familiar, it's because I said it earlier: as a kid I, too, wore oversized clothes for the same reason Deyanira did. I think our shared experience says a lot about how Black and brown women are made to feel ashamed of our physicality, especially women with curvy and thick bodies. Because our bodies are so overly sexualized, we are often scrutinized for the way clothes fit on us.

I'm bringing up race here because the way that certain clothes and appearances are judged on young Black and brown women is different from how

> **We are constantly navigating how to appease men simply because of the fear that they might hurt us if we do not.**

the same clothing and styles are perceived when worn by young white women. This comes up regularly in my conversations with teenage girls, who invariably notice that, say, a young Black or Latina girl with colored hair, short shorts, and tattoos will be treated very differently from how a white counterpart with the same style is treated. Historically, white American society has proceeded as if Black and brown girls are more sexually available than white girls, that they are less deserving of respect, and that they can be approached in an aggressive manner.

Deyanira talks about experiencing this very phenomenon as a kid, when she was racialized and sexually harassed in school. I ask her what that was like.

I got a scholarship in sixth grade to go to a private school. I was the only Latina and there were maybe two other Black kids there, everyone else was white. I remember sometime in the seventh grade I was in the bathroom after school and this bunch of little white boys were calling my name and telling me to come out. I didn't really understand if there was a sexual tinge to it, but I kind of knew that there was.

I now recognize that it had to do with the stereotype of being a Latina and speaking fast and being seen as hot and loose. I have experienced that a number of times since, but that was the first time because up until that point, for my whole life I'd been surrounded by people of color, my own folks. It was new to have the stereotype in my face. When I date outside my race, it still pops up again. A guy will say, "Call me Papi." Oh, okay, so now you're fetishizing me.

Latina women deal with a stereotype of being overly sexual, sassy, lusty. A lot of brown women and women of color have spoken to me about being exoticized by white men. When considering racism in the context of sexual harassment, fetishization is a common form: objectifying women based on stereotypes around their race or color.

The type of harassment women of color receive from white men is markedly different from the harassment from men of their own race. From the

dozens of conversations I've had for STWTS, I've learned that women of color have felt the most disrespected and belittled by white men.

Once again, we see harassment as an act of power: white men feel more entitled to the bodies of Black and brown women because we do not hold the same societal power that they do or that white women do. We are also less likely than white women to report their abuse because we have historically been disempowered by the police, who hold tremendous power over us.

Of course, these racial and gender power dynamics take hold early. Boys are socialized to see girls in certain ways. It fills me with sadness and anger to imagine how, as the only brown girl in her all-white middle school, Deyanira must have felt so alone in the face of racial and sexual harassment by her white male classmates.

WHAT WOMEN WANT TO SAY TO STREET HARASSERS

"YA BASTA!"
—LORENA, NEWARK

On Motherhood and Street Harassment

Not having children myself, I often wonder what it's like to worry about your kids when it comes to sexual harassment, consent, and related issues. I'm also curious about how parents talk to their children about these things. Having herself been sexualized as a child, Deyanira knows the lasting effects of that very well and that it still happens to girls.

How does she approach such conversations with her children?

I've never been with my children and had anybody talk to them, but I would lose my damn mind if it happened in front of me, especially with my fifteen-year-old. She has told me it has happened, men have tried to talk to her and she realizes how gross it is. And then we talk about how that feels to her and I can just see in her fifteen-year-old eyes, "Ew, that's just disgusting. I don't know what's wrong with them."

I tell her, I know you don't want that, and you do need to keep yourself safe, and you can always tell me, if you want to talk about it. It's a damn shame. And it's not a conversation I'm having with my seventeen-year-old son or my twenty-four-year old son about being safe in the street.

I talk about consent with my boys. My seventeen-year-old just recently had his first girlfriend. I've always spoken openly about sex with my children because it was a mystery for me growing up. I talk to him about consent and always asking permission. His own consent too—that if he doesn't feel like that's something that he wants to do, then he shouldn't.

I imagine it to be challenging and frustrating to raise children in a society that pressures girls to strive for and adhere to beauty standards, then sexualizes and harasses them for that beauty. Equally frustrating is the way our culture rewards and encourages boys to be womanizers. Add to those forces the way the world pushes children into a rigid gender binary with fixed roles for girls and for boys, and it's no wonder that men treat women badly and get away with it.

The sad truth is that parents can't always control or even know what society is teaching their children. Kids are frequent witnesses to the sexism that pervades our lives. When a woman is harassed in the street in front of her children, it has an effect on them too. A mother I spoke with in Baltimore, who held her young daughter in her arms as we conversed, said she would say back to her harassers: "Your actions are teaching my kids that this behavior is okay."

Thankfully, Deyanira and other parents like her are teaching their boys to treat girls and women with respect, and teaching their girls that they deserve it. When we respect women as full human beings, we do not objectify them. So much of the discussion of sexual violence has been around blaming women and girls for their attire and behavior. Even well-meaning people will

WHAT WOMEN WANT TO SAY
TO STREET HARASSERS

"I AM A HUMAN BEING."
—AMISSA, BALTIMORE

tell women not to wear certain clothes in order to protect themselves against assault, not realizing that that very message is part of rape culture.

But when does the conversation focus on the behavior of boys and men? Not nearly often enough, though parents like Deyanira are doing that work.

When Street Harassment Turns Physical

Next, Deyanira mentions another kind of harassment she's been subjected to more than once: strange men trying to touch her. I have experienced it more than once myself. I ask her to describe these incidents and how they made her feel.

> During my pregnancies, more than once men asked to touch my belly. Sometimes they didn't even ask but just reached out; thank God they never actually touched me because I would of course recoil and move away. But I couldn't believe they would just try to touch my belly. One man was like, "Oh, can I touch your belly, it's good luck," like I was a crystal ball and not a fully formed human being.
>
> Once, a man tried to touch my feet. I was going downstairs and a man was coming up and he said, "Oh my god, can I touch your feet?" And he started to bend down to touch them!

A lot of women I have spoken with talk about being touched without permission by men and boys, in the street and in lots of other settings. My own most recent experience was when an older white man at a conference touched my face as he commented on my smile. My gut instinct was to punch him in the face, but I resisted the urge.

Instead, I sternly told him to step away and then reported him to the organizers of the conference. I was infuriated that even at a professional event, I was made to feel like my body was up for consumption by an entitled man. This type of physical invasion of a woman's space is another really common, really infuriating form of harassment. To me, the solution seems frustratingly simple: men should not feel they have the right to touch women's bodies.

That same male sense of entitlement is often expressed via another familiar dynamic of street harassment: verbal abuse. When harassers don't get a

response they like, some resort to insults or shouting. Unsurprisingly, this has happened to Deyanira, more than once.

> Certainly, there is a lot of verbal assault, if you don't pay attention to them—"You ugly anyway. You bitch. You stuck up." And meanwhile you haven't even said a word, you're just walking.

Taken together, Deyanira's experiences with being touched by strange men in public and being verbally abused by them are clearly part of a frightening pattern of behaviors that can quickly and easily escalate. Men feel entitled to women's bodies—to comment on them, to touch them—and when we resist them in whatever way, they feel as if we have wronged them. When women simply walk by harassers and go on with our day, the men often take that as a rejection of their masculinity. Lots of people say that street harassment should be taken as a compliment, but I wonder how they would react to verbal abuse they received simply for remaining silent in the face of "compliments."

Parents can't always control or even know what society is teaching their children.

As I mentioned earlier, harassers' reactions to being ignored aren't always limited to verbal abuse—it can become physical. I have heard of men throwing things at women, grabbing them by the arms, slapping them. In Los Angeles, a woman recounted something that happened to a friend of hers. She was walking when a man approached her and asked for her phone number. She told him she did not want to give it to him, so he punched her in the face.

Fear of retaliation is one reason women smile and nod or try to keep the interaction neutral when dealing with men on the street. We just do not know if or how men will get physically violent.

Like many women, I often have an internal debate about whether or not to speak to a given harasser. In some situations, our best guess might be that responding civilly will protect us from verbal or physical abuse. Civility seems like the better option, even though he may well take it as an invitation for further interaction.

But the frustrating thing is that sometimes when we take the civil path and squash our natural inclination to speak up for ourselves, it doesn't even work; he might still become abusive. For many of us, these kinds of rapid-fire

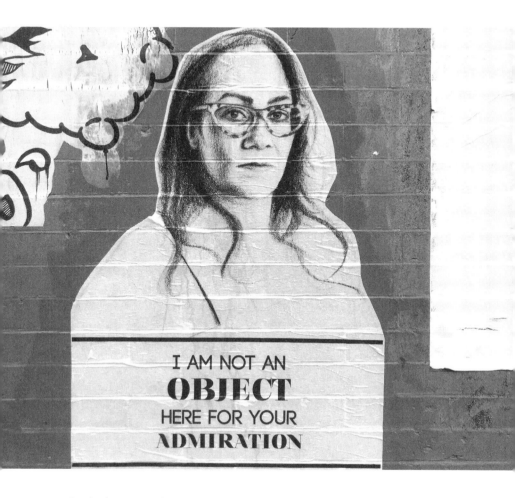

mental calculations and assessments of the situation are just a part of regular life. We are constantly navigating how to appease men simply because of the fear that they might hurt us if we do not.

Tragically, our fears are founded in reality. Many women have been killed by men out in the public space for rejecting their advances.

I always think of Mary Spears. In 2014 in Detroit, she was shot in the head by a man for refusing to give him her phone number. I remember reading the news story: I had just finished giving a talk about street harassment at Northwestern University, and I felt immense sadness. Mary Spears was a fiancée, a mother, a young woman with the autonomy to say no. That no made a man feel so disrespected and so rejected that he killed her.

I think about these and other senseless deaths as I have conversations with women, as I make art, as I leave a party late at night, as I get into a cab, as I

go about my daily life. There is a clear, direct connection between street harassment and violence. And Black and brown women, LGBTQ youth, lower-income women, Black trans women, and trans people of color are extremely vulnerable to both.

No One's Baby: Street Harassment and Age

One thing about aging is that I'm starting to react in new and different ways to harassment, both internally and externally. I feel more entitled to my own body than I used to, and more ferocious about the fact that men are not at all entitled to it. It's one of the reasons I was eager to interview someone in her forties about what it's like for her now.

Near the end of our conversation, I ask Deyanira how street harassment has changed for her as she has aged.

> I don't feel old at all, but I am forty-eight. It does still happen to me. I think sometimes people think that this only happens to the cute girls who are twenty-three, when it really happens to anybody, for any reason, at any moment; it's at the man's whim. It shouldn't be that way at all. It happens less now because I'm older, though it hasn't stopped. It's not something that I miss.
>
> It's interesting, I had a conversation about that with my ex-boyfriend. He was a low-key misogynist. He said, "I know this one girl that said that if the guy talking to her on the street is cute, she'll give him an opportunity." I said to him, "Because of that one woman you're saying that that's every woman's opinion? I'm telling you that I would rather go about my day without hearing any of this." He said, "Oh but when it stops you're going to miss it."
>
> And I told him, "No, I'm not. This is not validation to me. I could get this validation from people who mean something to me if I need it. I don't need some random dude being fresh to make me feel like I'm pretty."

Interestingly, I have heard from other women in their forties and fifties who say that comments from men in the streets have dwindled as they have aged, and that they do appreciate the attention from men when it comes. But I am more in line with Deyanira and would rather receive no comment from strange men on the streets.

Frustrating exchanges such as the one Deyanira had with her ex-boyfriend are why more parents need to be having the kinds of conversations with their kids that Deyanira has with hers. Her concerns and responsibilities as a mother are never far from her mind, especially when she tries to envision a future without street harassment.

> It would be freeing. That's the first word that popped into my head, *freeing*. And as a mother, I would feel better knowing that my girls are walking around and no one is going to say shit to them. They don't need to hear it. I wish that world for them.

It's a huge relief and inspiration to hear such depth and candor from a woman who has been going through these things for almost forty years and who has emerged not only unbeaten but also powerful. This is why it's important for these conversations to happen between people of different ages. We have much to learn from the women who have been suffering and surviving sexism longer than we have.

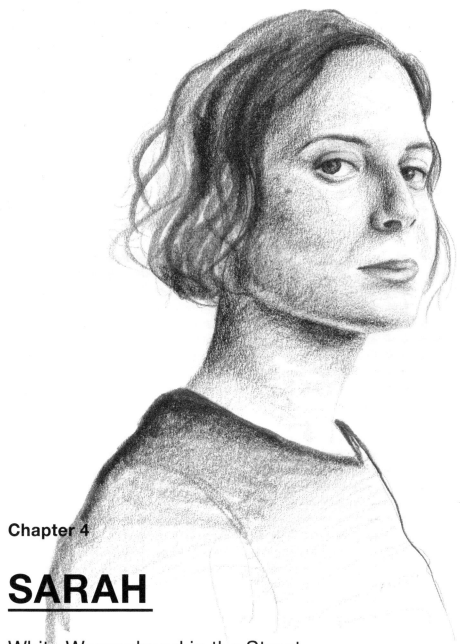

Chapter 4

SARAH

White Womanhood in the Street

Age: 32
Identifies as: White, bisexual, cis woman

Sarah grew up in San Francisco and now lives in Brooklyn, where she teaches elementary school. She started following the art series Stop Telling Women to Smile because she was disturbed by memories from her early life, when she'd been subjected to harassment on the street. You'll notice that this is becoming something of a refrain here in the book—how young we are when the harassment begins. I'm eager to emphasize this aspect because it is something I hear from the majority of women and girls I speak with.

I ask Sarah at what age she first started experiencing street harassment.

Growing up in San Francisco, we walked around a lot and were just out and about. I distinctly remember when I was thirteen turning fourteen, walking next to Golden Gate Park, where we went to high school. Two guys in a pickup truck started yelling comments at us about our bodies. It was so confusing because we were kids.

When I ask her how she defines street harassment, Sarah talks further about the disorientation caused by being harassed.

It's any interaction with a stranger that is unwanted. It's kind of hard to define because we're humans, we're in a society, we're in a community. It's okay to say hello to people and things like that, but where is the line between a man being friendly and when he's approaching you on the street because he finds you attractive?

Sometimes you just feel that a man is asserting his power over you. That power dynamic of him being able to say whatever he wants to say and feeling okay about it and not feeling that it's an overstep of boundaries or that it's harassment.

Entitlement and power—these are also common themes. Sarah is right that street harassment is usually less about desire and more about dominance and control. When men feel they can say anything they want to a woman and then expect her not only to accept it but also to take it with a smile, that is an exercise in power. Like all sexual harassment, regardless of where it happens, street harassment is about men dominating a space by intimidating women with sexual comments.

I ask Sarah about how she identifies and how she presents in public:

> I tend to present pretty feminine, and that in and of itself is kind of confusing. I identify as bi or queer, but I feel like an identity is placed upon me because I present as feminine. I don't feel feminine all the time, I feel closer to the middle, if you're looking at it as a binary or a continuum. So that's something that's always been confusing to me, especially as a teenager, when I experimented with different types of dress, but generally geared toward the feminine, even if I was wearing boxers and jeans. So I've always received that male attention.

Even our self-perceptions and our ability to determine our own identity are co-opted by street harassment and all the related treatment men regularly inflict on women.

Ambivalence: Confusing and Common

As our conversation continues, I am struck by Sarah's willingness to examine the various kinds of confusion she feels in reaction to street harassment. Earlier in the book I talked about the bewilderment I often experience in the immediate aftermath of being verbally abused by an unknown man. And I can also relate to the other sorts of perplexity she describes.

How does street harassment make her feel?

> Sometimes there's that weird emotional range in response to it. Sometimes you're like, "Oh, that's a nice compliment, that made me feel good because I was dressed nice." It almost feels weird reacting that way. Then, most of the time, it's the opposite, where you just feel gross and don't want it.

I'm glad Sarah makes this point. It's true that what men say to us in the street and our own reactions can be confusing. Sometimes, it truly is simply a compliment and not an assertion of power. Other times, the comment may rightly be considered harassment, and we might still feel flattered by it. The frequency can be unsettling, too: someone can offer a kind gesture, while someone else on the next block makes a crude remark. In certain instances,

we may feel ambivalent—either truly not knowing how we feel about it or being aware of feeling both validated and repelled at the same time.

In cases when we truly do feel flattered by a comment that would widely be considered harassment, there are a couple of factors at play.

First, I believe that when we feel validated by harassment, it's because we have internalized the gendered messages, intentional and unintentional, that all girls get from the moment they are cognizant. With such constant and outsized emphasis on our appearance, how could we not internalize at least some of it? The desire to be found attractive looms disproportionately large in most girls' and women's lives, because it is often treated as the most important thing about us.

WHAT WOMEN WANT TO SAY TO STREET HARASSERS

"I OWE YOU NOTHING."
—HOLLY, CHICAGO

I don't feel this way anymore, but when I was younger, if I went a few days without being harassed, I can remember thinking, *Am I not cute anymore?* And then I'd immediately judge myself harshly for my ambivalence about getting that kind of male attention. My own reaction was confusing to me. And going back even earlier, to my early adolescence, I can remember feeling both things: that some of the attention from men and older boys was inappropriate, and that I sometimes liked it because it made me feel seen.

The second thing to consider here is that, though some of us have felt that kind of ambivalence, most women who have experienced a lot of severe harassment don't have confusing reactions to it—they simply do not want strange men talking to them outside, period. For many women, and in many settings, the crude, sexual type of remark happens much more frequently than the courtly, complimentary kind. And because those gross remarks can turn quickly into outright abuse and even violence, lots of women are wary of any comments at all from men. And many survivors of rape or sexual abuse are similarly wary of any attention from unknown men.

To be clear: women know what compliments are. I've mentioned this before, but one of the most condescending responses to my work that I have heard is that we should take street harassment as a compliment. What that interpretation misses completely is that women do not have the luxury of assuming that a comment from a man is a benign compliment. So many times when we do, and, say, smile in response, the comments immediately turn overtly sexual. Or the man will reach for more—your phone number, your conversation—as if we owe it to him. Some men think that because they paid a woman a "compliment" it is okay to follow her and continue talking to her, whether she welcomes it or not.

The Complexities of Privilege and Sexism

This book is mostly about gender and sexual harassment, but many kinds of harassment happen in the street. All sorts of people get publicly harassed for all sorts of reasons: race, religion, sexuality. In our current political landscape, this country has seen an increase in racist and xenophobic violence in the public space. Hate crimes spiked notably around the 2016 presidential election, with race remaining the number one reason.

I've given talks and done workshops with students in New York City where I've asked the whole group about ways they have been harassed on the streets. Many of the young men have talked about their experiences with stop and frisk—a practice in New York City that allows cops to stop citizens on the street and frisk them without a reason. The main people targeted in this practice are young Black and brown men. Though it's government-sanctioned, it is still, straightforwardly, harassment by the police on the basis of the young men's race and economic status.

I ask young people this question for a couple of reasons: to show that oppressive and harassing behavior happens not only to cis women and girls, and to engender in the boys some empathy for the girls. I want them to see that all of them have been harassed on the basis of who they are and that, in addition to racial harassment, the girls are also experiencing harassment that is sexual.

When I asked this question in one high school class, it didn't quite go as I expected. Almost everyone in the room said that, yes, they'd experienced harassment. And almost everyone in the room empathized with the boys for

being harassed because of race and their neighborhood. But when it came to the girls, most of the class, including the female students, found ways to blame the girls for the harassment they receive—saying, for instance, that their attire sometimes warrants it. This was fascinating, disheartening, and not completely surprising. Our sexist society affects all of us and often shows up as victim blaming—not only by men and boys but also by women and girls.

I ask Sarah how she thinks her race affects how she experiences the public space.

> Last night a friend and I were walking down the street holding beers in little brown bags. A cop passed by in a Jeep, so I moved the bottle to the other side of my body, out of his sight. He yelled out the window, "Nice move."
>
> Because of who I am, that's what he said, but had I been a big Black guy or someone more masculine presenting, someone who doesn't fit the general societal view of women, maybe he would've said something drastically different. He looked at me and thought, *Oh, this is a cute woman we have to protect.* It made me think about that idea of protecting white women and the dichotomy. I have so much privilege because of my skin color and because of my presentation. It's fucked up, when you think about the depth of it.

Sarah is right—if she were a Black man and a police officer drove past while she was trying to conceal a beer, it would have been a very different experience and outcome. Equally important is her discussion of her white privilege—how, as a person out in public, she gets away with things and is simply allowed to be in certain places and experience the street in a way that Black people do not.

Sarah's description of being able to do something illegal outside and the jokey, casual, indulgent reaction of the cop that would have been very different if she were a Black man demonstrate a particular aspect of white privilege: the ability to interact with the police without fear.

Some high school girls I talked to told me that some police officers they pass on their way to school make sexualized comments to them. These girls were all Black and brown; I have never heard of this happening to any white women or girls. I found it shocking and incredibly discouraging.

I've also heard about police giving trans women a hard time. Police officers often assume that trans women are sex workers, and therefore that they're

sexually available to them, and they harass them accordingly. If the very people who are supposed to be out there on the streets protecting us are perpetrating harassment themselves, where can girls of color or Black and brown trans women go for protection?

WHAT WOMEN WANT TO SAY TO STREET HARASSERS

"MY HUMANITY AND SEXUALITY ARE NOT YOURS TO CONFLATE."
—JUSTINE, OAKLAND

I recently heard a story that hit close to home. A police officer had pulled a woman over in her car, and he told her he wouldn't give her a ticket if she smiled for him. That is some next-level telling women to smile.

And, of course, the ways police abuse their power get much worse when they're out of sight. A police officer in Oklahoma City recently went to jail for molesting women. He used his power and authority to coerce them into sexual acts, telling them they had to do it or he'd get them in trouble with the law. These women were Black and from low-income neighborhoods. I know because a lot of them were from the neighborhood I grew up in. This officer, like most of the officers who harass Black and brown women and girls, used his power to take advantage of and further disempower these women and girls.

If sexual harassment is about power, just think of the power differential between the police and people who are already disenfranchised—people who are poor or Black teenage girls or trans people of color. Sarah's experience reveals the huge gap between how most white women and most women of color are perceived and treated by the police.

Of course, the recognition of Sarah's white privilege doesn't excuse the men who comment on her body, nor does it diminish her very real experience of street harassment. But it paints a wider picture of how certain bodies are treated in the streets. Racism is another layer of oppression women of color experience in addition to sexual harassment. It's important to hear a white person say, *Yes, I am sexually harassed in the street, but I also understand that I am privileged in other ways when it comes to the public space.* Race also shows up in

how certain bodies are treated in the streets when the discussion is about how Black and brown men are the supposed culprits of sexual harassment. A lot of white women who move from smaller cities to mostly Black neighborhoods in big urban cities experience a heightened sense of visibility in the street. So, when they are harassed, it seems as if Black men are the only or the majority of perpetrators. But rarely are white women implicated in the problem of race. A white woman sexually harassed in public not only is subjected to sexism but also experiences race in the street in the opposite way from how a woman of color might experience it. Rarely does anyone call a woman out about her whiteness or blurt out stereotypes about her and her community (in the ways that Latina women are called sassy or Asian women are seen as subservient or Black women are hypersexualized) or mistreat her because of her race. To the contrary, white women are often treated protectively by white men. And as I discussed earlier, a lot of men of color leave white women alone for fear that the women will react in a racist manner and maybe even call the police.

> **Even our self-perceptions and our ability to determine our own identities are co-opted by street harassment.**

Of course, I have heard white women speak of being called "snowflake" or "white girl" in the streets. This is a crude recognition of a white woman's color, and it is harassment. The difference is that these names are not steeped in stereotypes, historical racism, or systemic racism, and the men have no racial power over them, so there are no material consequences for the white women receiving these comments.

It's important for white women to understand that they experience race in the street in a very particular and privileged way, because it allows them to see that, in the context of street harassment, the treatment they receive is very different from the racist abuse that women of color receive on top of sexual harassment. Examining these racial disparities is crucial if we hope to change the mainstream narratives about street harassment and open the conversation around how different people are forced to deal with the public space.

As I do this work, I continually turn my gaze on my own privilege. I ask myself how I can complicate and challenge the narrative of street harassment, while understanding that I am experiencing it from a relatively lucky

position. It is often difficult to see how we might be privileged in the context of an issue that is so terribly and obviously difficult and oppressive, and sometimes traumatic. But I believe such self-examination is necessary for the larger movement to protect and acknowledge all of our stories, especially those of the most vulnerable among us. Even though my history with street harassment has been awful, as a cisgender woman, I understand that women who are trans experience harassment and violence on the street to a much higher degree than I do. And that understanding isn't a finite act; I need to keep looking at the experiences of people who are more vulnerable than I am, and keep looking at my own privilege, and walk in that.

As I tell my story, I need to recognize that even though my experiences have been hard and unacceptable, my life is not in as much danger on the streets as the lives of my trans sisters.

It is important to be aware of our own positions of privilege in the context of sexism and sexual violence even as we are the victims of it ourselves because this recognition is what propels us to fight not only for ourselves but for others

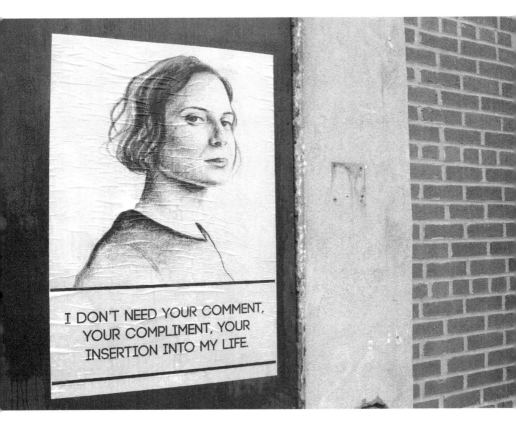

too. We cannot dismantle sexism as an isolated oppression. Sexism does not work alone. We have to chip away at it while also chopping away at racism, anti-Blackness, transphobia, homophobia, and other injustices.

WHAT WOMEN WANT TO SAY TO STREET HARASSERS

"RESPECT THAT GAY WOMEN DO NOT WANT YOU."
—JESSICA, OAKLAND

Kid Talk

Sarah and I talk some more, and I find myself wanting to know if she's talked about gender dynamics with her elementary school students.

> In interactions between the boys and girls, kids get told things like, "Oh, he's mean to you because he likes you," and that's seen as an acceptable thing. I thought we were way past that. So, part of working with kids is teaching them, no, that's not how we express liking someone. We're kind to each other.
>
> I hope that overarching message of kindness trickles down into all of their interactions with one another. I've also talked to them a lot about touching. It's a hard one to navigate because at that age kids like to get hugs and physical affection, and that's very important. School is a place where we learn about socialization, and we need to ask before we touch someone.

From a very young age, children are flooded with both intentional and unintentional messages around consent and touching people's bodies, and much still reinforces our age-old gender inequities. We impose certain roles, traits, interests, and behaviors onto children on the basis of outdated ideas about gender. We teach specific versions of masculinity and femininity, and how to perform those roles, very early.

All of that early socialization leads directly to girls being objectified and mistreated. This work is about telling our stories, but it's also about changing

the status quo: How do we prevent these damaging behaviors or intercept them once they've started? How do we redirect the socialization of children in a way that brings about more equal and safe treatment of girls and women? These are questions we all need to keep asking ourselves and others to find answers and make real change.

We finish the conversation as usual, with me asking, "What would you want to say to men who harass you on the street?" Her response is clear:

I don't need your help. I don't need your validation. I don't need your comment, your compliment, your insertion into my life. No thank you.

When I hear Sarah, Deyanira, Candice, and others talk about the conversations they are having with kids about consent, respect, and kindness, it gives me some sense that we may be setting up today's children for better things. Maybe Sarah's male students will grow up understanding that girls and women are full human beings, not sexual objects. Maybe her female-identifying students will grow up not needing to assert and defend their right to autonomy over their own bodies; maybe, when they are adults, it won't be so necessary to tell men, "I don't need your validation."

I hope they'll feel safer walking down the street than women do today. It's possible such a world is not as far off as it sometimes seems. Meanwhile, I'm full of relief and gratitude that women like these are taking responsibility for making life better for the next generation.

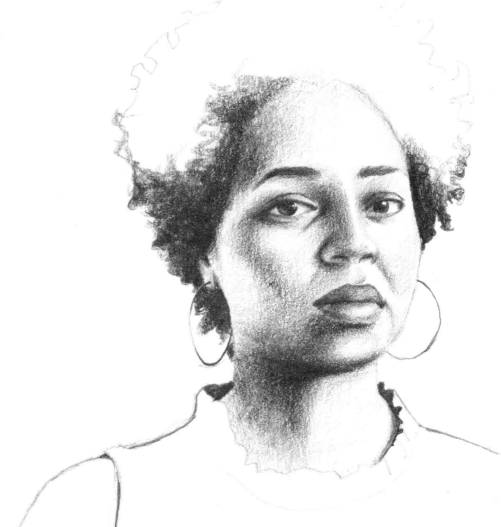

Chapter 5

RAKIA

The Blurry Line Between Friendliness and Harassment

Age: 39
Identifies as: Black, woman, sister, daughter, first-generation
 American

Rakia is a book editor who lives in Harlem. She will turn forty soon, and much of our conversation involves the competing needs of and demands placed on Black women: our need to keep ourselves safe; our desire to participate in our neighborhood communities; the external pressure to accept street harassment within those communities; and our fervent wish to be able to walk down the street in peace.

I open the conversation by asking Rakia how she defines street harassment.

I define street harassment as men saying something I don't want them to say to me. For me personally, when a man is just looking at me, I don't take it as harassment. At this age, a man could say something positive and still I'd define that as street harassment. It's different from when I was nineteen and a man said something positive, I might have accepted that as an overture. Like, "Oh, hey, what's your name?" Not anymore. I'm more territorial about my body now. A man speaking to me saying more than good morning, good afternoon, good evening—if he is saying something about my physical appearance—I consider that street harassment. That happens almost daily.

Rakia goes on to talk about the tone and intent of men's words, which raises a big question: How do we deal with the men who are clearly sexualizing us and making us uncomfortable but who are seemingly harmless? I asked Rakia how she experiences this kind of interaction.

It's not just "good morning." It's "good morning" and their eyes are going up and down. If I say good morning back, now I'm engaging, right? Now they've got an opening. If I don't say good morning back, it's, "Dang, you can't say good morning to nobody." It's this clever workaround.

I love saying good morning to people, but when he's looking at me like he wants to do something and he's like "good morning," no thank you. Please don't. I'm hearing "smile" a whole lot less than I used to, but that could be me aging out of it. And I'm hearing that very inviting good morning a whole lot more. "How you doing? You can't speak? God, just trying to be friendly." And on paper that's what it looks like, but that's not what it feels like.

I understand exactly what Rakia means. I'm familiar with that kind of interaction in which men greet me as I walk by in a tone that makes me feel seen—not in a good way, not acknowledged—but seen as in exposed.

Sometimes, from some men, a "good morning" is not just a pleasant greeting. There is another intent there. When the meaning of the words seems innocuous but the intent might not be, that is when the line between friend-liness and street harassment becomes blurry and difficult to pinpoint and ar-ticulate. As a woman, you know the intention behind that "good morning" by how the man says it, how he looks at you, and how you feel in response to it.

If you have to question whether someone will become violent toward you if you do not respond to them, or do not respond with what they want to hear, that interaction can be defined as street harassment. The act of sexualization and the potential for abuse cross that line.

Why should Rakia have to navigate the nuances of a "hello"? Or jump through mental hoops in the moment to decide whether responding to this "hello" might put her into a bad situation? Women should not feel compelled to say "good morning" to anyone at all. And we should especially not feel compelled to say it to someone who is sexualizing us on the street.

In addition, if a woman's experience of men saying "good morning" to her on the street has historically been laced with sexualization and aggression, that is her personal reality and will influence her determination of what is and what is not harassment.

WHAT WOMEN WANT TO SAY TO STREET HARASSERS

"FUCK ALL OF THAT ENTITLEMENT THAT YOU FEEL YOU HAVE, FUCK YOUR PRIDE, AND FUCK YOUR EGO."
—KHALIYAH, NEW YORK

Street harassment is not always straightforward. A lot of people, most of them men, think that if it doesn't involve insults, cursing, or physical touch, it's not actually harassment. They believe women are creating an issue out of something that is not really an issue. This is one of the reasons why talking about street harassment can be so difficult. Sometimes it takes the form of a stare or a suggestive tone of voice. It's being made to feel uncomfortable while we're simply walking down the street. It can be frustrating to try to describe the depth of vulnerability and intrusion to people who do not experience it.

Many people who hear women complain about this kind of innuendo say something like, "Well, what's wrong with saying 'good morning'? It's just a greeting." This limited, intentionally obtuse response aims to discredit women's accounts of street harassment. In fact, it's very easy to understand that the meaning and perception of words change with context and tone. That how someone receives your greeting depends heavily on how you say it.

The criticisms of those of us who speak up about it are attempts to make our stories erroneous, to make women doubt themselves and worry that they do not know what they are talking about. It is gaslighting.

Street Harassment and Community

What happens when these supposedly innocuous greetings are coming from someone in your neighborhood on a daily basis? These are the men who live near you, whom you cross paths with on your walk to the subway, or who frequent the coffee shop you go to. Men with whom you have a familiarity and who think it's okay to flirt with you. And even though you turn down their advances and are not interested, they continue to walk the line between being friendly and being unwelcomingly flirtatious.

> **From a very young age, children are flooded with both intentional and unintentional messages around consent.**

When it's a regular interaction with the same man, the dynamics become even more complicated. There is the desire to be cordial to your neighbors for the sake of community. Especially with Black folks, in Black neighborhoods that may be threatened by white gentrifiers, there's an urge to be in unity with each other. And for a lot of Black women, we are positioned to feel that if we speak up against the Black men who harass us, we are betraying our community, even our race.

I ask Rakia how she feels about the conflicting impulses to take care of herself and to participate in her community.

I hear more than anything: "You can't say good morning?" It opens you up to all of these criticisms. There are all these concerns surrounding us about community, and this larger idea about your place in the world. Everyone is more disconnected than they've ever been before.

You want to engage with your community because gentrification is a real problem. When you see somebody who looks like you, who's been here as long as you've been here, there's a sense of same-wanting-to-recognize-same. A genuine, friendly good morning can make you feel connected.

And so, on paper, your reaction can look bad. If a guy says, "Well, I tell this woman good morning every morning, and she doesn't want to engage with me. She's not a part of this community thing," your not engaging can seem a lot bigger than it is. And he knows what's really going on, but that is very hard to explain to somebody who is not there in that moment.

I can relate to Rakia's feeling of divided loyalty. Even though I strongly believe in speaking up to the men in our neighborhoods, and that women should not have to feel uncomfortable where we live, it is not that simple or easy.

Some Black women appreciate the comments from Black men on the street, even the inviting greetings. They find affirmation in those comments, especially when they know they won't get that affirmation in the mostly white spaces they might be traveling to, like work or school.

I do not feel that way. Rakia is speaking about the kinds of comments and dynamics in which the men have a domineering intent, not about honest, transparent friendliness. That said, the divergent reactions among women can also stem from our different perceptions of similar behavior. Here is yet another complicating factor of street harassment and a part of a larger conversation about public culture and interactions, community, and solidarity.

The Doubled Burden for Black Women

I've spoken with plenty of Black women who feel particularly offended when street harassment comes from Black men. One woman in Miami expressed frustration and even anger at being sexually harassed by Black men when Black women are constantly fighting for and supporting the lives and better treatment of Black men.

Of course, this does not only happen in Black communities. A Latina woman in Atlanta had this to say about sexual harassment within her community: "You turn around and you oppress me. We are both already oppressed just for being brown and living here, and maybe being undocumented. But then you turn around and oppress me even more. While I'm here fighting for all of us."

For brown women in migrant communities, immigration status is yet another layer of vulnerability that overlaps with sexual harassment and racism.

As I've pointed out before, an enormous amount of street harassment is intraracial. We usually live next to and spend much of our time around people who look like us. Sexualized harassment will likely happen between the people who live in a given neighborhood, whether it is mostly white or Black or brown.

When the men in your own community abuse you, even as you all suffer under the same political, social, and racial forces that work against your community, it feels that much more hurtful. So, for Black women, being harassed by Black men can sting particularly hard.

Black women are constantly experiencing race and pushing back against racism, but the face of that fight is usually a Black man. Simultaneously, we are constantly experiencing gender and pushing back against sexism, but the face of that fight is usually white women. And so when Black women talk about sexual harassment at the hands of Black men, we are usually accused of prioritizing a women's issue over the problem of racism and of dividing the Black community.

And yet, it is Black women who are at the forefront of social movements pushing for fair treatment of Black people and women. Black women have been agitating for gender equality for centuries, despite being excluded and whitewashed from the feminist movements. And Black women lead the marches when a Black child is killed. A woman in Houston, Josie, says, "One thing that has been difficult for me to talk about is pushing for equality between Black men and women because it has meant pushing back and pushing away some Black men that I love."

Navigating Conflicting Demands

Rakia tells me about one man in her neighborhood who has been harassing her daily over a long period.

How does that feel to her, I ask, and how does she deal with it?

> On my block, the corner boys don't bother me and I don't bother them. We say "Good morning, how you doing," very cordial and short. But there is another dude on the corner, he's much older, I think he's in his early fifties. He asks me out at least two to three times a week, like, "when you gonna let

me take you . . ." and because I have to pass this corner several times a day walking my dog and going to the train, there's no way to avoid him.

I have navigated it by not being a bitch about it and not having an attitude about it. By saying, "how you doing" and "good morning" and sort of accepting it. Within the past couple months he's started putting out his hands, he wants me to shake his hand and I don't want to give him my hand, so I pound his hand. Now he has taken to holding onto my hand a little bit. When I walked out this morning to run some errands, I avoided that corner because I knew he was going to be standing there. Luckily, he wasn't there when I got on the train, but when I came back later he was there, so I avoided him again.

I'm almost forty years old and I'm doing this in response to a guy on the street because I don't want to have to deal with him. If I said to him what I really felt, I don't think that I would feel endangered, but it would feel uncomfortable because I'd make him uncomfortable, because he thinks he's being nice.

WHAT WOMEN WANT TO SAY TO STREET HARASSERS

"I DIDN'T ASK FOR YOUR APPROVAL. I HAVE MY OWN."
—NI'JAH, BALTIMORE

Even though Rakia isn't afraid of this man, she identifies that there's still power at work here because she's yielding her comfort to allow him to feel comfortable with her. She's letting his behavior slide even though it makes her uncomfortable so that she stays in good standing with him. This is interesting to me because it complicates the idea of street harassment and is an example of the mental and emotional gymnastics women do just to walk their dog down the block. Just to be outside.

I ask Rakia if she has ever considered responding to him differently.

I wonder how I would deal with him if I had a daughter. I remember one time when I was probably in my early teens and it was late at night. My mom was driving, I was in the front seat, I think my siblings were in the back seat. She had to get gas. It was a shady area in southwest Atlanta and it wasn't full

service, she had to get out of the car and pump the gas. There were guys hanging out at the gas station doing god knows what. My mom is a very attractive woman, especially when she was in her early thirties. They spotted her immediately. "Redbone," they called her. This was happening in front of her children and I just knew my mom was going to speak up: "Not today, not me. I'm not the one." I thought her chest was going to expand and she was going to stand up to these men.

Instead, when she saw what was happening she leaned into the car and she said, "You all sit here and keep the door locked. Don't say a word." Everything in her shrank. I'm thinking, *Mama, you're not supposed to do that.* I had never seen her do that. They asked her, "Where are you from?" and she answered the question. She didn't engage with them beyond that. She was complying just enough to get her gas and get us out of there. I remember being very disappointed in her that she didn't say anything. But I understand now why she did that.

I can sympathize with Rakia wanting to see her mother stand up for herself in that moment. But it makes me wonder about how society puts the onus on women to keep themselves safe, even if it means allowing men to mistreat them. Men are collectively allowed to be the biggest danger women face, and women are expected to avoid it, block it, compromise themselves to protect themselves from it.

Yes, speaking back to men in the street and confronting their behavior is one way to denormalize harassment, but in a moment like the one Rakia describes—and, really, at any moment—that shouldn't be expected of women. Instead, we should all have the basic expectation that men will not behave that way. Rakia's teenage disappointment would have been better directed toward the men harassing her mother, but that is not how we are taught to make sense of things.

That is not to say that women should shrink and stay quiet when experiencing aggression from men. But I do understand that sometimes that is the only option to keep yourself and your family safe.

From her current vantage point, how does Rakia look back at her childhood expectations of her mother?

I'm still disappointed she didn't say anything. In my mind, my mom is a superhero. She's not a human being at all, she's not even a woman, she's my

WHAT WOMEN WANT TO SAY TO STREET HARASSERS

"I RESPECT THE RESPECTFUL."
—ATHENA, NEWARK

mother. I don't say that with any kind of pride, that is how I honestly feel. I've never said this to her because I would sound unreasonable.

I understand exactly why she responded to those men like that—you've got your babies in the car. She didn't want any foolishness at the gas station in the middle of the night in this neighborhood. But I remember thinking, *Man, I thought you were a real one. Sit here, be quiet, and lock the doors? What?*

And how many other times had she had to deal with this? She'd been dealing with this longer than I'd been alive. But it was the first time I remember seeing more than somebody just looking at her, and seeing her feel the same kind of discomfort that I feel passing this [man] on my block. But it was heightened for her in that situation, because there's nothing about this guy that feels dangerous, but these men were strangers to us and we weren't in our neighborhood. There wasn't anybody around, it was just us and several men. I get it, but I wasn't proud of her and I wanted to be. It's weird.

Now I would probably do the same thing because you're just trying to get home. But how would I respond to this [man] if my fifteen-year-old niece was walking with me down the block? Would I say something or would I continue? I'd like to think I would say something. I'd like to think, "We not doing that today," but I don't know that I would.

That's what the talk to young Black men is all about: We're just trying to get home. It doesn't matter how comfortable you feel, we're just trying to deal with this and get home.

To grin and bear it just to make it home. A lot of us are familiar with "the talk" that is given to Black youth—particularly Black boys—about how to deal with police in order to make it home safely. But Black women and girls are dealing with the same threat of violence, not just from police but from men and boys in general.

> I don't need your help. I don't need your validation. I don't need your comment, your compliment, your insertion into my life.

Earlier I recounted stories of police officers sexually harassing women, particularly Black and brown youth and trans women. So, for many people, it's not easy to find a sense of safety in the street when harassment is coming from different angles, including from those who are supposed to protect you. And again, for every one of us, the goal is the same: just to make it home safely.

This brings us back to the complication of the man on Rakia's block being both a source of discomfort and protection. When the police are a source of danger rather than protection, members of the community want to feel protected by each other. She understands and values that about this man and the other men on her block, so she weighs the consequences of losing that if he reacts poorly to her turning him down.

Rakia shouldn't have to make such compromises. It doesn't seem like too much to ask that, as she walks down the street, she should be allowed all three things: personal comfort and freedom; safety; and good relationships in her community. And yet, for many Black and brown women, the reality is that they have to choose among these things all the time.

I wonder how Rakia juggles these conflicting needs.

It's about trying to get home, yes, but also it's trying to walk your dog, get your groceries, go for a jog. And it's all the time, for every woman. You know, even a CEO, even a titan of industry, in front of the wrong kind of guy, she will shrink. And that would be the smart thing to do. It's complicated.

But that makes your work really important. I think a lot of people who weren't familiar with the words *street harassment* didn't believe that it really happens. "I'm just paying her a compliment. I'm just being nice. You being too sensitive. Y'all taking it too seriously. Aw, man, feminism." But now, Stop Telling Women to Smile has become a part of the lexicon.

It's exhausting to deal with these various competing dynamics Rakia has to walk through every day. I know I'm drained by it. So, it's always encouraging to hear from someone that my work has begun to make a difference for them.

I hope that as my work and other anti–street harassment campaigns make the problem ever more visible, more and more people's eyes will open to the damage street harassment causes. They say exposure breeds familiarity. Who knows, if enough of us keep aiming a spotlight at sexual harassment, maybe even some of the doubters Rakia describes will come around.

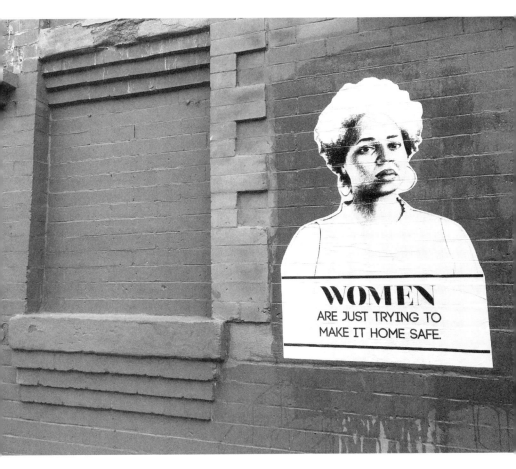

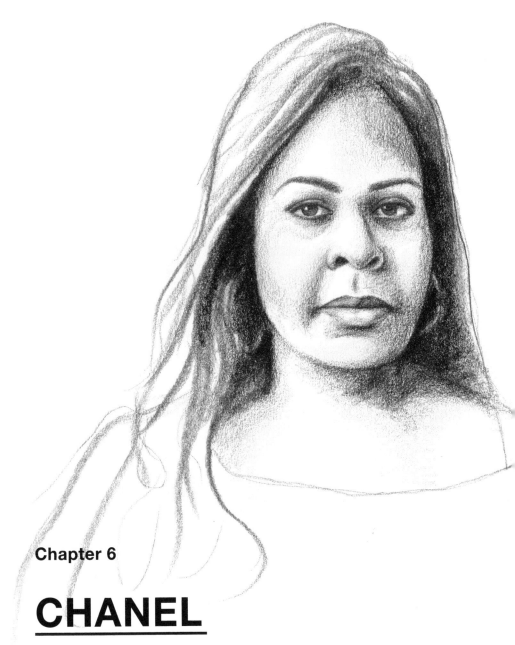

Chapter 6

CHANEL

Of Trans Experience

Age: 44
Identifies as: Trans woman of color

Chanel has done advocacy and activism work for the trans and nonbinary community for the past fourteen years. She and I met at her job, where she works as the transgender community liaison for a city agency. Chanel and I have an open and candid conversation about her experiences with street harassment, and because she has worked in the community as an advocate for other trans women, she also offers insight into a wider array of experiences.

Like many of the other trans women I've spoken to about street harassment, Chanel describes how her trans identity is a major factor in how she is treated in the streets.

How does she define street harassment?

When people are intentionally bothering you, whether it is catcalling or discriminatory, that to me is harassment. And when they follow you down the street, that's harassment. I get that a lot. Even just today somebody was like "Hello, beautiful baby, oh beautiful." And I get "Oh, you should smile more."

I keep walking because when I'm in the streets I don't like to call attention to myself. Always in the back of my head I'm thinking, "You're a trans woman, be careful." So, if a guy "compliments" me, I just keep moving.

I've had some guys tell me, "Oh, you don't have to hide, you can smile, I know what you really are." And when they try to say they know I'm trans and it's okay with them, I'm supposed to be like "Okay," like that makes the harassment okay.

The particular way in which men point out Chanel's trans identity interests me. Other women of trans experience have told me that men sometimes see them as being deceitful about their identity and get angry at them. Both kinds of harassment start from the same erasing, objectifying place of assuming trans people are trying to fool us with their gender presentation.

Harassment based on this misguided notion of deception is very specific to trans people. A Black trans woman I spoke with in New York talked about how men respond to her as if she is trying to trick them:

It just feels like, for the world around me, it's so easy for them to do anything to me because they have been taught that who I am in my person is deceitful. So they think, "We need to destroy it because this keeps tricking

us. I just noticed you and I thought you were cute, but you're not a woman, you're a man, and I feel conflicted."

All of that is happening at the same time. It's scary. As I go through life, I try to pack it away and layer it up with stuff like it's not happening. But you feel really disempowered. You're at everyone's mercy. Every day, you're hoping nobody will say or do anything.

I want to pause for a beat to break down the reactions of a man who feels "tricked" by trans women: He assumes that any woman he sees outdoors is there to please him. He sees his own arousal at the sight of this trans woman as a deception on her part. He punishes her with transphobic insults and threats. Imagine how his rage would escalate if he also felt rejected by her.

His implication that she is tricking him into desiring her is a problem for many reasons. One, it assumes that attraction to trans women is something to be ashamed of, and if you are ashamed of it, you may become violent in order to hide that desire. Many trans women have been killed by lovers—cis men who felt shame at desiring them and who felt that these women's lives were disposable.

WHAT WOMEN WANT TO SAY TO STREET HARASSERS

"MY WOMANHOOD IS NOT UP FOR DEBATE."
—OLYMPIA, NEW YORK

In Chanel's case, on the other hand, the objectification has a conspiratorial slant, which the harassers use to try to win her acceptance of being mistreated. It's as if they are saying: *I'm in on your secret; I accept you as a sexual object regardless; because you're trans, I assume you are even more available to me than most women; and therefore I'm even more free to invade your space and comment on your body than with cis women.*

To be clear, sexual attraction to trans women is natural and should not be taboo. However, just as I mention in other chapters, harassment is not about attraction. That may be an excuse on the surface (why we're often told to take it as a "compliment"), but it is ultimately about power and dominance. So,

whereas desire and attraction is one thing, harassing trans women is something else entirely.

I ask Chanel how it makes her feel when men say things like, "I know what you are."

> It kind of questions my femininity. It upsets me a little because I'm like, oh what, I'm supposed to turn around now and drop on my knees?

The expectation that trans women should be especially grateful for being sexualized adds insult to the injury of being made to feel uncomfortable and unsafe. It is an additional coating of dehumanization that harassers use to feel powerful over them. And it's not just harassers: our culture as a whole is complicit in this extreme otherization of trans people.

For instance, society's widespread suspicion and anger about trans lives are evident in the frequent and purposeful misgendering of trans people. This kind of harassment happens in all sorts of situations, but it's especially common any place photo ID is required—bars, government offices, airports—if the gender marker on their ID does not match how they identify. This form of psychological violence denies trans people their identity and directly questions the validity of their humanity.

WHAT WOMEN WANT TO SAY
TO STREET HARASSERS

"SOY MÁS QUE UNA ETIQUETA. NO ME JUZGUES SI NO CONOCES MI ALMA O MI ESPÍRITU." ("I AM MORE THAN A LABEL. DO NOT JUDGE ME IF YOU DO NOT KNOW MY SOUL OR MY SPIRIT.")
—ESTRELLA, ATLANTA

Perceptions of Realness

In response to my next question, Chanel raises another issue related to cis society denying her identity. My question: When were her first experiences with street harassment?

When I started transitioning, ten years ago. I've always had big boobs so people thought I had implants, but really, big boobs run in my mom's family, plus I was heavy. So when I started losing weight, and started taking hormones, my boobs stayed.

And at first I was like, "Oh, okay, that gets attention." But as I got older, I realized that's not what I want. Now I'm always trying to cover up because that's not me anymore. That's the mentality I had when I was much younger, but now I just find it so disrespectful, especially when guys are in your face. Or I guess they're not really in your face, they're looking at your boobs.

When I was younger, I was more okay with it because it gave me a sense of realness. I didn't see it as disrespectful because I was like, "Oh my God, that means I look real, they see me as a woman." That's the mentality you have when you first start transitioning.

And there's a whole other dimension to the desire for this realness. It is not only about feeling validated as adequately feminine. It's also a matter of safety. For trans women, being seen as "real," as if trans women aren't in and of themselves real women, by men provides protection from the extreme hatred and violence directed toward them.

Further, the abuse trans women face isn't only from cis men in the streets. It comes from any and all directions. It could come from anyone they encounter, in any setting, at any moment. I can't imagine how frightening and difficult it must be to navigate a world where many people do not understand or agree with who you are as a person, and therefore feel they can verbally and physically abuse you.

I ask how Chanel sees the correlation between the perception of "realness" and her safety.

It might sound kind of fucked up, but the more real you look, the more passable you are and the less vulnerable you are to violence. Some girls risk it and don't say anything about being trans. I don't, I'm very much like, "I'm a trans woman, do you know what that is?" A lot of people want to look "real" because it makes you feel good about yourself. To me realness is not about impressing someone, it's about my safety.

I tell Chanel about a trans woman who described her feeling that she needs to look perfect whenever she leaves the house. As a cisgender woman, I

have the privilege of setting aside concerns about adhering to traditional notions of beauty and femininity. But for some trans women, beauty and feminine presentation are about protecting their lives. When one's presentation is not mere personal expression but a life-or-death matter, just stepping outside of your apartment is a very layered and complicated situation.

Does Chanel feel that same need to look perfect?

Again, it's about safety. You're not going to go to the store with a do-rag on because you look kind of masculine, I don't need to call that attention to myself. I also feel that way about being a trans woman in a workplace. I have to be more than what's expected of me because I'm a trans woman, a trans woman of color, and only have two years of college. We always have to overcompensate.

I ask her about the mental impact of daily street harassment and fear for her physical safety.

It keeps me guarded a lot of times. When I'm in the streets or I'm on the train, I have this guard up. Sometimes I notice myself looking at my phone but not actually looking at anything on the screen. I'm just doing it because I don't want attention.

I don't like traveling alone, so a lot of the time I go places with my brother. He's gay so we're always together. I'm never alone. I don't put myself in harm's way. I'm not gonna go to a house party if I know it's a bad area. I wouldn't put myself in that situation.

But it does mentally mess with you because you are on constant guard.

Violence Against Trans Women

Chanel's fears are heartbreaking and, unfortunately, very real. Trans women receive a disproportionate amount of harassment and violence. The sexualization experienced by trans women overlaps with transphobia, homophobia, and, depending on their other identities, racism and other forms of oppression. The constant fear Chanel describes is not only psychologically damaging— she and all trans women are in real danger of men responding to them with anger and aggression.

Has she had any particularly bad incidents of street harassment?

I had this one really scary situation with a guy who looked sort of intoxicated. I live in Hunts Point. They're cleaning it up, but there's still a lot of drugs around there, and still a lot of sex work going on. A lot of the sex workers are trans women so that just makes me more prone to be a target.

One day I was walking and a man was like, "Oh, come here, let me talk to you." I was like, "I'm good," and I just kept walking. He kept following me for three blocks, trying to catch my attention, and I was like, "Yo, I already told you, like, I'm good." And then I had to get real masculine: "I told you I'm fucking good."

And he was like, "I know what you are. I don't care what you are. It's all good." He said, "I could give you some head." I was like, now you're being really disrespectful. So I walked to my building and I was telling him I'm about to see my boyfriend, but I wasn't, I was just gonna hang out with my friends. I didn't want to tell him that I lived there.

And he kind of forced his way inside the building when I opened the door to go in. I had to practically shove him out, and then I closed the door. Then for the next two days he was stalking my door. It just so happened that we were missing each other, but the lady I lived with told me, "Oh, there was a Black guy standing there for the past couple of days."

This sounds truly scary and makes me wonder about what precautions Chanel might take to protect herself.

My brother got me this big container of police mace. I haven't had to use it, thank God. It was a very scary moment because, again, I have that fear: what happens if they don't know I'm trans and then they find out and then their masculinity is questioned and now they want to get violent about it? So that goes through my head a lot.

It's happened to a lot of trans women I know. The guys don't know, and then when they find out, the women either get killed or they get beat up. I'm not trying to go through all of that.

Toxic masculinity is the force behind a lot of sexual harassment, particularly street harassment. And toxic masculinity is fragile masculinity—easily threatened. As we talked about in Candice's chapter, men become violent with

masculine-presenting women and gay women because they take the woman's presentation as a threat to their own masculinity. They feel their masculinity even further called into question when they feel "tricked" into being attracted to trans women.

Chanel experiences a very particular type of fear that I don't have as a cisgender woman. The threat of violence for me is very real, yes. Women of various identities are constantly in a state of potential danger from men. In the United States in 2016, the number of women who were victims of murder increased by 21 percent from 2015, reaching the highest recorded level since 2007, according to a study by the research group Security.org. And the 2011 Centers for Disease Control and Prevention's National Intimate Partner and Sexual Violence Survey reveals that nearly one in three women experiences physical violence by an intimate partner.

But trans women face a disproportionate amount of that violence, specifically because of their trans identity.

The 2015 US Transgender Survey report found that 47 percent of transgender people are sexually assaulted at some point in their life, and the percentage rises to 53 percent for Black transgender people. The figures get worse when you add more layers of vulnerability: 61 percent of respondents with disabilities, 65 percent of respondents who have experienced homelessness, and 72 percent of respondents who had done sex work have been sexually assaulted.

And the amount of fatal violence against trans women is appalling. In the United States in 2018, at least twenty-six trans women were killed, most of whom were Black. In 2017, at least twenty-nine trans women were killed. A lot of these murders were perpetrated by intimate partners. So, when Chanel talks about her fear that the men who approach her will become violent, that fear is founded in the very real fact that trans women die because of transphobia.

WHAT WOMEN WANT TO SAY TO STREET HARASSERS

"I DESERVE TO FEEL SAFE."
—ANNIE, KALAMAZOO

Exclusion All Around

In addition to violence that trans people experience on the street and elsewhere, they face all sorts of other discrimination. In medical treatment, for instance, even though it's illegal to deny them medical services. An NPR poll found that 22 percent of trans people said that they've avoided health care for fear of being discriminated against. An understandable fear, when so many of us face humiliating questions about our bodies and identity when getting medical treatment.

They also face employment discrimination, and as a result they're pushed toward criminalized and high-risk occu-

> **The expectation that trans women should be especially grateful for being sexualized adds insult to the injury.**

pations. Trans women are more likely than most groups to do sex work in the street, putting them in particularly vulnerable positions.

I spent some time with Estrella, a trans woman, activist, and immigrant from Mexico who lives in Atlanta. When she moved to the States, she immediately faced discrimination with housing, employment, and safety because of her immigration status, being brown, and being trans. She experienced sexual harassment while living without a home and while doing sex work. If you are homeless and do not have equitable access to public spaces like hospitals or shelters, you are at higher risk of experiencing violence on the street.

One in five trans folks has experienced homelessness in their lives, according to the National Center for Transgender Equality. Like Estrella in Atlanta, so many trans women face housing discrimination, which makes it difficult to find sustained housing. And because she also couldn't find work, she worked as a sex worker while living on the street, putting her at even higher risk of sexual violence.

As always, race adds another dimension to the mistreatment trans women receive. I've already mentioned several statistics showing that Black and brown trans women are especially vulnerable to violence and discrimination.

I ask Chanel how her race intersects with her experiences of transphobia and sexual harassment.

It comes a lot from white folks. I met these white folks that sexually idolized trans women, especially if you're a woman of color. One of them was

like, "Oh, you're so hot! What are you Dominican?" and I'm like, "Yeah, I'm Dominican." "Oh, I like a hot Dominican and you're trans, oh, you're just a plus, baby."

I get that a lot from the white community. They have this fetish, and, excuse my impression, but they'll say, "Oh, you're a chick with a dick." And I'm like, Dude, what is going on? It is totally disrespectful. And for some people that's cool, they like that, but like I said, as I get older, it's like, nah. Nah, that to me is straight disrespectful. My body's my temple, respect it.

Earlier in the book, Deyanira also talked about being fetishized. A common experience for Black and brown women, it is one more way they are stripped of their individuality and their personhood.

When you are discriminated against for layer upon layer of who you are, you are pushed to the margins of society, making you that much more vulnerable to all forms of abuse. It is also that much less likely your story will be heard—and that much more important that we hear it.

> Toxic masculinity is fragile masculinity— easily threatened.

Chanel is doing exactly that: making trans women's challenges and needs more visible as part of her activism work in the transgender and gender-nonconforming communities in New York.

I want to hear about her work and what it's taught her.

I worked with an LGBTQ+ nonprofit organization for seven years and we worked on everything from hate crimes to domestic violence. They had gotten a grant to provide services for trans women. At the time, I was the only trans person that they could come to.

And what I saw was we're all different people, but we have that same walk of life. Because I'm a survivor of sexual violence and domestic violence. I'm a survivor two times because I was sexually molested by my uncle when I was younger, and then by a partner.

So that was my line of work. And from there, I felt the community needed a voice, so that's when I started getting into more advocacy, and just reaching out to folks. Network helps a lot. That's why I do counseling and advocacy and more hands-on activism in my community, the trans community, because we're the most marginalized, vulnerable community.

It is incredibly important to listen to trans women. It is not enough to support trans women after a death or tragic event within their community. We must uplift, listen to, and support the livelihoods of living trans women every day. Particularly within the context of street harassment.

When I speak of how street harassment is not just an annoyance, how it can be physically violent and fatal, it is not an attempt to be extreme for the sake of making a point. It is a reality that trans women of color are among society's most vulnerable groups. Women like Chanel are doing the work of supporting their communities. But they can't do it alone.

Through her work, Chanel has met and heard the stories of many transgender people, specifically trans women. What are some of the common experiences for trans women that Chanel has witnessed?

I've spoken to trans women who are undocumented and they come here to work and the guys just make them sex workers. They get into relationships with these abusive guys who actually put them through sex work.

I've also talked to a lot of them who have experienced hate crimes. I've met girls who've been slashed across the face for just walking down the street. As a trans woman I'm soaking all that in and I'm like, "Okay, Chanel, keep your guard up." I have to be careful.

Just recently on a Friday I spoke at a rally for the three trans women that were murdered. So I ended my week there, and then I come back to work the next week and there's a rally for the trans women that died in the hands of ICE. I was like okay, I can't. I really can't start my week off on that note. It's a lot. And just yesterday they found another trans woman dead in Dallas. It's like we're at war.

Just in this one conversation, Chanel mentions many ways that trans women face violence. For undocumented women, the US Immigration and Customs Enforcement (ICE) agency is a threat not only to their status in this country but also to their lives.

It must be overwhelmingly frightening at times, facing the same dangers that you are working hard every day to stop. I ask Chanel what a future without street harassment would be like for her. How would that change her life?

It would mean I could walk down the street without having to be so guarded and just have peace of mind. Knowing I'm going to walk down the street and

get home safe. Just that simple. I just want to get home safe. [*laughs*] I just want to be in no harm's way. That's what it all comes down to—our safety. You just want to live free.

For so many trans women, and Black and brown people, the act of simply getting home safe is not something they can just take for granted—and it

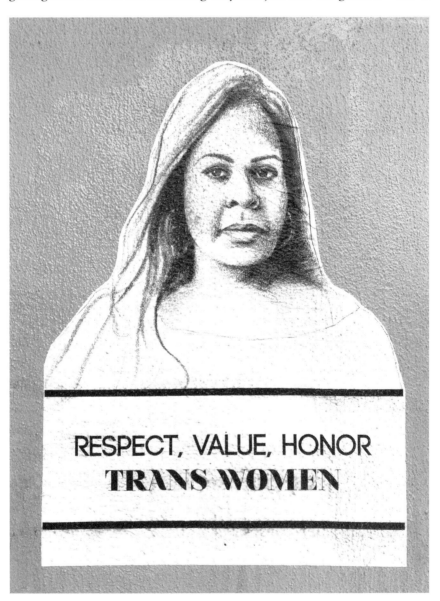

RESPECT, VALUE, HONOR
TRANS WOMEN

should be. No one should have to look to the future in hope of one day being granted such a basic freedom.

Given everything we've talked about, what would Chanel want to assert about herself to the public?

> My assertion is that no matter what you see on the outside or how you view me on the outside, I still deserve respect like any other person. Whether you see a trans woman, whether you see a woman, whether you see someone who's [gender nonconforming], whoever you see, at the end of the day, it's all about respect.

Again, these are basic things Chanel wants: safety, freedom, respect. I'm in awe of the incredible courage it takes for trans women just to set foot outside every single day. But I see cause for hope that things will become safer and better for them, because trans visibility is increasing all the time.

And though that often comes with backlash (in the form of bathroom bills, military bills, and so on), that very backlash evokes immediate outrage and activism, and that is already having an impact. As more and more trans people are elected to government positions and participate in mainstream society in all sorts of ways, they will not only be increasingly seen as part of that society, they will also have their own say in how they exist within it.

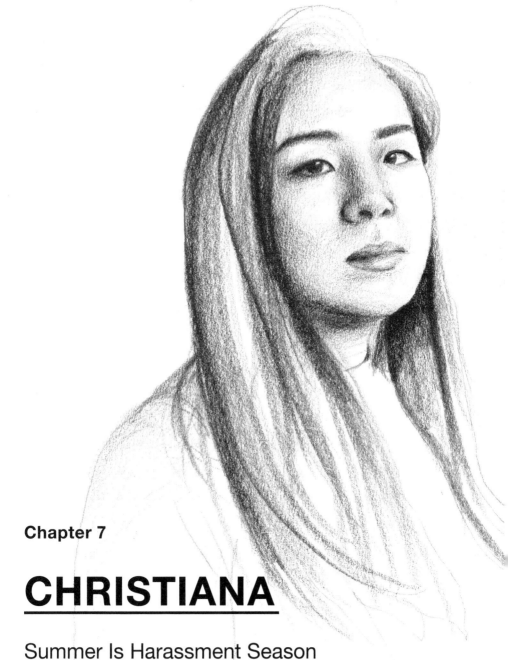

Chapter 7

CHRISTIANA

Summer Is Harassment Season

Age: 29
Identifies as: Asian American, bisexual

I meet Christiana, who works in media partnerships, at my studio in Brooklyn. As a longtime New Yorker, she's had years to observe and analyze street harassment and recalibrate her reactions to it. Like most of the women I spoke to, she is eager to talk about her experiences.

As always, I start the conversation by asking her to define street harassment.

> This is how I define it for myself and how I explain it to people who hear me complain about it and say, "oh, it's a compliment." It's usually men who say "I'd love to get complimented like that." If you're a woman or presenting as a female and someone makes a comment to you in public, would that person say that to you if you were walking with a man? If not, then it's street harassment.
>
> You can say, "You look beautiful in that dress today," and I have no doubt that you would say that to me in front of my father or my husband; but if you're saying something that is obviously disrespectful, in tone or in word, you wouldn't say that to me if I was walking with my father. It's not out of respect for me, it's out of respect for him. Because people will say all the time, "this person was just saying hello," but I don't think men would say hello to me like that if I was walking with my husband.

I absolutely relate to what Christiana says. I have found that when I'm walking with men, they act as a buffer. I feel safer and more comfortable when I walk with a man because I do not receive comments. Similarly, women often lie to men, telling them that they have a boyfriend, in order to be left alone because that works better than simply saying no. Harassers do not respect our "no" as an answer because they do not respect us as autonomous people. Instead, they might respect that we "belong" to another man.

Sometimes, though, harassers seem to think there's a loophole open to them in this situation: If they assume that the man I'm walking with is my partner, they'll talk to him about me, instead of addressing me. They'll say things like, "You got a good one there" or, "Nice job." I consider this indirect harassment. Though I might feel safer for being with a male friend or partner, I am still being objectified, and in some ways it feels just as bad as comments made directly to me. In those moments, even though I'm right there, too, I am being discussed literally as if I were a nice car.

It reminds me of stories I've heard from queer women and lesbians about walking down the street with a partner and the different way men objectify them. Harassers often treat lesbian couples as if their sexuality is a performance for men, saying things like, "I'd like to watch." Or they'll attempt to "convert" the women (e.g., "You just haven't had a man like me yet.").

There are many variations and depths to the ways men assume, arrogantly, that any person they perceive as a woman on the street either is straight or should be straight, and furthermore that she is available and there for them.

It Always Starts Early

By now you may cringe when I ask for the women's first memories of being harassed, because you know what's coming: It started *really young*. I know, it's awful. And most of the hundreds of women and girls I've spoken to have had the same experience.

I've led many workshops with teenage girls, and talked with them privately, too, and they tell me that sexualization of their bodies comes mostly from adult men. What does this say about our society that girls are having their bodies sexualized and harassed at such an early age? And what consequence does that have?

I ask Christiana to tell me her first recollection of being harassed.

> I remember the first time somebody called out to me from a car, I was ten or eleven. When I think about it now and talk to other people who have experienced harassment like that, it's always shocking how young we were.
>
> This isn't something that you are introduced to when you have the emotional and mental capacity to handle it. It always comes at you when you're a child.
>
> But maybe that's true no matter what age you are, when you start to get these kinds of external assaults you're never prepared for them.

It's poignant to hear Christiana talk about how she was not mentally or emotionally equipped to deal with being sexualized by adult men. I've already described how it colored my understanding of my growing body and sexuality. Sexual harassment and abuse of children interrupt their growth as

autonomous individuals. And for girls, it teaches them that their body does not belong to them. That getting sexual comments, stares, touches is just a part of being a girl, that the world has a right to your body.

Christiana continues:

I remember being ten, eleven, and twelve and just being so shocked that men were calling out to me on the street. It was something that I didn't tell anyone because I didn't know how to. I usually couldn't even hear what they yelled, so it would have been like, "oh, there was a car full of men yelling at me just now."

It was something that I would just keep with me for the whole day in the back of my mind; it kind of eats away at you.

It wasn't until maybe ten years later that it clicked and I started to realize that this is harassment. That it's harmful, and that it shouldn't be happening. And then maybe another five years after that I realized it had started when I was a kid. I've been traveling, living my life with this, growing up my whole life with this kind of occasional humiliation.

It's funny how you get introduced to sexual harassment before you have any concept of what sex is, what attraction is. Before you even have those words, you're introduced to it in the most crude, raw form.

WHAT WOMEN WANT TO SAY TO STREET HARASSERS

"I'M NOT AN ORNAMENT, I'M A WOMAN."
—KARLYN, CHICAGO

If harassment is a form of bullying, an attempt to assert dominance over someone, it makes sense that men would harass the people they feel they have the most power over, and that includes children. And for the harassers, these are throwaway comments they probably forget about immediately, but for the children being sexualized, the consequences can be lifelong.

It's always wrenching to hear about a young girl's experience of sexual harassment. However, this is one area where I actually feel a little more hopeful that change is starting to happen—maybe not on the street yet, but I believe

that in the case of preteen and young teen girls, it will trickle down sooner rather than later. The sexual harassment of little girls should not be tolerated, full stop. And that seems like an easier, simpler message for the larger culture to accept.

Here's why I think it might be starting to change for the better: Pedophilia is no longer hiding in the shadows, nor is sex trafficking. We are all quickly learning how widespread these abuses are, and the latest wave of revelations (after three decades of periodic scandals about pedophilia) seems, finally, to be penetrating the broader consciousness.

More children are talking about it when it happens to them. More adults are listening to them and believing them.

> **Women often lie to men, telling them that they have a boyfriend, in order to be left alone because that works better than simply saying no. Harassers do not respect our "no."**

I believe that sexual misconduct against children is one area where people can easily understand the connections between all the various forms of mistreatment. The link between street harassment of preteens and the sexual abuse of children is very easy to draw, and very clear to see.

Already, in many elementary, middle, and high schools, girls (and boys) are beginning to get different messages than my generation did about their agency over their own body, their right to say no to adults whose behavior makes them uncomfortable, and their power to tell people when they're being mistreated. Many parents have conversations with their children about these topics as well.

Of course, there is still racism to contend with here. It's by now well understood how white society often regards Black children with fear and suspicion and reacts to their childlike behavior as if they are adults. So, I do worry that a lot of the newfound concern for children's welfare is focused on white kids. But even this deeply rooted prejudice is being dug up and held under the light. I hope it means that Black children will start to be allowed their childhood.

Nonetheless, I believe we can hope that soon it will be socially unacceptable for grown men to talk to girls in sexual ways in public. At the very least, girls in this country today are being empowered to identify and name situations in which they don't like how they're being treated and to say no. That's a significant change that will have a broad impact on their whole generation.

Asian American Stereotypes

Early in our conversation, Christiana mentions that the harassment she re-
ceives is often racialized. This is true for a lot of women of color and Black
women. In addition to receiving racism, women of color and Black women
also receive a higher frequency of street harassment. I've heard firsthand from
many women about how men on the street make racist comments, from call-
ing them by their skin color to referencing a racial stereotype.

I ask Christiana to tell me about how she experiences race on the street.

I'm Asian American, but when I was younger I wanted to be seen as Amer-
ican. I get the question, "What are you?" all the time. In terms of street
harassment, that's always a part of it, there's always the racial piece.

If I had to put a number on it, over half of the time it's "Ni Hao" or "Hey,
China," or "Are you Chinese or Japanese?" Or something that mentions my
race. And not only am I not Chinese or Japanese, but also that as a greeting
happens as a part of street harassment.

It happens in my daily life; in my professional life that happens all the
time. It happens all the time when I'm talking to acquaintances, or when I'm
talking to people that I consider friends, so those microaggressions kind of
creep in.

And then being an Asian woman, that is an identity that is sexualized
in a very specific way. It adds a layer of additional grossness. It's another
thing that I'm very used to that I sometimes don't think my white friends
understand. My white female friends also get street harassment, but I don't
think they get the same type, that is both demeaning in terms of your sexual
and gender identity and also demeaning in terms of your racial and ethnic
identity.

It's kind of funny, though, because I get those types of aggressions
everywhere: I'll go into a business meeting and someone will be like, "So,
where are you from?" and I'm like, "I'm from New York," and they say,
"Mmm, where are you really from?" So, I get that in what are supposedly
respectable interactions, and also from a guy yelling at me on the subway.
That's just another part of the baggage that you carry through your whole life.

The stereotyped sexualization of women of color is very real and in-
fluences how we are harassed. Black women have been categorized as the

WHAT WOMEN WANT TO SAY TO STREET HARASSERS

"DON'T COMPLIMENT ME. I DON'T CARE IF YOU THINK I'M PRETTY."
—NEETI, CHICAGO

hypersexual jezebel; as mentioned, Latina women are stereotyped as sassy. Women of East Asian descent described being called things like geisha and generally getting aggressive racialized harassment that is directly related to sexual stereotypes of nonwhite women. In Oakland, a woman named Suzanne said similar things to what Christiana says here. Her poster reads "Not Your Asian Fetish, China Doll, Geisha."

Racialized harassment is another layer of humiliation in the street. As with sexism, racism follows you from one environment to the next. We are experiencing these aggressions not only in the street but also in the workplace, at school, and in public-private spaces like retail stores.

Black and brown women are also more likely to be propositioned on the street. I have heard from some women who don't like to linger on the streets when waiting for a car ride like Lyft or Uber because men will proposition them for sex.

I ask Christiana if she ever talks to white people about the racial aspect of street harassment, and she tells me that the comments her white friends hear are often less vulgar than the ones she experiences.

It's really hard sometimes to have conversations with my white friends because they will talk very freely about comments they get, like, "Oh, this guy was gross" Or "they yelled this thing at me." And then when I mention, "He was like, Oh Me So Horny," it just feels more embarrassing than the comments they get. And they are kind of like "oh, okay."

I think it's hard for some people to understand that there's stuff beyond their experience. It's not like we all have the same experience with street harassment. There are some experiences that are more layered. But I don't want to say my experience is worse than that one but better than this one. It's probably all a big soup of bad stuff.

> With my friends who are white, my friends who are male, trying to break it down for them can be very labor intensive, it's an education process. Even that can be frustrating to have to explain to them. That's work that gets put on marginalized people, unfairly, to try and teach people stuff.

I can hear Christiana's frustration and anger here. I understand it, and I feel similarly. I'm sure a lot of women do. Sometimes the entitlement that men display is baffling. I've thought to myself several times how it would never even occur to me to say such crude or sexual things to a complete stranger on the street the way that a lot of men do. So much of street harassment feels like obvious bullying and abuse, and yet a lot of men don't understand why it makes us angry.

WHAT WOMEN WANT TO SAY TO STREET HARASSERS

"WOULD YOU SAY THAT TO YOUR MOTHER?"
—KRISTY, ATLANTA

The Privilege to Speak Up

One useful aspect of the concept of intersectionality is the perspective it affords us on the ways we might each have more, or less, or no privilege in different settings and with different groups of people. I've already discussed my personal experience of it: how society gives certain people privilege over me (as a woman, as a Black person, as a Black woman); and how, because I am cisgender and usually read as straight, I in turn am privileged over trans and readably queer people in terms of safety, freedom, and inclusion.

This lens on harassment always fascinates me, and it comes up again when I ask Christiana my next question: How does she respond to harassers, and has that changed over time?

> There's been a big change in how I handle it. I made a decision two years ago that I was going to answer every person who talked to me. When I told friends and family that, they were very worried about me because they were

like "Your safety comes first, don't say anything, you're in New York, you could get hurt." But that is a risk that I am personally willing to take.

And so there's a lot of risk, a lot of volatility when I go for a walk by myself. I just know that if someone calls out to me, that I'm going to answer them and that's going to be a very charged interaction. It always is, no matter what they say. I never had someone say, "You know what? I'm so sorry."

I used to put in headphones and ignore it, it was a form of armor protecting me from hearing the comments. But I actually think that's less safe because it's taking away one of your senses. Someone can come up behind you, grab you or something. Also I just feel like if you always ignore it and they never get pushback, they'll never stop.

I wrote earlier that, like Christiana, it has crossed my mind that it might make a harasser angry to be ignored, which might cause him to run up from behind to attack or grab me. It's enraging that I am afraid of being attacked by a man because I happened to not hear him speak to me. But it's a frightening and very real possibility, so another, safer option is wearing headphones and not listening to music. That gives harassers the illusion that you can't hear the comments and therefore provides you with an excuse not to respond but still allows you to hear if anyone approaches from behind.

I applaud Christiana for taking back her power by deciding, for herself, to talk back to these harassers. It's especially satisfying because it flies in the face of another pervasive stereotype of Asian women: that

> **Black women have been categorized as the hypersexual jezebel; Latina women are stereotyped as sassy.**

they are meek. Thankfully, that's one stereotype that finally seems to be on the wane as more Asian women gain prominent positions in society, especially in the media and popular culture.

There is no right or wrong or one-size-fits-all response to street harassment. When, where, and how a woman responds depend on a lot of different factors. I do agree with Christiana that if men never get any pushback, they will never stop. Yet I think women should not and do not bear all the responsibility for pushing back. That pushback should come from other men and bystanders as well. There should be a collective, societal response that makes men stop.

Where does Christiana get the wherewithal to respond so comprehensively?

> Part of the reason that I feel comfortable [answering back] is I have a lot of privilege because I have the emotional and physical capacity to defend myself, maybe not against everyone, but generally I'm at the point where I can stand up for myself.
>
> I feel like it's my responsibility to say something to harassers because I can protect myself, while there's a lot of other people who don't feel they can defend themselves; maybe some people just don't have the emotional ability for it.
>
> I always just want to say, "What do you want from me? What do you want me to say to you?" Comedians have made jokes about this: "What do you think is going to happen when you talk to women like this? Has a woman ever said, yeah, let's just go back to your place?" So much of what I want to say is questions: Who taught you to do this? What do you want from me? What makes you think that's funny? What makes you think that's okay? Do you think your mom is proud of you right now?
>
> That's one thing I'll say to people when someone calls out to me. Sometimes I just say fuck you or sometimes I say your parents aren't proud of you, that one usually gets a bigger response.

Because sexual harassment is about asserting power, Christiana's decision to take control and not let these men dominate her space and body is meaningful. But she's right that in some ways it is a privilege to be able to make that choice. For many different reasons, a lot of women are not able to bark back at harassers or assume the risk of physical violence.

Some women do not have the physical ability to stand up to their harassers, knowing that violence may occur. They may feel unable to talk back because of their size and strength or because of physical disabilities. It's a shame that we have to measure our ability to defend ourselves against physical violence when we are approached by strange men on the street.

Part of Christiana's privilege comes from the fact that she presents femme and therefore meets society's normative beauty standards. For feminine-presenting women, there is often a veneer of respectfulness to the harassment, even if their femininity is seen as weakness. That thin layer of false respect is

not accorded to masculine-presenting women, gender-nonconforming people, and anyone else who doesn't fit into the very limited beauty ideal.

That's because harassers are less likely to get aggressive when they know their target is approved of by mainstream society (even if, as in Christiana's case, that approval is tainted by exoticism). Trans and gender-nonconforming people are not accepted by the broader culture, and therefore men feel even freer to assault them.

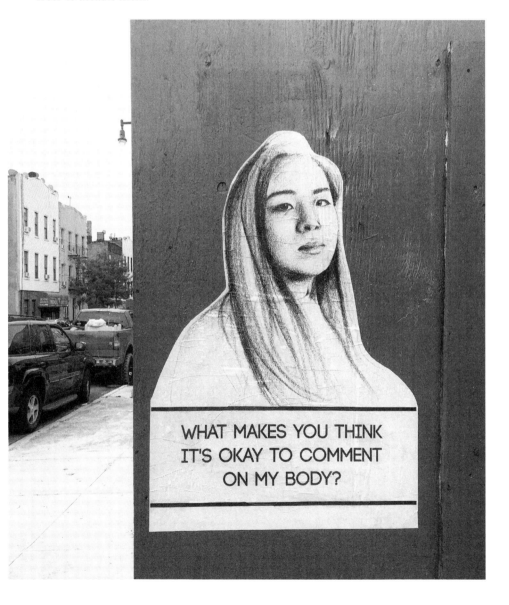

WHAT MAKES YOU THINK
IT'S OKAY TO COMMENT
ON MY BODY?

The Freedom to Feel Safe

Finally, what would a future without street harassment be like for Christiana?

I think I would feel safer. I've spent almost my whole adult life in New York, so I feel very comfortable and safe in the city.

Especially in the summer. I can tell it's becoming summer when I start getting more harassment. The temperature changes and you put on a pair of shorts and it's like, "spring is here because I now have strangers yelling at me on the street." It's constant. You'll be walking down the street enjoying the beautiful weather, in any neighborhood, someone's going to yell at you.

It definitely makes me feel less good about the world. It just feels like a stream of unkindness running through the world. I've been lucky enough to travel and I know that there are places where there's less street harassment and there are places with worse street harassment, and I know it's not necessarily an indicator of how men feel about women, about sexism. I know I've been places where there's no street harassment but women are still treated terribly. Still, it feels like a very public kind of unkindness toward women.

As I've gotten older I've held onto a lot of anger about men, what we let men get away with. It's something that I'm still trying to work through. So, on a very personal level it would make me have fewer negative feelings about men.

Also as I get older I think about having a family, and about preparing daughters or children who present as female for a world like this, where it happens so young. If I was a parent now, I would never think, "I should probably talk to my eight-year-old daughter about handling people on the street." I think if and when I have that conversation, it's going to be so difficult.

And then if I have a son—how do you raise a son in a world that presents that as acceptable behavior? I'm sure that parents aren't teaching their sons, "go and harass this person or scream something horrible at her," but it's all the little things that people pick up on as they grow up that make it seem like certain things are fine or funny, or like girls and women aren't going to do anything about bad male behavior. If there were no street harassment, it would make me feel better about having kids in this world and how life might be for them.

I don't think people realize that over the years, in addition to harassment that people face in the workplace, that people will get from their partners, from their friends, from people that should be allies, that even the kindest people who don't really think about this stuff can be so hurtful and so harmful. "Well, it was a compliment" or "he was just saying hi."

Now I can say to them, "I know that I'm not being sensitive because people have made art about this, people have spoken out about this. I swear to god it's not just me." Just being able to show people I'm not the only one who feels this way is extremely helpful.

Being able to feel safe is a crucial part of being free. A future without street harassment would mean greater freedom—for women and people who present female, for children, for gender-nonconforming people.

And there's another part of it I hadn't really thought of before. When Christiana imagines feeling less anger toward men, it makes clear how such a future would mean greater freedom for them, too. Because in the absence of street harassment, half the world's population wouldn't walk around in public constantly regarding men with suspicion and fear.

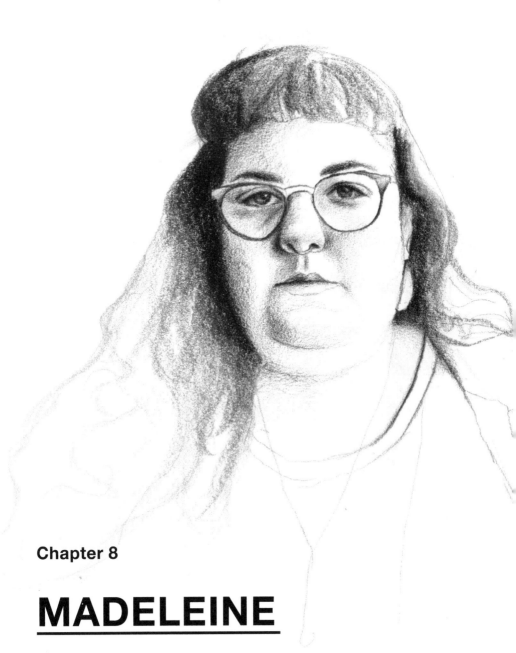

Chapter 8

<u>MADELEINE</u>

Beauty Ideals

Age: 28
Identifies as: Queer, white, fat, femme

When Madeleine, an artist, comes to my studio to speak with me, she has lived in New York for almost a year. She's from Philadelphia, where she'd had a lot of experience with street harassment over many years. She wanted to participate in my work specifically to talk about the treatment she receives as a fat woman. This is a group that is often overlooked. If we can better understand their experience of the public space, we will have a more complete picture of street harassment in general.

I begin by asking for her definition of street harassment and when it began for her.

Street harassment is any uninvited attention that's given to you based on how you look and your existence. I feel like I've always had it. I remember being maybe twelve, thirteen and experiencing it a lot in my neighborhood in Philly. That's when I started picking up on people following you, or people touching you when they weren't supposed to. I remember walking home from camp one day and a man came up behind me and grabbed my butt and just stood there holding it.

I was scared. I was really scared.

This work is about learning how women experience the public space by simply being who they are. From Madeleine I learn that existing in the public space as a fat woman brings abuse and violence.

Identities are often placed upon us as markers meant to "other" us: Black or Person of Color as a marker against the norm of being white, Queer as a marker against the norm of being straight. Madeleine says she identifies as fat because "that's what other people identify me as and I've started to come into that."

Out on the street, men are constantly imposing their beauty standards on women, evaluating us out loud, pointing out our body parts and deciding whether they are sufficient or not. When they find a body good enough, they give "compliments": "Nice legs." "Beautiful, baby." And when they deem a body not good enough, because it does not meet their beauty standard, the harassment often becomes taunting or even cruel.

I ask Madeleine to describe how her size affects the way men treat her in public.

A lot of the harassment is about my weight. People stop me and tell me that they know how to treat someone with my body.

Madeleine's experience of men projecting onto her their ideas of what it is to sexually please someone of her size, and assuming that her partners are unable to do so, sounds very similar to what men say to women who are visibly gay and with their partners. It's another iteration of the ways men assume that women's sexuality and bodies are there for their consumption, and any evidence to the contrary is just because that woman hasn't "met me yet." It is yet another way harassers attempt to dominate women.

WHAT WOMEN WANT TO SAY TO STREET HARASSERS

"NO, I'M NOT GAY BECAUSE I 'HAVEN'T MET THE RIGHT MAN YET.'"
—BRITTNEY, OAKLAND

We mistreat people for not fitting into the standard of beauty that has been set out for us. We deem them not worthy of kindness. We've seen from these women's stories that it happens to women of every race, class, age, presentation, and size. The types of harassment depend largely on a lot of these traits, as does the degree.

Has Madeleine experienced harassment turning into violence?

I get a lot of violent harassment. And huge changes in mood when I say no. I've had people throw rocks at me. I've had weird violent things happen when I say no. And it always comes with a comment about my body and about my weight.

Street harassment ranges between extremes—from a mild comment to physical assault. And at the same time, that range exists on the spectrum of and within the larger problem of violence against women, up to and including rape and fatal violence. In my years of talking with women, it has not

been uncommon to hear that they or someone close to them has experienced physical violence in public. Just like domestic violence in the home and sexual assault, violent street harassment is a terrible reality for too many women and has been for too long.

It bears repeating: street harassment is about power. And just like other forms of sexual violence, it has little to do with actual sex or attraction. When Madeleine says no to her harassers and they become violent, it is punishment for rejecting them, and that is a gross assertion of power.

When Madeleine and all of these women tell me about their experiences with street harassment, they are reclaiming power.

I ask her about the effects violent street harassment has had on her life.

I don't walk on the same side of the street when I see a man, no matter if he's eighty or if he's twenty. I just don't like being around men at all. I find that I don't go to places where there are a lot of men. And I think it honestly has almost helped me come into my queerness more because I'm surrounding myself with queer people and queer spaces that I didn't when I was younger because I didn't have those spaces. And it kind of pushed me in a direction that I maybe needed to go in. So I've acknowledged that that experience has helped me grow in other ways.

It's impressive and encouraging that Madeleine can see an upside to it, but the fact is that extreme and constant street harassment can have huge, lasting emotional and psychological effects. Earlier I described my own enduring anxiety about it, and this is a problem for a lot of women. There's trauma associated with being a woman, and its heavy weight affects how we navigate our cities and our world.

> **Out on the street, men are constantly imposing their beauty standards on women, evaluating us out loud.**

Earlier, Candice spoke of the precautions she already takes to protect herself from men, and of others she wonders if she should take, such as keeping a weapon in her home. When Madeleine crosses the street at the sight of any man of any age, she is participating in an age-old practice common among women everywhere: protecting herself from male harassment and violence. So many of us regard all men on the street with similar wariness, because

we never know who the harassment and violence will come from. Given the statistics, and our lived experiences, it is easy and maybe safest to assume that every man poses a threat. There are no particular markings that let us know who will become violent with us and who will not.

So we try to keep ourselves safe from harassment and the possibility of violence in every way we can think of, from crossing the street, to pretending to talk on the phone, to all sorts of other measures. I've even heard of women moving to new cities to try to get away from it.

WHAT WOMEN WANT TO SAY TO STREET HARASSERS

"MY DISABILITY DOES NOT DEFINE ME."
—JESSICA, MINNESOTA

Like many women, Madeleine has been restricted in her ability to move freely in public. Street harassment, then, is a form of public terrorism against women. It creates a hostile territory where women are not able to go outdoors without fear. Even before leaving the house, we are preparing ourselves for a hostile environment.

When we walk by a man who speaks to us, we theoretically have the right not to respond or to respond with a no, without fear of being cursed out, grabbed, or having things thrown at us. But the reality for most women is that we do not have the actual freedom to respond however we'd like because of the threat of violence. We live with the fear of that every day.

Street Harassment by Women

Madeleine raises another aspect of sexual harassment: it does not only come from men. Even in queer spaces and among women, sexism exists. Society's belief that women are consumable and up for grabs is not something only men are socialized to believe. We women have all been socialized to look at ourselves and other women that way, and consent must be learned and practiced by all of us, in all spaces and environments.

WHAT WOMEN WANT TO SAY TO STREET HARASSERS

"LEAVE ME ALONE. I'M NOT HERE FOR YOU, AND I'M NOT HERE TO ENTERTAIN YOU. I'M HERE TO LIVE MY LIFE."
—DIANNA, CHICAGO

I ask Madeleine: How has she experienced being harassed by women?

[Women] seem to think it's okay for them to do it because I'm interested in women and I'm single and they assume nobody's interested in me. In one instance, someone was physical with me and then made comments after, and in the other instance, the person was just physical with me and then walked away like it was okay. The people around me were kind of shocked that they did that, and I was shocked, too, but it didn't really hit me until afterward that if a man did that to me I would call it harassment.

Madeleine is right; it is shocking that other people feel such a sense of entitlement to her body. All women experience that, but for women who do not look or present in the normative ways society expects, harassers seem to feel an even greater right to comment on or touch them. Many women have experienced the disconnect of having a harasser proceed as if their behavior is flattering and should be taken as a compliment. The intensity of verbal and physical abuse increases when the harasser assumes his or her target does not usually receive compliments.

Harassers Who Think Fat Women Should Not Be Happy

The idea underlying this version of harassment is that fat women are not desirable, which is not true. The presumption is that a woman like Madeleine should be grateful that someone finds her attractive. It's offensive and insulting. Even though I've been exploring this problem for years, I'm still

sometimes stunned by the audacity of anyone who thinks that they have the right to speak to anyone's looks.

I ask Madeleine about receiving that type of harassment.

I've gotten it at work a couple times just because I work in the service industry. But I think I get it the most online. People will leave comments on things, or they'll send you a message and it starts off kind of normally, then it escalates. And you're like, "Why are you talking to me?" I got rid of a lot of dating sites because I used to get really crude messages from people who had no interest in me, they just wanted to harass me.

It's interesting—I think the more confident I am with myself, the more responses like that I get. I think people are uncomfortable with me being happy because they're so used to seeing unhappy people who look like me. It's how we're represented, right?

I've heard from many women that social media, dating sites, and other online spaces are venues where they face harassment, and people often feel free to say even worse things when they can hide behind screen names. We've all read articles about how teen bullying can be much worse online, but it's not something that's been discussed as much when it comes to sexual harassment. Just like in the real world, the harassment is unwanted, unprompted, and can be scary. The anonymity of online harassment also intensifies the fear that women already live with: How do you know if the person reaching out to you on a dating site is really interested in you, or specifically sought you out to abuse you?

I'm disheartened by Madeleine's astute observation that harassers don't like seeing her happy. And I'd take a step further and say that, in American and probably much of Western culture, there is a prevalent notion that heavy people do not deserve to be happy. Madeleine is right that we are unaccustomed to seeing contentedness in people who look like her.

> In our image-obsessed society, fat people are one of the few remaining groups it's still socially acceptable to mock and disparage.

A lot of that is because the media generally represents fat folks as sad and as if weight loss is their main concern. Media in all forms, from TV to movies to advertisements, teach women and girls to vie for the attention of

men by conforming to beauty norms, and it teaches fat women to try to shrink themselves, to hide, and not to take up too much space. It also teaches broader society to expect that from them.

If media instead represented women as whole, rich, complicated human beings with autonomy over our bodies and our sexuality, and in all our beautiful varieties, perhaps we wouldn't hold so tightly to the oppressive ideas that women are only here for consumption and should move through the world in a particular way. I sometimes try to imagine a space where women are not judged, and therefore are not mistreated and abused, on the basis of their physical appearance.

I wonder what a world without street harassment would mean to Madeleine.

I think I would think about things less. I don't stand near the edge of the train tracks because I'm afraid someone's gonna push me under the train, that kind of thing. It's this constant anticipation of what someone might do to try to hurt you. So, I feel like it would be more freeing, and life would be less stressful.

Madeleine isn't just worried about the possibility of unwanted comments, she lives with the fear of being pushed under a train. All of us women have felt this kind of anticipatory fear, though not all of us have to live that way as constantly as Madeleine does. As someone who experiences a lot of anxiety about street harassment, I can't imagine how difficult it would be to exist day in and day out with the even more magnified and constant fear that Madeleine describes. When people ask me about the importance of making art about street harassment, and why it is a priority topic in the context of women's rights, I try to impress upon them the fact that we are discussing the very real, and realistic, fear for our lives.

I ask Madeleine if anything about her experience of street harassment has changed over the years.

I stick up for other people now when I see them get harassed. I never used to do that. So, it's kind of helped me grow a little bit. And I also speak up more when it happens to me. I'm twenty-eight now. Probably until I was twenty-four or twenty-five I would just kind of ignore it and walk away. Now

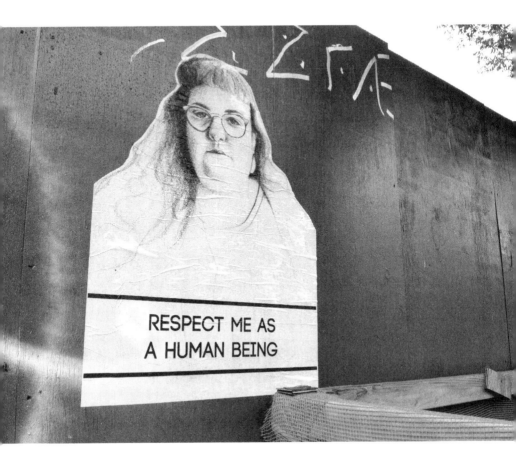

RESPECT ME AS
A HUMAN BEING

I don't. Now I'm a little more vocal about it, and even though I personally avoid being harassed as much as I can, it still happens.

What would Madeleine like to say about her experiences to the public?

I almost feel more mentally violated than physically violated when people think they can get away with harassing me because they assume that no one else pays attention to me. I feel like they're saying that I don't deserve to be treated normally because I look different. I am a strong person and I deserve to love and be loved without you pushing your ideals on me.

In our image-obsessed society, fat people are one of the few remaining groups it's still socially acceptable to mock and disparage. The media situation

is finally starting to improve, with more visibility for "plus-size" models and clothing. So far, though, that push has still focused on traditional ideas of feminine beauty, including whiteness, minus the requirement that women be thin. But many women do not and are not interested in conforming to those aesthetic norms, and we must create space and safety for them, too. We are lucky that more women like Madeleine are speaking about their experiences and concerns. Now we need to listen to them.

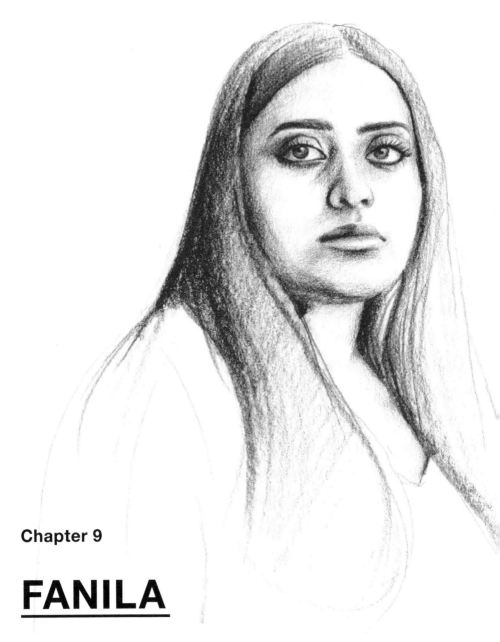

Chapter 9

FANILA

Sexism Across Cultures

Age: 22
Identifies as: Muslim, American

Fanila grew up in Pakistan and moved to the United States ten years ago, at age twelve. She recently graduated from college in New Jersey. Like many of the women that I've interviewed for Stop Telling Women to Smile, Fanila was familiar with the work when she responded to my request for interviewees. I'm always glad for the opportunity to include people originally from different countries; it brings interesting dimensions and perspective to the discussion of sexism and street harassment.

I ask Fanila what resonated with her about the project and why she wanted to participate.

The work resonated with me personally because it gave voice to something that I'm not comfortable speaking about, a part of me which I don't discuss with most people, if any at all.

Growing up in Pakistani society as a Muslim woman, my family household was mostly very traditional. My mom was educated, but her education wasn't looked at as "Oh, this woman's educated." It was like it was nothing. She was told to do housework and to take on all "womanly duties," as people say.

I used to be sad as a kid, I don't know why. I'm the first child of three, so I was a little serious about certain things in life, because society made me that way, and because I wanted to protect my younger sisters. And so I always kept to myself and was quiet.

And I loved to learn. I loved reading. But I was told not to go to school at all, I was shunned from it. During that time my father used to be like "Oh, Fanila why don't you smile more?" And I felt like, I don't necessarily have to do anything if I don't feel like it.

So, the quote really resonated with me because it's not just from my childhood, but it has carried on, to now as well. The men I've dated or even my friends say, "Why are you quiet?" Why can't I just keep to myself? I don't have to be a social butterfly all the time, it's just not possible all the time.

I was the same way as a child and got the same comments from family members and other people in my life. I was a quiet and serious girl who kept mostly to myself. I remember feeling obliged to smile and be pleasant to people because it was impolite not to. I do not remember my boy cousins or older brother being told the same thing.

It Starts at Birth

We teach young girls to smile and be friendly in a way that appeases other people. It makes you likable, and women and girls are supposed to be likable. Pleasant. Approachable. A girl who is deep in thought, or serious, or intense is too much for a society that wants you to simply be pretty and sweet.

In my experience, and I believe it's true for many others, these expectations placed on me as a child taught me to perform niceness in a way that was not beneficial for me. It may even have been damaging.

If we are taught to be polite, even against our own wants and feelings, then we find ourselves even in adulthood struggling to stand up for ourselves, to be stern and mean when a situation calls for it, especially toward men. We are taught to appease other people, and as we grow and experience the abuses and violence of men, we are conditioned to be polite to men even in situations that make us uncomfortable. I wish that, instead of being told to smile and to "stop looking so mean," I'd been encouraged to speak about how I felt. (Not that my mother didn't raise me right, she did. She's great. Hi, Mom.)

> Smiling makes you likeable, and women and girls are supposed to be likeable. Pleasant. Approachable. A girl who is deep in thought, or serious, or intense is too much for a society that wants you to simply be pretty and sweet.

Fanila's experience as a little kid offers another perspective on the way girlhood is affected by sexist traditions and how, although it takes a very different form in her adulthood, sexism still affects her everyday life today.

I ask her to tell me more about the beginnings of sexism in her life.

Sexism started to have an impact on me at a very early age. I probably started comprehending what was going on when I was four or five. All my cousins went to school, even the girls. My father did not let me go to school because he'd wanted his first child to be a boy. So, funny story, he stopped believing in Allah. He would say, "I don't believe in him because he gave me a daughter."

My mom used to go to the shop to get books for us. We used to hide them from my father and I would read them at night. It was cool, when you're forbidden to do something at such an early age, it pushes you to do it more and more.

My mom finally convinced my dad to let me go to school. It's interesting because I have a sister who is nine years younger than me. She doesn't know any of this because she grew up here. So, in Pakistan, when I enrolled in school, I had to clean my dad's motorcycle at five a.m. and convince him to take me to school because it was far from our house.

So, when it comes to sexism, it's the fact that I was not allowed to go to school, I was not allowed to go outside, I was not allowed to play, and on top of that I was told that I need to marry early. That's all coming from my father. He actually wanted to marry me off to my cousins, and just stay with them. Mind you I was a little kid. It was ridiculous. My parents had an arranged marriage, so that's where these fundamentals come into play.

Fanila's situation is very different from those of other women I have talked to. But her experience is on the same continuum of sexism all young girls are subject to; we are all, in some way, not treated as equal to boys and are subject to the decisions of men.

WHAT WOMEN WANT TO SAY TO STREET HARASSERS

"HOW WOULD YOU FEEL IF IT WAS YOUR DAUGHTER WHO WAS BEING HARASSED? WOULD YOU BE OKAY WITH THAT?"
—ERICA, CHICAGO

Comparing Cultures

I've had the chance to learn how street harassment happens in various American cities and a few other countries. I've always been very interested in how different places and societies allow and disallow different bad behaviors by men. I'm curious to hear from Fanila whether young girls in Pakistan are

sexualized and approached by men on the street like they are here in this country.

When does she first remember being harassed by men on the street?

I started experiencing sexual harassment at about age nine, maybe even as early as seven. No matter what age you are if you go out in the street in Pakistan and there's men—old men, and young men too—they'll always try to talk to you, and hold onto your wrist, or your *dupatta*, which is like a scarf. It's very disrespectful.

And then when we came to America, we thought those things would go away, but they didn't. They didn't. It was fine as a kid, but at college, some men feel the need to come up to you and try to hold your face. It's like, what are you doing? Suppose it's a night out with your girls and you're walking to a bar or something, some men feel the need to hold your ass while you're walking.

That was very weird and confusing to me, as a Muslim person. Literally, when you're just walking, random people touch you, and I did feel violated. Some girls were okay with that, but for me it did not feel okay. You're not my man. Even if you were, I'm not comfortable with that type of stuff. That was very annoying.

Street harassment and violence against women are global problems. In North America, one in four women will be sexually assaulted during her lifetime and 65 percent of women in the United States have been street-harassed, according to Stop Street Harassment and Sex Assault Canada. According to UN Women, between 40 and 60 percent of women said they had experienced street-based sexual harassment in the Middle East and North Africa. Research from Actionaid, an international charity, found that 79 percent of women in India, 86 percent of women in Thailand, and 86 percent of women in Brazil had been harassed in public.

The public harassment of women is such a normalized phenomenon that, in the United States and many other places, it is expected and accepted as a part of the culture. It's heartbreaking to hear that Fanila thought it would be different in the United States but instead found that it is prevalent here as well, though it manifests somewhat differently.

Fanila mentioned being taken aback at the overtly sexual nature of the ways strange men touch women here versus how it happens in Pakistan. But

wherever on your body a man might touch you, it comes from the same sense of ownership of girls' and women's bodies. A new study conducted by Stop Street Harassment, a nonprofit founded and run by Holly Kearl, reveals that in addition to 77 percent of women experiencing verbal harassment in public, 51 percent of women have been unwelcomingly sexually touched. Perhaps even more than comments, physical harassment leaves a mark. Certainly, my own strongest memories of street harassment are of when men have touched me or physically assaulted me.

WHAT WOMEN WANT TO SAY TO STREET HARASSERS

"I HAVE A RIGHT TO BE ANGRY."
—KENZIE, MINNESOTA

Layered Identities, Layered Sexism

Hearing Fanila describe differences in street harassment between the United States and Pakistan makes me wonder about another way they might differ: the racial aspect. We've heard from a few of the other women in the book about how their racial identity affects the way they're sexually harassed in public. Now I want to hear about that angle from someone who is read as foreign and, further, whose culture is particularly denigrated, feared, and misunderstood by Americans at this moment in history.

I ask Fanila how her other identities besides being a woman affect how she's treated in public.

> That's a good question. I feel, in regard to my Muslim identity, that I'm mostly stripped of my true successful, alpha woman, achiever identity. It mostly has to do with intellect, achievement, things like that.
>
> In regard to my American identity, the sexism has more to do with sexual harassment and misconduct.
>
> I think my Muslim identity and my American identity play to different sexisms.

That's a fascinating and insightful perspective on the ways our different identities evoke different and overlayered kinds of sexism and harassment. We've already seen some of that in hearing from Deyanira about the harassment she received as a kid from white boys at school. It's a theme that comes up again and again in my conversations for the street art series, and we'll look at it more later in the book.

Off the Street: Harassment by Intimate Partners

Fanila brings up another variant of harassment that I want to highlight: as a teenager and young adult, she has been sexually harassed even within relationships.

Without going into detail, she recounts a bad experience with a former dating partner. It involved him pressuring her to do something she didn't want to do and attempting to proceed with what he wanted even after she'd made her wishes clear. Unfortunately, many of us have been in that kind of situation.

I'm glad Fanila mentions sexual harassment between intimate partners because it is an especially invisible part of the problem. Sexual harassment, abuse, and violence against women occur in every area of our lives, and each instance informs the other. Street harassment does not work on its own. How women are treated inside the home influences how we are treated in the street, the workplace, and so on. It is a cultural and societal issue.

That is why addressing street harassment is important. Because when we confront one context of sexual harassment, we are also confronting the other forms. When we make street harassment

> **Addressing street harassment is important. Because when we confront one context of sexual harassment, we are also confronting the other forms. When we make street harassment unacceptable, we are also saying that any violence against any woman, in any location, is also unacceptable.**

WHAT WOMEN WANT TO SAY TO STREET HARASSERS

"HOW HAS IT STILL NOT REGISTERED WITH YOU THAT ALL I FEEL IS FEAR IN THIS INTERACTION?"
—ANONYMOUS, NEW YORK

unacceptable, we are also saying that any violence against any woman, in any location, is also unacceptable.

There is a common perception, especially among older generations, that consent is automatic between partners in a relationship. That notion could not be more wrong.

I ask Fanila about the emotional fallout from the experience.

I'm still figuring out how to deal with this stuff. People say you're supposed to talk it out, but sometimes talking it out makes me think about it more than I need to, so I feel as though I am still in it. Mostly I try not to see the bad in everyone. I expect a lot from people because I know people should expect a lot from me. So why can't I expect a lot from people?

It's very interesting because life has taught me I shouldn't expect anything because sometimes people aren't worthy of that expectation, which goes back to the question of how to deal with sexual harassment. I don't feel comfortable talking about it to my friends, my family.

I'm always told: you should be strong, you should be independent, you should have your shit together and move on. I've been trying to do that all my life, and I have been blocking my actual feelings and not talking about them.

Fanila's point that we are expected to keep quiet about these things is an important one. Talking privately and publicly about our experiences with sexual harassment has only recently begun to be normalized. Some of us keep quiet simply because it's taboo to discuss it, and it carries with it shame and humiliation for the recipient of the harassment (and much less for the harasser).

The Consequences of Speaking Up

But many women have even better reasons not to talk about it. There can be very real consequences for speaking up. You could be called a liar. You could be mocked or ridiculed. You could lose your job; you risk having your reputation ruined. So many of our societal systems are set up to protect men so that when women are vocal about their abuse, it's the men who are automatically believed.

Thankfully, it's beginning to change: With the recent movements attempting to dismantle this part of the patriarchy, like Tarana Burke's #MeToo movement, more and more women are speaking out, and more and more people are believing them.

Nevertheless, we still live with the expectation that we should be strong and suck it up. I believe this is particularly true for Black and brown women.

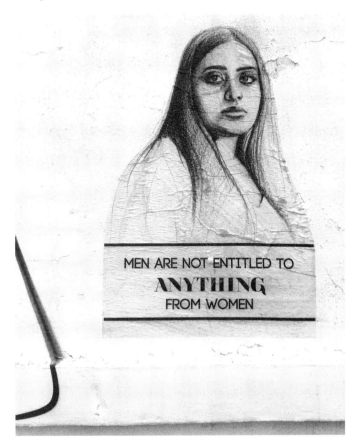

Personally, I come from a long line of Black women who were expected to be the pillars of the family and the community. And that meant silencing themselves about the abuse they experienced.

I feel the weight of not speaking. I feel the weight of carrying around the aggressions, the slights, the anxiety of simply leaving my house if I'm wearing certain clothing. I carry the times someone said something sexist to me and I didn't speak up for myself, the memories of what men have done to my body, the fears of what a man might do to my body anytime I leave the house. In this work, I am laying down that weight, and hopefully giving other women the opportunity to do the same.

The silence imposed on us is the very reason I always end the interviews by offering the women the chance to speak their truths and to be heard.

What does Fanila want to say to the world about her experiences?

How women have to protect ourselves from others' expectations, and from society's assumptions about us. We are always shielding our bodies from others' expectations.

A lot of us usually just go with the flow. I feel as though going with the flow is not necessarily the best option. At times you should really sit down and reflect on what just happened and take some time out for yourself. I think a lot of people don't do that, including me, to be honest. I'm guilty of just letting things happen. We actually need to have a dialogue about it. Also talking about it with yourself is helpful.

By having these conversations, we are refusing to go with the flow. We interrupt the status quo when we question the necessity of socializing girls to be pleasant and not make a fuss and when we voice our anger about harassment and abuse. Fanila is making a conscious effort to stand up and be loud and honest about what has happened to her and what she is no longer willing to take. I wish such courage for all of us.

Chapter 10

SONIA

Gentrification and Street Harassment

Age: 30
Identifies as: Queer, femme, gender nonconforming, Latinx
 person of color, migrant

Sonia is an artist and activist. They came to my studio to talk with me. As a nearly lifelong New Yorker, they have years of experience with street harassment and have seen big changes and new complications to the street culture in the place they grew up.

How does Sonia define street harassment, and when did it begin for them?

As a Harlem-raised person, growing up with cis men of color constantly around me, street harassment was about my childhood being oversexualized, and erased. So, when I think of street harassment when I was young, it was the cornering of a younger body into a very sexualized being. I would get catcalled even if my mother or my father were with me. That breach of personal space and autonomy and agency to dictate the safe space that I want to walk in.

So many times when we think about street harassment, it is as if women and femmes are trespassing on space that does not belong to us. The public street does not feel like our own; it is as if we do not have the same right to it as men. But, of course, we do have a right to safe personal space, to feel safe within our own bodies no matter the location or environment.

A different sort of safety, though, is afforded to Black and brown people when we live in our own communities. Rakia discussed the unity and support she wants to uphold in her neighborhood in the face of gentrification. I'm always curious to hear from people who grew up in places that have been dramatically gentrified.

How has Sonia seen the street culture, and especially street harassment, change in the neighborhood where they grew up?

With gentrification, as I've gotten older, I've noted this heightened attention to the brown femme body by white cis male students that attend Columbia University and City College. Two schools that have expanded into our neighborhoods in Harlem and continue to push for more eminent domain practices now. Street harassment is impacted by powerful systems that can reach into your identity and the safe places you carved as home in your neighborhood.

If you're a woman of color or brown person of color, where does your race come in the discussion of street harassment? Lots of ways it is

reflected in the power imbalance between how a cis male student from Columbia University is able to move around and a longtime Harlem resident feeling constrained. That kind of intertwined breaching of space. I don't know if I'm making sense but I'm trying to describe the intersection of race and class and gentrification and sexualization.

Sonia makes an important and fascinating point in describing how different types of power and dominance in the public space can affect a community. Gentrification of a neighborhood can cause a lot of tension between incoming residents, who are more affluent and mostly white, and long-term residents.

Various dynamics can make a long-term resident in a gentrifying neighborhood feel unsafe or insecure in their environment. The power and white privilege of the new arrivals are generally unavailable to them. Moreover, that new affluent white culture often gentrifies the neighborhood's older, established culture out of existence. When you add identity into that mix, it often leads to the further disempowerment and vulnerability of the women, girls, and femmes who have grown up in these places.

> **Whether documented or undocumented, many immigrant women have limited power and status . . . and they have less means to say anything about it.**

A young Bronx woman, for example, who is already experiencing sexualized harassment will feel even more vulnerable because of the additional harassment, based on class and race, that comes as her neighborhood is gentrified. These things overlap in devastating ways.

An inverse situation often occurs for young middle-class white women who move into lower-income neighborhoods as they gentrify: they receive harassment from long-term residents who may feel that those young white women do not belong in their neighborhood. Gentrification pushes people out of their homes, out of their communities, out of the neighborhoods that they have lived in for generations. There will be tension. Does that mean that any sexual harassment that these women experience on the street is justified? No.

But it does complicate the conversation and requires us to unpack the power dynamics of street harassment more fully. In a white supremacist society, Black and brown men arguably do not have power over white women,

WHAT WOMEN WANT TO SAY TO STREET HARASSERS

"WHEN YOU OBJECTIFY ME, YOU'RE ALSO DOING A DISSERVICE TO YOURSELF AND DISRESPECTING YOURSELF."
—ANONYMOUS, ATLANTA

especially in an environment where their economic and housing status are vulnerable because of the changing neighborhood.

On top of that, white women who move into a Black and brown neighborhood may be more sensitive to harassment from Black and brown men because of racial bias, whether overt or unconscious. They may be more fearful because of their own racialized assumptions, particularly their preconceived and racist notion that Black men are aggressive.

We're all familiar with the spate of recent news stories about white people calling the police on Black people for doing normal everyday things. If catcalling were illegal, we would likely also see white women weaponizing the police against Black men for harassment.

This is why criminalizing men for street harassment is tricky. When white people feel afraid of people of color, even though that fear is very often racist and unjustified, police will inevitably be called, leading to the further criminalization of a community that is already under police force.

I ask Sonia if there's more to say about the overlap of gentrification and street harassment.

Gentrification in general has heightened the racial inequity. And so for the brown bodies in that neighborhood—maybe it's a migrant person who recently arrived who doesn't speak English, and they receive that kind of harassment on a Sunday or Saturday afternoon or late at night from white college students in the train station. The ice cream vendors, for example, are usually undocumented women of color.

And people who have been able to come and gentrify Harlem, they will just exploit their privilege by either screaming at the vendors to make them move over, or things like just outright taking pictures of them without

permission. For a teen or young person who is originally from there, just existing there, coming home from school and having to deal with that kind of environment on the bus or in the train or in the corner bodega, it's difficult.

And then adding surveillance by police because, of course, the new residents from middle-class backgrounds feel more entitled and in a safety net, with that perceived support of police enforcement.

So, who, then, do the local residents go to about these grievances that are coming up?

Sonia's observations about gentrifiers who are aggressive to residents shed light on another form of harassment: privileged persons exerting power over those with less privilege by making them feel insecure in their body or environment.

And where does this leave immigrant women? Whether documented or undocumented, many immigrant women have limited power and status, and they receive plenty of racial harassment and discrimination. On top of that, they may experience even more sexual harassment because they are marginalized and have less means to say anything about it. Undocumented women are especially defenseless against sexual harassment in public and private spaces when their harassers are aware of their precarious situation; these women have literally no recourse, because there is nowhere safe for them to ask for help.

WHAT WOMEN WANT TO SAY TO STREET HARASSERS

"DO YOU REALIZE THAT WE ARE WHOLE PEOPLE?"
—EGYPT, ATLANTA

Harassment in Today's Political Climate

In discussing the migrant experience in this country, it's impossible not to think of the broader political situation we find ourselves in today. Given that several of Sonia's identities—queer, Latinx, gender nonconforming, migrant—are under direct attack by the government, I imagine they have felt particularly unsafe in recent years.

I wonder how Sonia's personal identities affect how people experience and treat them.

As somebody who reads brown, who reads femme, who reads young—it is present in all places. I travel a lot for work and harassment has become very present at airports by TSA agents, or by Lyft/Uber drivers, or at hotels I am staying for art conferences. Just like when I'm walking down the street in New York City, there's this inclination to speak over me or push me over; there's an erasure of my presence by white bodies, just their entitlement while walking down the street.

If I'm in a very cis and straight space, the markers of my shaved head or tattoos or purple lipstick or just my presentation as a femme seem to provoke a further sense of entitlement, with people projecting their assumptions onto me, or trying to straighten me up, or harassing me or asking why I'm queer or why I am doing these things with my body.

And then as a migrant person, anywhere I go, especially in locations like Arizona or California or anywhere near the border, my identities are then hypersurveilled—the legalities of my body are up for question. My brown migrant body is left to be in turmoil and unsafe. I am constantly harassed and asked if I belong here and what am I doing here? There's the question of whether I'm American. My accent gives it away that I might not be American-born, which puts me in the position of people questioning my statehood and if I have papers. Just questioning my agency in being in certain spaces. I am constantly navigating that.

Our bodies are part of the definition of home.

Sonia addresses a lot of important intersections here: their queerness, their presentation, the questioning of their right to a space, invisibility and hypervisibility. And the way that, in these different spaces, different parts of them are under question and under threat. Sexism is one of these, but it is complicated by who they are in other ways. Being a queer femme is an identity with particular challenges when it comes to sexual harassment and harassment in general. It requires having to steer through sexist environments that could also become homophobic or transphobic if you are "outed" as queer.

WHAT WOMEN WANT TO SAY TO STREET HARASSERS

"I REFUSE TO FEEL ASHAMED."
—TAMARA, LOS ANGELES

Presenting in a way that deviates too greatly from a conservative, white, cis male aesthetic may make you vulnerable to harassment from this group for simply being who you are. The Center for the Study of Hate and Extremism issued a study in 2018 that showed anti-Black, anti-Semitic, anti-gay, and anti-Latinx hate crimes were the most common types of hate crimes, and the number has risen in the last four years.

As a result, people who are not white, cis, straight, and male feel increasingly vulnerable, and the fear is realistic. In 2017 a Muslim couple in Oregon was told to go back to their country just weeks after two men were killed for helping a girl being harassed for wearing a hijab. Nooses have been placed outside of schools and in Black museums. An Asian man was attacked in NYC and told to go back to his country. And there are many, many more such instances.

And, of course, women and femmes who are already enduring sexual harassment in the street and public space harbor the very real fear of even more violent harassment stemming from the political ground we currently occupy. Even if you don't fear for your own personal safety in the street, being a part of a marginalized group that is currently demonized or dehumanized in the media and politics will have an effect on your interactions with the public and how they experience you.

How has Sonia felt the effects of today's political climate?

Now more than ever, in the Trump era, I think about having a safety plan. As a femme, migrant person, formerly undocumented, and my queer/trans/gender nonconforming chosen family of color, we have to make sure to have exit plans in lots of places.

Yesterday, with another queer person of color, we were passing the Barclays Center and there was a hockey game. There were so many white

people coming from the suburbs, and it was very straight cis men smelling of alcohol. So navigating this, walking past, and them saying "America" or whatever they were trying to congregate on brotherhood around, the dynamic has become really heightened.

And I have to be careful on social media too. The markers of hashtags, or the markers that my photos may be presenting—those were there before, but now more than ever those have become really strong markers.

What does Sonia want to say to the public—the people who have harassed them, this city, this country, whomever—about who they are as a person and the ways they have been treated and the ways they no longer want to be treated?

Our bodies are part of the definition of home. Our bodies are the places that we feel safe. These are the rituals that we do—for me it's my eyebrows and

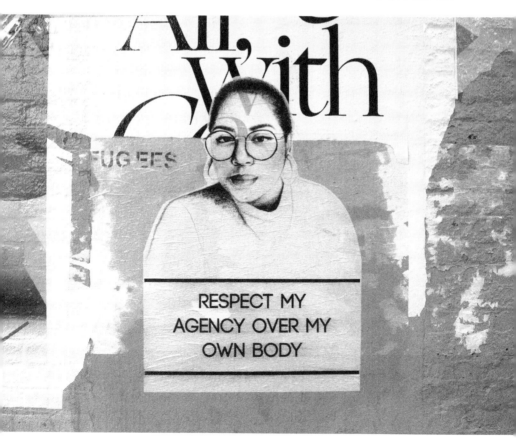

eyeliner, and jewelry. Or tattooing myself up. This is the way that I'm able to literally survive in this country, survive in this empire, survive in this world, as a body of color that is always under attack. And so how do we claim that back?

What does it mean when other folks dictate how my body should be perceived or how my body should be able to move around?

I want them to know that they have to respect my agency in how I move through this world. Because for a young brown migrant girl, it takes a lot of courage to just make it into the streets. Especially when your body is developing as a teenager or you don't know how to speak English yet. To navigate all of those spaces, it takes a lot of courage. So just respect that and leave us alone to exist in our own glory without questioning, or surveillance, or touching without consent.

We adorn or mark or dress our bodies in ways that help describe who we truly feel ourselves to be, and enormous freedom comes with that. Our bodies are our homes. Street harassment is a direct assault on that sacred space that is our bodies. Women and queer people, trans and gender-nonconforming people, people with disabilities, Black people and people of color have a particular history of having our bodies attacked, mocked, and regulated. When we have for so long had to shield our bodies from violent oppression, street harassment keeps the wound open.

It takes time for a young girl to understand herself and her growing body enough for it to feel like that safe space. What happens when that understanding of our developing body, sexuality, and self is hijacked by other people and all of society projecting onto us their notions of who and what we should be? When it's interrupted by society's sexism or a man's fantasies or a racist's fears? Sonia's demand rings powerful and true: they are simply asking for all of us to understand and respect their agency over their own body and the courage it took for them to get here.

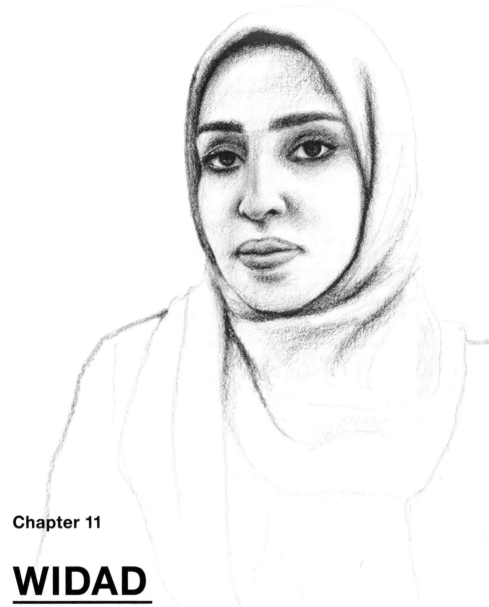

Chapter 11

WIDAD

More Than Race or Religion

Age: 30
Identifies as: Muslim, Yemeni, American, woman

To interview Widad, I meet her at her workplace. She's a community organizer focused on Muslim Arab community issues. When I ask her how she identifies, she tells me that she used to identify as a Muslim American woman, but as she's gotten older, she wants to be more precise with her heritage. Since the Muslim bans, and the targeting of Yemeni communities in particular, she has become more intentional about proudly identifying her specific ethnicity.

I start by asking Widad how she defines street harassment.

I would say street harassment is someone calling out to you as you're walking or someone making inappropriate motions or looking at you in a way that makes you feel uncomfortable. I'd say the worst kind of street harassment is the harassment that takes place on public transportation: it feels more humiliating because you're stuck in that position and there are witnesses.

I've spoken in earlier chapters about how street harassment is complicated by identity. As a Muslim woman who wears a hijab, Widad's identity certainly influences the kind and degree of harassment that she receives. Sure enough, this aspect of her identity comes up right away when I ask her about her earliest experiences of street harassment.

I'd say it started when I was in high school. Our uniform was very modest. It was like a long dress. I wore a hijab and I remember being surprised that people would call out and say things. It wasn't just Muslim and Arab men, it would also come from non-Arab and non-Muslim men.

I remember when I was younger, men who weren't Arab would call out to me using Arabic endearments, like, "Oh, Habibi," or things like that. And I don't know if it was intentional or not, but sometimes they'd also incorporate Arabic curse words into it.

I don't know if it was a fetish, but there was also this perception in my neighborhood at the time that a young Muslim woman is "pure," you would hear comments like that. I remember guys would be saying horrible things about women that they were dating, talking crap about them behind their backs, and then they'd say, "But, oh, a Muslim woman is untouched." They were pitting women against each other, making this dichotomy of "the good woman" and "the bad woman."

Race often plays out like that in the street: Men will recognize a woman's identity markers—Muslim, Arab—and use them to harass her.

The prevalent belief that Muslim women are pure compared to other women is another way that women are perceived as something other than regular human beings who have a full range of personality traits and emotions and behaviors. Instead, we are seen as either too sexual or not sexual at all. Either way, men view us primarily in relation to their own desire.

Widad reports that most of the sexual harassment she has experienced has come from non-Arab and non-Muslim men, and that she has not received much of it in sacred spaces. But some Muslim women do face sexual harassment within the religious community. #MosqueMeToo was a hashtag created by Mona Eltahawy, a wonderful writer and activist, for Muslim women to share their stories of harassment within religious spaces, particularly during hajj, the Islamic pilgrimage to Mecca. In Widad's case, it's comforting to hear that, at least in that one context, she has been left alone.

I wonder how being sexualized as a teenager affected Widad.

In high school I was never really into boys or dating or any of that stuff, but I felt like I was being viewed in a very sexualized way at a very young age and it made me very uncomfortable in my own body. Even though for the most part I dressed modestly, I remember still feeling like I had to put my hijab over my chest or I couldn't wear something more form fitting.

Or if I was walking on a street and there's a bunch of guys hanging on the corner, I'd feel like I couldn't walk there because I'd feel their laser vision on me. It almost made you want to shrink. My body was fuller than most other young teenage girls, and I used to kind of hate that about myself. I'd feel like I was taking up too much space. I'd even walk a little hunched over because I didn't want to be viewed as too womanly.

We've talked before about the lasting emotional impacts of being sexualized at a young age. One of those impacts is that we choose what clothes to wear and how to present based on how we are being treated, which is based on how our bodies look.

Like me and Deyanira, Widad had the instinct to hide. As kids, we think it's our fault that men are sexualizing our growing bodies. We think we need to hide ourselves to stop the harassment. Of course, it does not work, because

it is not our fault that men regard us in this way. They purposely and overtly look at young girls precisely because of their youth, regardless of our clothing.

Widad's experience illustrates that when premature sexualization gets crosshatched with racial stereotyping, these internal struggles over clothes and comportment become even heavier and more confusing.

And how does Widad compare the street harassment she receives here in the United States to that in Yemen?

I was an adult the first time I ever went to Yemen, it was 2012 and I'd recently finished college. In Yemen for the most part women are covered from head to toe and even there they were getting harassed and catcalled.

So this has nothing to with how women dress or carry themselves. This is all about men not knowing how to carry themselves or how to control themselves. It always made me uncomfortable. A lot of times it was older men.

Sadly, street harassment crosses cultural and national borders and pervades many societies around the world.

WHAT WOMEN WANT TO SAY TO STREET HARASSERS

"I DON'T EXIST FOR YOU."
—JETAIME, SAN FRANCISCO

Anti-Muslim Harassment

Widad tells me that, in addition to sexual harassment in public, after the 9/11 attacks she also started to get anti-Muslim harassment, and it has persisted, especially now in the Trump era. Widad's hijab signifies to harassers that she is Muslim, and therefore they see her as a target.

After 9/11, when she was a preteen, several of her friends' parents told them to not wear the hijab for that reason. They would leave the house without it on, but took it with them and put it on once outside, in defiance of their parents' concern.

Widad's personal experience is representative of the huge and enduring upswing in harassment and violence against Arab and Muslim people since 9/11. A report from the New York City Commission on Human Rights, with responses from 3,100 Muslim, Arab, South Asian, Jewish, and Sikh New Yorkers between July 2016 and late 2017, found that 19 percent of respondents who wear religious clothing, including the hijab, had been shoved while on a subway platform.

> **What women wear and how we present ourselves in public are policed.**

I want to emphasize again the importance and effectiveness of bystander intervention here. Because so many people are vulnerable to this type of harassment, having others step in and defend them is crucial. The political climate today makes Muslim women, Jewish women, and other religious minorities vulnerable to physical attacks. It's important for bystanders to be aware and alert and come to the aid of those in need.

If the climate is one of hostility toward these religious groups, we must challenge it by creating safer spaces for people wherever we go. We must step in when we see a hostile situation. If standing up to the harassers seems unsafe, we can create a distraction or ask the victim if they are okay. We have to fight back against a hateful society by protecting victims and shutting down harassers.

I ask Widad to tell me about the anti-Muslim harassment she receives.

When I was a teenager I hated it when someone would catcall me. Now, with all the Islamophobia and anti-Muslim rhetoric out there, there's been a shift in the way I'm harassed in the street. I've gone from being catcalled to being cursed out or called a terrorist or told to go home.

So, for most of my young adult life I was experiencing that kind of harassment, and then the times that someone would catcall me, I'd feel a sense of relief that I wasn't being attacked in an anti-Muslim way. "Yeah, that's annoying, but at least this person is not attacking me."

Because the anti-Muslim harassment was just very much more aggressive, much more threatening. Even the proximity felt different, when people would get close to you, you're looking right at someone who's looking at you with hatred, and there are even times it almost seems as if they're about to hit you or throw something at you.

I never know what's gonna happen when I'm out. It might be someone who's harassing me in an anti-Muslim way or it might be someone who's catcalling. In some weird way it makes me feel like I have to rank the harassment, and the anti-Muslim kind is the one that makes me feel more unsafe.

Which sucks because you shouldn't have to experience any kind of harassment. But every time you go out into the street as a visibly Muslim woman, you're just gearing yourself up for survival. So, whatever seems the safest thing for you at that moment, you'll take it.

It's wild to hear that sexual harassment comes as a relief when it replaces a more aggressive racist and xenophobic kind of persecution. We've seen how sexual harassment can be violent too, of course. But this other type that Widad describes is rooted in pure hate and ignorance, which is very frightening. The perception of Arab people as terrorists is based on a national misconception fueled by propaganda against the Middle East coercing public acceptance of the wars between the United States and various countries in that region.

> **That is what we all want: to be seen as who we are.**

As someone who is also of Middle Eastern descent—my father was Iranian (Persian)—I feel close to Widad's experience. I have never received any discrimination or harassment based purely on my appearance in this way because, as with my queerness, I do not read as Persian. But I have Persian friends and family who experience xenophobia.

Arab and Muslim women are facing violent anti-Muslim harassment. They are assumed to be terrorists. They are also seen as not American, when they are just as American as anyone. American is a nationality. It is not defined by race or religion.

In Widad's experience, how does her gender interact with anti-Muslim harassment?

It's always men harassing and attacking women. There's that gender dynamic. You never really see a Muslim man being attacked by another man. That's another way I see power being exerted in terms of harassment. They wouldn't have the audacity to harass someone who is at their same level,

but they'll go bother a woman or an old woman who can't defend herself because they know that they can overpower her.

It's really horrible. And I think it has a big effect on women. Even the women in my family, I feel like I'm much bolder than them because I'm more connected to so many different networks and communities. I have more of a supported network, so I don't feel so isolated when I'm verbally attacked.

But for women in my family who didn't have the opportunity to go to college or finish high school, or got married very young, their defense mechanism is to just stay home. Or if they go out, they have someone drive them. They're not going to take public transportation. They're not going to just stroll in the street. They're not going to walk by themselves, ever, because it's not safe for them. And it's heartbreaking that so many of these women feel unsafe in their own body and vulnerable to violence and hate because of how they look or what they believe.

Which is why we butted heads a lot, because they'd tell me I wasn't thinking about my safety when I'd go to protests or events at night. It does affect how some women choose to live their lives. Women who probably would have wanted to go to college but are just scared to leave their home. Or scared to be in an environment where they feel like no one is going to accept them, and they don't have a voice to defend themselves.

It's infuriating that the older women in Widad's life have felt the need to avoid public places out of fear of being violently harassed because they are Arab Muslim women. What are the ramifications of not being able to live your life fully for your own protection? Muslim women are being attacked out of hatred, and it has a huge impact on their ability to live complete lives. A 2016 statistic from the Pew Research Center shows that the most common form of hate crimes against Muslims is intimidation and threat of bodily harm.

Many of us live with the economic, mental, emotional, and physical effects of harassment, though in this case those effects are much more extreme. When we take a car home instead of walking in order to avoid harassment, it takes a financial toll. When we develop anxiety that keeps us from leaving the house because of fear of harassment, it takes a mental and emotional toll. Widad witnesses in her own family the ways harassment limits opportunities for women.

And it shows, again, the ways women in particular are targeted for many sorts of harassment in the streets.

WHAT WOMEN WANT TO SAY TO STREET HARASSERS

"MY RACE ISN'T ANY OF YOUR BUSINESS."
—JANAN, BALTIMORE

Exoticizing Arab Women

So far, we've heard from multiple women about being fetishized and exoticized. I ask Widad to tell me more about that component of her experience of the public space.

> Bringing in race or ethnic identity, there have been times when these weird stereotypes of what it means to be an Arab woman have come into play, like comments suggesting that we have a secret life, or that we are belly dancers. People would make you out to be something exotic, and assumed you liked hookah because you're Arab. I don't smoke at all and I hate the smell of smoke.
>
> I've heard comments about "Arab money," suggesting I had a certain lifestyle. And as an Arab girl from Brooklyn, all these stereotypes didn't fit in with who I was. I think people were seeing these things on TV or in the media and placing them onto me.
>
> People would call me "Princess Jasmine," from *Aladdin*. Or I got stereotypes about Arab women's bodies: "Oh, Arab women's bodies are curvier" or "I wonder what you're hiding under all that" and "Well, I'm sure you look amazing under all of that." It felt really weird because it just oversexualizes me as an Arab woman. I'd just be thinking, "Oh, I'm a regular person with a bad hair day under this. It's not like you're gonna see this Arab Goddess." [*laughs*] Things like that just made me feel really fetishized.

Like many other women of Middle Eastern, South Asian, and North African descent, Widad isn't flattered by these comments. Instead, she accurately feels othered by them. Being considered exotic is not a compliment. It assumes a deviation from whiteness and sexualizes her on the basis of her ethnic identity and appearance.

Widad and other Muslim women are visibly different from white and Christian women, the historically mainstream narrative of who qualifies as American. She is sexualized by non-Arab people as something different at the same time that she is being hated for being Muslim.

It boils down to her not being allowed her humanity.

I notice that Widad described that exoticization in the past tense, so I ask her if she still experiences that sort of harassment.

It doesn't happen so much now. When I was younger I spent more time just sitting out on our front steps or hanging out with my cousins in public spaces for much longer. Just hanging out, being idle, being young.

As an adult I don't have many of those spaces anymore. I'm in the office, then heading straight home. I'm just living a much more fast-paced life, so I don't occupy public space in that way anymore. That kind of extended harassment, where someone's fleshing out the details of what they're thinking about you, that doesn't happen to me as much now, I get more of the quicker interactions.

Widad makes a sharp observation about children in the public space. Children have a lot of opportunities to be outdoors, and therefore a lot of opportunities for men to approach and linger: going to and from school, playing at a playground, or just being outdoors because there aren't many other places for them to hang out. It adds another layer to how girls and teenagers are harassed.

Does Widad respond differently to harassment as an adult from how she responded as a child?

I have a much more aggressive side to me that I didn't have when I was younger. As a girl I was very, very soft spoken. I couldn't speak back if someone was making me feel uncomfortable. I remember when I was young there were times where I was even being followed, and as a person who always thinks of the worst case scenario, I'd be thinking, "Oh, I'm gonna get murdered on this block and no one will ever find me."

Now as an adult, if someone's trying to get into my space or making me uncomfortable, I feel that I have a voice to shout back at them and say stop, or even curse if I need to. When I was younger I would just stay quiet. As an adult now, I'm just like, "What the hell are you doing?"

I feel similarly to this and probably a lot of other women do, too. When I became an adult, and as I continue to get older, I feel more assertive in standing up for myself. There is the understanding of yourself as a full human being, more confident in your autonomy over your body. And after so many years, the sheer exhaustion and frustration from street harassment make women more vocal and assertive in speaking back.

Other Kinds of Othering

In addition to the street, where else does Widad experience sexism and these types of harassment?

> I experienced it much more once I started to intern and volunteer outside of the community that I knew. That was when I started to be in other spaces with non-Arab or non-Muslim folks who would just look at me and automatically assume, for one thing, that I don't speak English, and other things about my cultural background or my lifestyle.
>
> It happened a lot in college too. If I was the only hijabi in the class, other students would automatically assume they knew my political views. They'd assume I was anti-LGBTQ or anti-feminism, or that I'm a conservative, oppressed woman. So, for most of my college education I would always have to fight back against these stereotypes, which was exhausting.
>
> I remember situations where women would be talking about their experiences of harassment, and I never felt comfortable talking about my experience because I felt like the women in my classes would think, "Oh, you're a covered-up Muslim girl, no one's gonna harass you." As if men don't really consider me desirable in that sense. But I think harassment has nothing to do with desirability.
>
> So I'm being sexualized in one way by men, but in another way by the view that Muslim women are nonsexual. We're between these two extreme stark images of what it means to be a Muslim woman.

Widad's analysis points to society's belief that how a woman dresses determines her desirability, which in turn determines how or if she is harassed. It is as if people are saying that women get harassed because of the attention they bring to themselves, that they are asking for it. And that only women deemed beautiful and attractive get harassed.

What's happening here with Widad is a hypersexualized/desexualized dynamic. She can't be a regular person, a full human being, because various people in various environments project their ideas of her sexuality onto her.

In a culture that is so preoccupied with how women carry themselves and that, meanwhile, allows men sexual and other kinds of freedom, the circumstances are ripe for victim blaming. And Widad's experience puts the lie to that tendency to blame girls and women for being harassed.

It's no wonder that young girls think that if they hide themselves and cover their bodies, it will stop men from harassing them; they are given that

WHAT WOMEN WANT TO SAY TO STREET HARASSERS

"NOT YOUR EXOTIC, NOT YOUR EROTIC."
—PAYAL, CHICAGO

message over and over. But, in fact, Muslim women can be covered from head to toe and still be harassed. Again, street harassment and sexual harassment are about men asserting power over women and a claim to our bodies and ownership of the public space. There is no way that we can dress or cover ourselves that will stop it, and it is not our responsibility to stop it.

Victim blaming is all too common in our society. We treat people who are the victims of sexual violence as if it is their fault, as if they should have prevented what was done to them. So many times when there is a rape or sexual assault, the questions turn to what the victim could have done differently. Men and women alike participate in this victim blaming. We are used to letting men off the hook and not holding them accountable for their terrible actions. We want to believe that women entice men and bring on their own troubles.

Victim blaming is equally apparent in the context of street harassment. I have heard many times men say that if "women didn't dress like that, they wouldn't get the attention." In truth, women are not asking for attention from men, and we are definitely never asking to be abused and disrespected. We hold men to such low standards.

Feminist work is trying to raise those standards. It's saying, *you are better than that*. Men don't want to be seen as sex-hungry animals who cannot control themselves. However, that is often the way they treat women. And it

is women who are blamed for enticing that sex hunger—by simply walking down the street wearing a pair of shorts or walking down the street wearing a burka.

The fact that some women are completely covered in religious clothing and are still harassed should eliminate any and all notions that women are "asking" for male attention and harassment. It is a ridiculous argument that is employed solely to let men off the hook when they mistreat women.

Policing Our Bodies

In addition to blaming women for the sexual harassment and assault that happen to us, what women wear and how we present ourselves in public are policed. This happens in schools, where dress codes are implemented specifically to keep girls in modest clothing for the sole sake of not distracting boys. All that does is enforce the idea that boys and men cannot control themselves and that women and girls must carry the burden of neutralizing men's desires.

This sort of policing appears in media and politics when political figures who are women are criticized for looking too stern or for how they choose to dress. It crops up in the workplace when Black women are scrutinized for how we style our hair. As mentioned with Chanel, trans women's bodies and appearance are always being assessed for how feminine they look. From children to powerful and accomplished women, our appearance and our bodies are always under scrutiny.

And where does society draw the line? What could women possibly do or wear to stop men from treating us this way? The answer is: there is no line, and there is nothing we could do. The experiences of women in hijabs and burkas make crystal clear that clothing is not actually the issue. Women are harassed and judged no matter what we wear.

It would do us all good if we held men and boys accountable. If we held them to a standard of being smart, thoughtful humans, they would be more than capable of deciphering that a woman's outfit is representative of many things—functionality, religion, fashion, profession, preference—none of which has anything to do with pleasing or enticing men.

How we are treated should never be about what we wear. And yet, in so many places, women are told how we must present ourselves to be accepted or respected.

I ask Widad for her thoughts on the policing of women's appearance.

Seeing what's been going on globally, especially in France and other European countries where you have the state trying to enforce hijab bans or even banning hijab-friendly swimsuits. There was this really great cartoon of one woman covered from head to toe and another woman in a bikini. They were looking at each other and both saying something along the lines of, "Oh, this poor oppressed woman."

All these things are pitting women against each other. At the end of the day what's really happening is governments and men are telling women how they should dress. Whether it's in France, with a niqab ban, or in Afghanistan, with the Taliban forcing the burka on women. It's men telling women how they should carry themselves.

If you really believe in women's rights and women's agency, you should let them choose how they want to dress. I always had to fight against these stereotypes when I was younger, with people saying, "Well, you can't really be liberated because you're dressed that way," or " You poor oppressed girl, someone's forcing you to wear your hijab." I used to really hate that, even being in my women's studies and gender studies classes, people would insinuate things about women in hijabs and burkas.

But actually there's a lot of nuances around that because as a woman in America, you wear it because you want to. They're not even giving women a chance to speak for themselves and when they do speak for themselves, it's like "Well, no, you're brainwashed." You can't win that battle. In that sense you just have to live your life and stop engaging people who constantly are trying to tell you who you are or where you're at in your life.

Widad chooses to wear her hijab. It is a choice that she makes because she is a person who gets to decide how she looks and how she expresses her religion. No one should feel pressure not to wear hijab, whether it's for safety or because others think it's oppressive.

What would Widad want to say to men who harass her?

I saw one quote somewhere, it was something like, "Don't tell women to cover up, tell men to lower their gaze." That's also an Islamic concept, that men should lower their gaze because they're not supposed to be ogling women, or sexualizing them with their eyes.

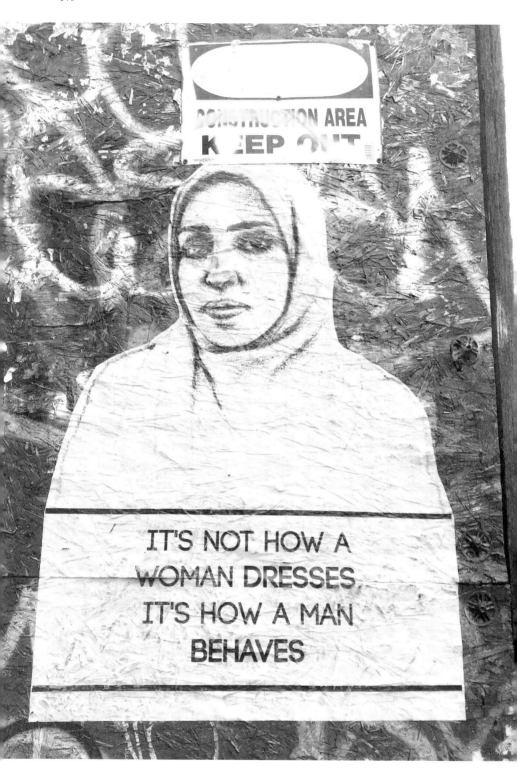

But at the end of the day the problem is not the way women dress, it's the way that men think and behave. I would say that even as a woman, a Muslim woman that covers up, I don't think women who wear shorts that leave them semi-nude deserve harassment. The problem is the way men look at women.

Last, I ask Widad what she wants to say to the public about who she is.

It's tough, there are so many ways that you're interacting with the public and so many types of oppression you're experiencing from the public, how do you put that into a message? But I think I've always felt most myself and most liberated in spaces where someone just looks at me as Widad, not as a Muslim Arab woman, not looking at me as my identity markers. The minute people look at me and only see those markers, every assumption they have comes into play.

And I feel like, you can't assume you know me just because you know another Muslim woman or another Arab woman. My experiences are unique, my thought process is very different from anyone else's, everyone is their own individual person. For most of my life I've always been lumped into a group, I've never been viewed as an individual.

So I would say, "Look at me as a person, as an individual. If you don't talk to me or get to know me, then you don't know me. Don't assume you know me because you read a book about Islam. That's not exactly how I think, that's not who I am. Who I am is a combination of so many experiences that go beyond those identity markers."

That is what we all want: to be seen as who we are. For Widad, the layers of oppression make it even less likely that she will be taken as an individual. We must all be vigilant in stripping away the racism, xenophobia, misogyny, and other forces that prevent us from seeing one another clearly and without prejudice. Identifying and naming those forces is the first step, and that work is finally beginning to happen.

Chapter 12

TATYANA AGAIN

What This Work Has Taught Me

Stop Telling Women to Smile was born out of anger, and here I am, seven years later, still angry—which, let's say it again, is the right response to sexist treatment.

But there is an essential difference to my anger now. Before, I was overflowing with hurt and frustration, but it had nowhere to go, and it was stressful and disempowering. I was being dehumanized daily, and I felt powerless to do anything besides shout at the harasser. During those several years when I was casting around for a way to make art about street harassment, I felt like a pot that was boiling faster and hotter all the time, but that would never boil over.

When I get harassed these days, of course it still frustrates me, but something else happens: I hear what the guy says and either respond or don't, then I think to myself, *Oh, there's a new piece for the project.* Not only is it satisfying to feel purposeful in my work, but also that sense of purpose in the moment is really helpful, mentally. It automatically inserts a protective layer of distance between me and the situation.

> Women are saying: We can't control what is in your mind, but we can protect ourselves by limiting your sexist, aggressive, and violent behavior.

I get to consider my internal reaction to it, and what I would want to say to them, and it turns into art for me. It gives me an outlet for the pain and anger I still feel in reaction to being treated like a thing. Now, my anger is purposeful, and focused, and clarifying. Now I know what to do with it, and I get to see its expression out on the street, and it makes me feel strong.

Just to be clear: I am still exhausted by the ways women are emotionally and physically battered by society. In fact, when I think about how I feel now versus how I felt when I first started making STWTS, I notice a new fatigue.

I'm so tired of walking down the street asking men not to sexualize me, to see that I'm a person, that I'm a subject, not an object. When it comes to racism, too, I'm tired of asking white people to see me as a human being. After a certain point, you just get tired of asking for that.

So, in the work, I don't want to say anything to the world about identity that feels like I'm asking people to accept my humanity. It's a somewhat new angle when I consider the intent of this art, what it's actually saying and doing.

And when I look at the work—all these women, and all the portraits of them looking very human and often displeased, and their words, which aren't questions but directives—I know that we are not asking. We are asserting our humanity and demanding to be treated accordingly. And that feels right.

Making Change Real

People ask me if doing the work for Stop Telling Women to Smile for so many years has changed me. In one way, that's hard to answer, because Stop Telling Women to Smile has shaped my entire experience of New York; I started it right when I moved here seven years ago. Sometimes I'm surprised at the fact that I'm still here, still doing this work, and the impact it's had—I wasn't expecting it.

But the answer is: Yes, I've definitely changed over the past seven years. That's why I wanted to write this book, to share what I've learned about people, about myself, about sexism and sexual harassment. I've come to understand sexual harassment as a very complex thing. Individuals are complicated, society is complicated, and the ways we move in the world and are received by it are not the result of any single aspect of who we are but of the intersections of our various identities.

Take me, for instance: I'm not just a woman, I'm a Black woman; I'm a mixed-race Black woman; I'm a light-skinned mixed-race Black woman who is from a specific part of the country and I mostly present feminine. These and so many different factors affect how people perceive me and how they treat me. That is why talking to all these other women fascinates me. I'm so curious about how they experience the world and how the world experiences them.

One way the project has changed me is it's made me a better person, more empathetic, more observant, more mindful. I have been listening to women talk about these issues and have been thinking about the pain and damage they cause for a long time now. And the longer I do it, the better I understand the reality and suffering of each individual woman.

It's also made me a stronger artist because I'm asking better questions than I used to, about society and about my art. I'm thinking more about how to make work that has an effect on people; about my audience, who they are, how to reach them. I'm also interrogating myself about my intent. If I decide

that my audience for a particular piece is the oppressive group instead of the oppressed, what are the reasons and intentions behind that decision?

Before Stop Telling Women to Smile, I mostly made oil paintings (I still paint a lot); the posters were a huge shift for me. The project wouldn't have succeeded in any medium other than posters and wheat paste. Thanks to those particular materials, it truly succeeds at what it's meant to do—it reaches the people I want to reach—and it can only do that by being out on the street.

Watching that unfold has made me think about all sorts of possibilities when considering new work: Where would it have the greatest impact? Where would it reach people? Would it be best outside, or online, or somewhere else?

I'm not sure if this is good or bad or some of both, but another thing Stop Telling Women to Smile has done is pull me away from my own story. The project started with me, but for years now I've been telling other people's stories. That's been invaluable to the series, and, like I said, the process has definitely helped me improve as an artist. But now, in new projects, it's time to go back to me again. There is power in telling your own story, in being expressive of who and how you are. I saw that with the beginning of this project, and now I am figuring out how to return to me as I move forward.

When I start from a personal place, the work feels more truthful. When you put truthful art out in the world, people can see it's coming from an honest and real place, and they relate to it more strongly.

Of course, I'll continue with Stop Telling Women to Smile, too. I imagine it will always be a part of my life.

I have been thinking that perhaps it's time to make a new self-portrait for Stop Telling Women to Smile; I haven't made another since the original one in 2012. It would be interesting to make a poster that better reflects me today (though I'll always hate being told to smile). For one thing, I look different now. I'm also a better artist.

As for the question I ask the women near the end of the interviews as inspiration for the poster's text: What would I want to say to men who sexually harass me on the street? I know that it is a large question that can have many answers.

For me, depending on the day, I can answer the question in different ways with varying degrees of anger or disgust or rage or exhaustion. My own

responses to street harassment depend largely on where I am, how I'm feeling, how much time I have, how safe I feel.

Many times, recently, I've stopped to have a conversation with a man who was talking to me on the street, especially if the unwanted attention went beyond slightly annoying and made me truly uncomfortable. Sometimes I'm able to stop these men and say, "What's happening right now isn't cool, and this is why."

But that doesn't always happen. Usually, I am in a rush and walk quickly past a comment about my ass. Or I am headed to a meeting in Lower Manhattan when a white man asks me "how much?" Or I am on my bike and someone whistles at me before pulling off in his car. In these moments, I am, still, baffled. They happen quickly, leaving me furious and without a response.

Recently, I walked by a man as I was talking on the phone. He said something about my appearance, a "compliment," and I didn't respond because I was on the phone and also because I didn't owe him that. Then he said, "You can say thank you," and that made me laugh. The sense of entitlement is still staggering and bewildering.

I created the art series, and now the book, as a way to have my response, which is: What I really want is to be left alone. To walk throughout the world without having to brace myself for humiliation or insults or comments on my body parts. But until that world is here, I've used this artwork as a way to push back and have my voice and other women's voices heard.

One woman I interviewed said she wanted to tell men: "I am not here for you." That has really stuck with me. It's so fundamental. It cuts right to the heart of it. At this moment in my life, I am focused on how men are not entitled to anything from me. I think about it as I walk down the street, on guard against possible harassers. I think about it as I interview, photograph, and draw my subjects. "I am not here for you" feels very definite.

I also like the phrase "I don't owe you anything," which conveys a similar message. I was in Paris a couple of years ago where posters in various languages around the city said "Leave her alone"; it was great. That very basic notion really resonates with me these days. It's direct and doesn't try to explain or justify our experience. And it expresses a sentiment that every woman has felt when harassed: *Leave us alone.*

You might remember that, in addition to "Stop telling women to smile," the two other earliest pieces I made for the series read, "Women are not seeking your validation" and "My name is not Baby." I see now that all three of

those first pieces focused on specific comments I'd received and my specific reactions to them, whereas my answers now are kind of wide-angle. And it's true that nowadays I'm thinking more about the bigger picture of sexual harassment, sexism, violence against women, and how I can address them.

The project also feels more communal to me than when I started out. All the women I have interviewed over the years, and all the women who have approached me in response to seeing my work out in the world—it makes me feel less alone with the hurt and rage. Even sometimes in the moment of being harassed, I know that my private internal reaction is shared by so many women all over the world, and it's comforting.

Visions for the Future

I often ask myself: What am I hoping to do by creating and putting up these posters in the street?

Right now, I am just worn out from asking men to change. That is not going to happen anytime soon, on a mass, societal scale. Women have tried, among other things, asking nicely and discussing it calmly for decades, even centuries. We have tried appealing to our shared humanity. We've articulated our circumstances, our feelings, our needs and wants.

And from many men the reaction has been the opposite of empathy: more abuse and anger. So, I know that's a fight I'll never win: changing men's hearts and minds. The long, long history of misogyny means we still have a very long road ahead in terms of shifting society.

With Stop Telling Women to Smile, I've never been interested in telling men not to have sexist thoughts. It's more straightforward than that: I'm telling them to stop treating women this way. It's saying, *No matter what sexist and racist thoughts are in your brain, keep them to yourself. You are not going to accost me on the street anymore.* If men do respond to my work with a change of heart, an awakening, that's great. But if they don't, that's fine too, as long as they know they can no longer act as if they're entitled to my body on the street.

What is in their hearts and minds is not really my problem, it's theirs. The point is that we do not accept this behavior anymore. And that is what this art is demanding, asserting: *This is who I am, and I will not take this treatment any longer.*

Its approach is similar to that of the #MeToo movement, which, instead of attempting to win men over to a feminist point of view, has made it so there are now consequences to sexual harassment at work. The fact that a bunch of extremely high-status men have been brought down makes other men think twice before harassing or assaulting a woman. Women are saying: *We can't control what is in your mind, but we can protect ourselves by limiting your sexist, aggressive, and violent behavior.*

Shaming is part of it; that's a pretty potent tool in the #MeToo movement. It is beginning to make sexual harassment and violence socially unacceptable in the workplace, and hopefully beyond. Now, suddenly, men are afraid of being caught and called out for their bad behavior.

Of course, it's the material consequences of #MeToo that are truly changing male behavior. The corporate world, government institutions, and organizations of all kinds are beginning to pay attention, which means that now men sometimes lose their jobs because they've harassed or assaulted women in that context. When men are worried about getting fired, that has a real impact on their behavior.

> **What I really want is to walk throughout the world without having to brace myself.**

But going back to the message I am trying to put out there: I am thinking about and approaching street harassment a little bit differently from how I did at the beginning. One of my more recent pieces reads: "Do the work to unlearn your sexism." It's the first one I've made that, instead of demanding men stop a specific behavior, widens its focus and addresses the whole range and scope of misogyny. Now that I really understand street harassment as part of the whole spectrum of misogynist mistreatment, I see the series as part of a larger socialization that needs to happen, wherein men need to start looking at sexism through a bigger lens.

For so long, women have borne the responsibility of trying to explain the situation to men and convincing them to change. And I don't want to do that anymore; that responsibility is not on me, and not on women as a whole. It is men's problem to fix.

I am telling men to do that work. I am still conveying the original message: Stop these behaviors. But it's bigger now, too: Take responsibility for yourself.

But until men do start to take responsibility for themselves, here's something I think about: What would I do if harassment turned into assault? Would I fight back? It's another one of the many ways I try to protect, prepare, defend myself.

At the beginning of the book I wrote that being sexually harassed as a child made me feel detached from my body. Though I no longer feel so self-conscious of and removed from my own physicality, I do still carry a feeling inside that I don't have control over it, that a man could touch me at any moment. That men on the street have access to my body, and they might just grab me.

I hate feeling like that. All women do. And I've certainly imagined what I'd do if someone grabbed me or attacked me on the street.

I like to think that I would fight back, kick and scream, and try to get away, but I sometimes worry that I wouldn't. Especially the screaming part, because I'm naturally a quiet person. I hope I wouldn't become panicked in that moment and would instead scream as wildly as necessary. In fact, I did

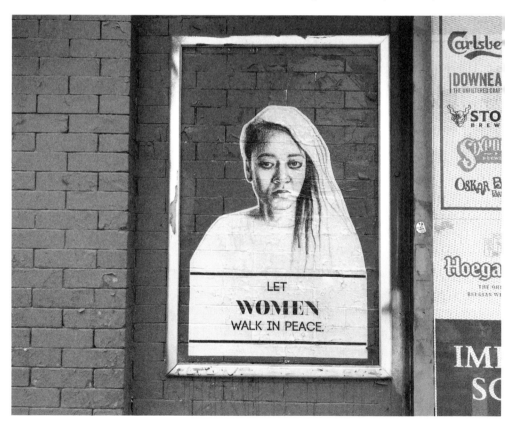

yell and scream when I was assaulted in the past (when that guy slapped my behind).

But what if the assault was worse, and I was in danger of physical harm? My friend who is a personal trainer has gone through some defensive moves with me, which makes me feel more capable of protecting myself. I tell myself over and over again: This is what I'd do if I were attacked. And it does help me feel more prepared, like I'd know what to do if it did happen.

Of course, we should not have to take self-defense classes just because men don't learn to control their violent impulses. That is still the world we live in, though. Until it changes, I want to feel strong and capable of defending myself.

I'm often asked what self-care I practice, given the weight of creating this series. This is a good question, and not only because of the work. Just being a woman, and especially a Black woman, who walks around in public—I feel like all of us need to tend to the emotional wounds from sexual and racial harassment. That said, I don't have a set self-care regimen. My healing mostly looks like me trying to parent myself.

But here are some of the things I do: I have been to therapy. I spend time with friends. Nature is important to me, and I visit the beach or the mountains as often as I can. I do yoga. I spend time being quiet and thinking. I write in my journal. I like to cuddle up and receive affection.

I watch YouTube videos of James Baldwin and Toni Morrison. I talk to my best friend on the phone. I go for walks. I smoke weed. I consume other people's art—movies, museums, music, poetry and other literature. And memes. Memes are great. Oh, and I try to exercise sometimes.

I surround myself with Blackness: movies, songs, conversations, online spaces, in-person spaces that celebrate and amplify Blackness with a kind of love that makes me feel at home and shielded.

And, it might sound strange, but I embrace the sadness and the darkness. For me, part of healing is to accept and truly allow myself to feel the pain or anger or simple sadness. I don't try to get happy as quickly as possible. I allow myself to feel whatever I feel for however long I want to. It's related to how I think anger is important and how I try to capture those "negative" feelings in my work. I don't deny them.

I don't deny them because they are a part of the full range of being human. That is something that is not afforded to us as women in our current

society. It is why men tell me to smile. They believe my emotional responsibility as a woman is to be happy, to be pleasant, to be approachable and to smile.

In fact, those things are not my responsibility. My responsibility is to be the fullest expression of myself. And that includes feeling rage and sadness. Stop Telling Women to Smile is more than a demand from women to leave us alone. It is an assertion, a declaration of women as full human beings, with full emotions and many different facial expressions, who don't owe it to anyone to change that about ourselves.

I find beauty not only in my smiling face and bright emotional states but also in my resting face, my stern face, and my difficult emotional states. But more than that, I find beauty in being left alone to be who I am.

That is what I want when I'm walking down the street. I want either to be treated with respect and kindness or not to be approached at all. I don't want to be expected to perform niceness on command by anyone, let alone by a man who has been taught by society that I owe him something—that I owe him my beauty, my smile, my conversation.

I want to be who I am. This project has taught me that, and brought me closer to accepting and loving who I am. Men do not have to accept or love who I am. But they will respect it.

PART TWO

THE ART AND ITS IMPACT

NOT
AN EXOTIC FANTASY

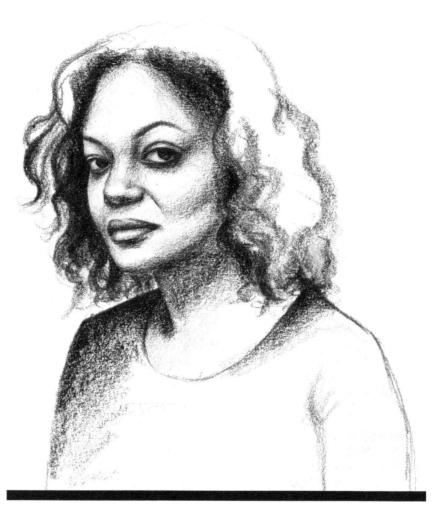

YOU WANT TO SEXUALIZE ME
WHILE I JUST WANT TO
LIVE ME LIFE

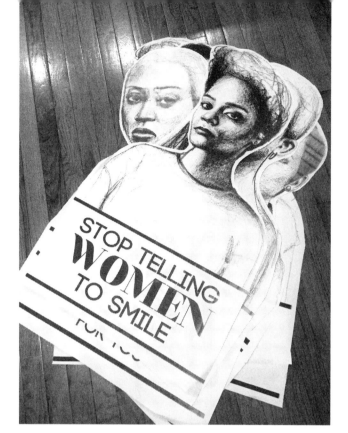

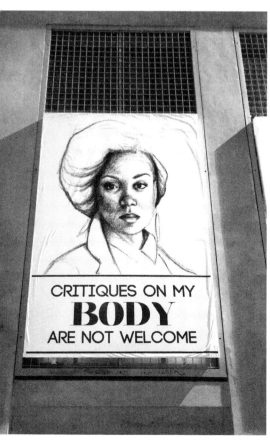

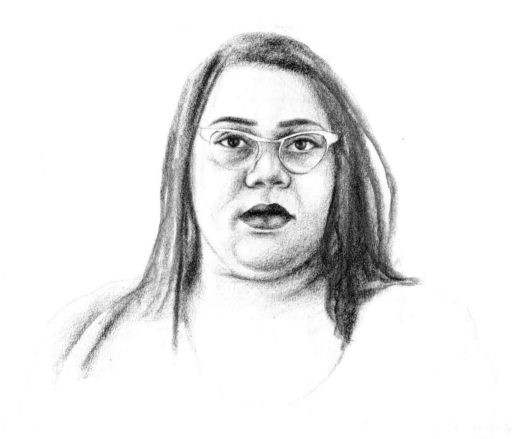

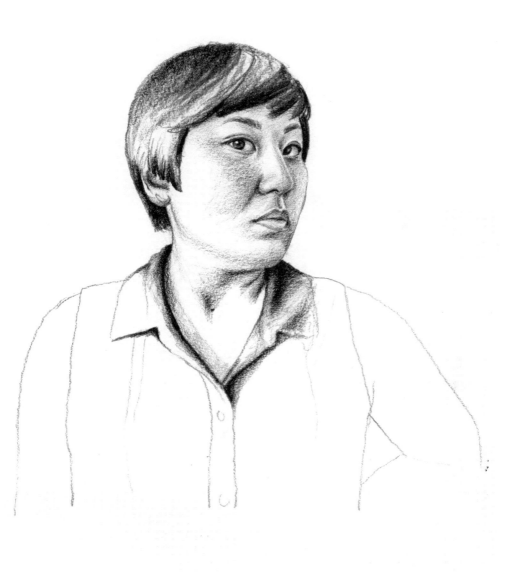

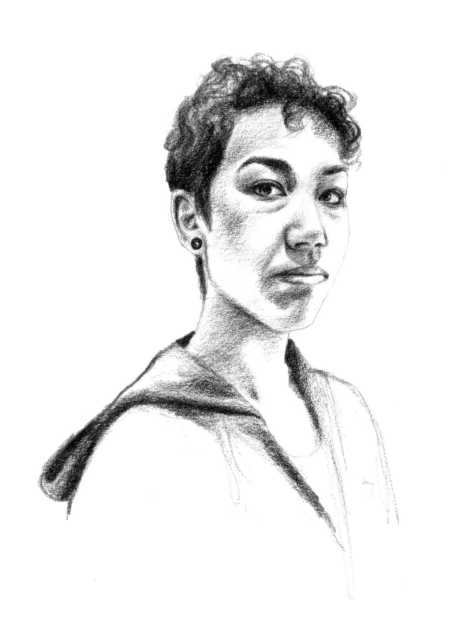

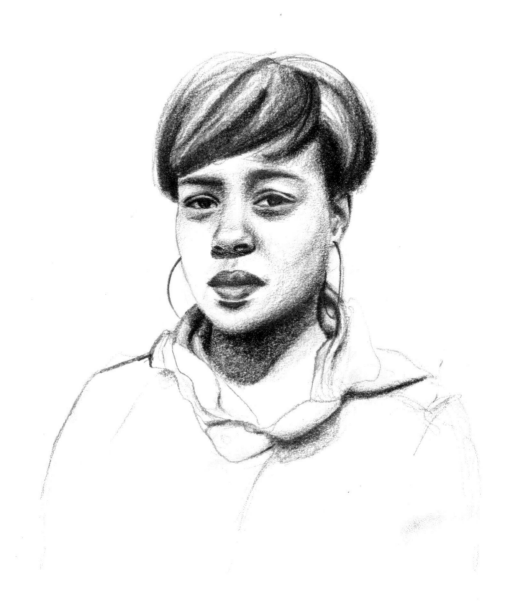

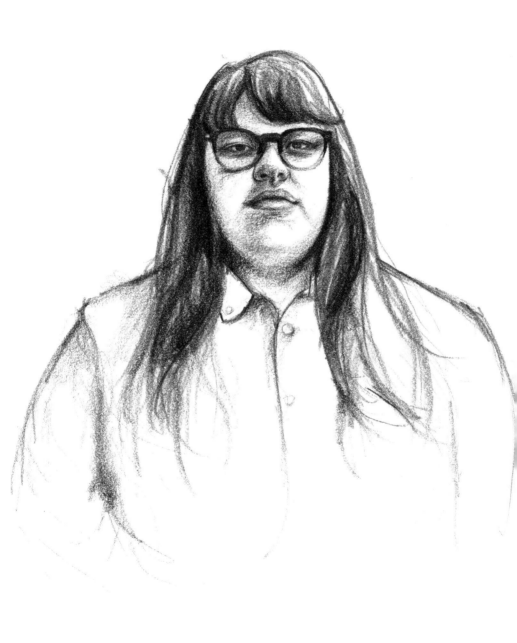

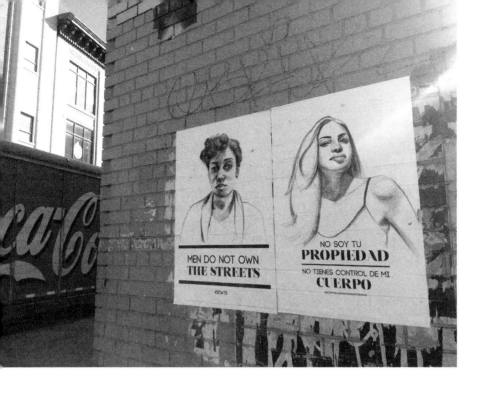

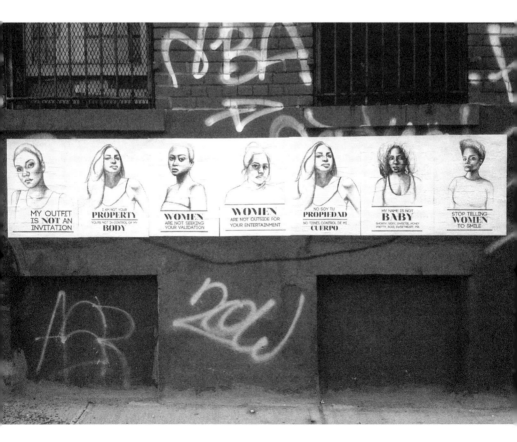

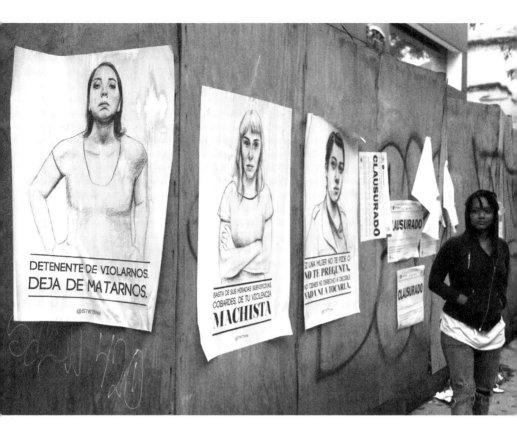

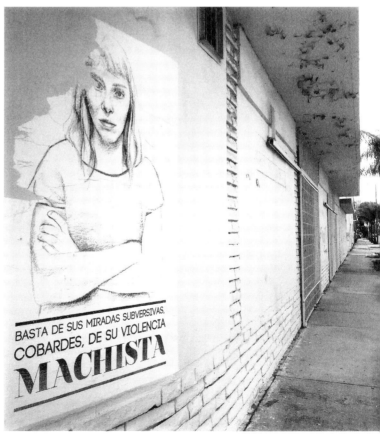

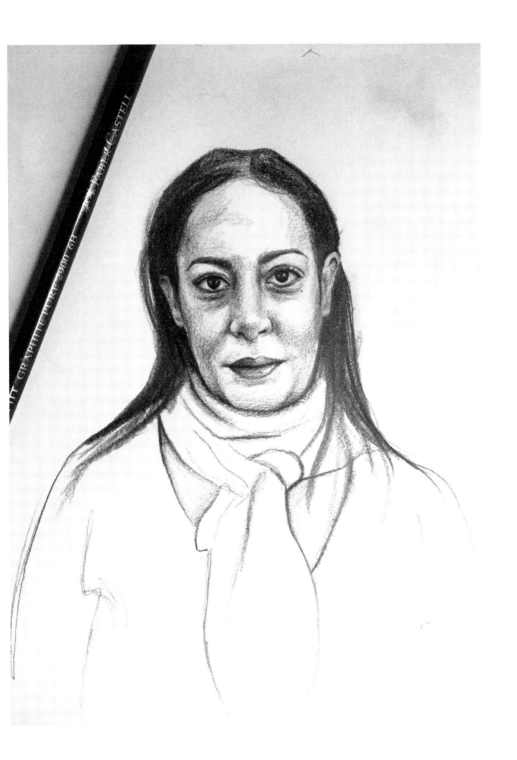

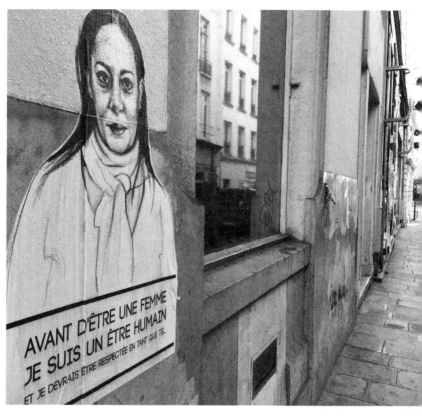

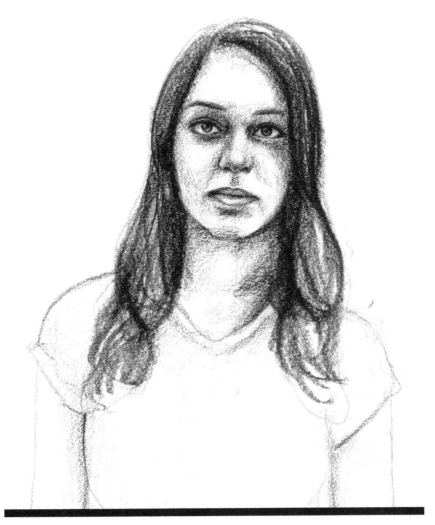

NOT HERE TO BE
PRETTY
FOR YOU

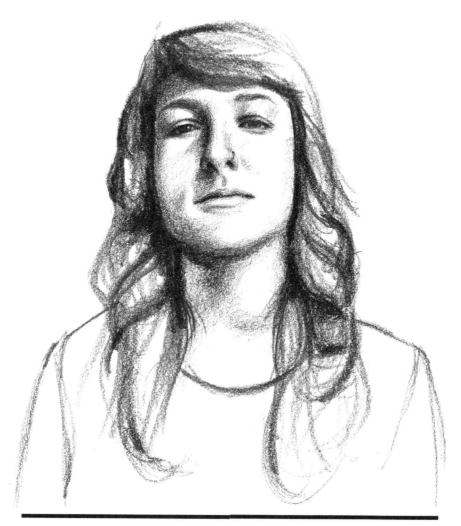

RESPECT THAT GAY WOMEN
DO NOT
WANT YOU

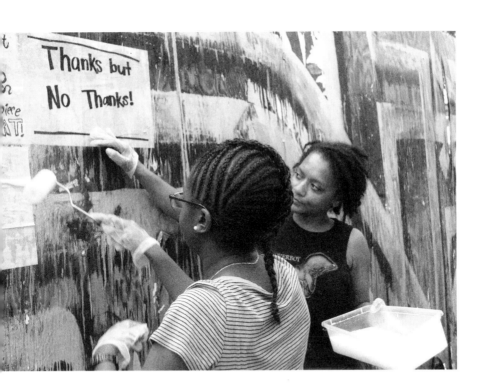

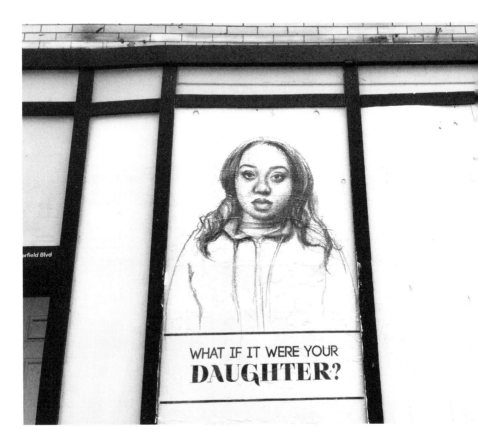

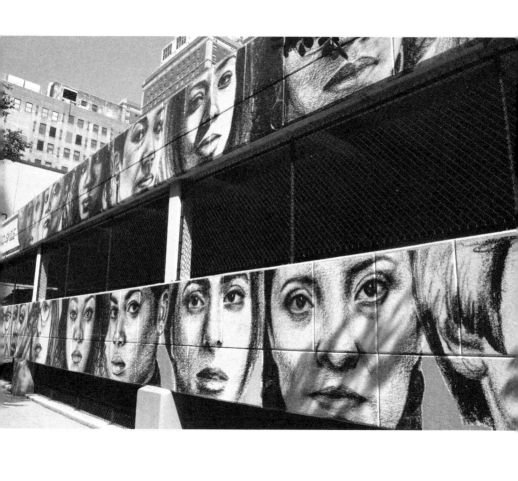

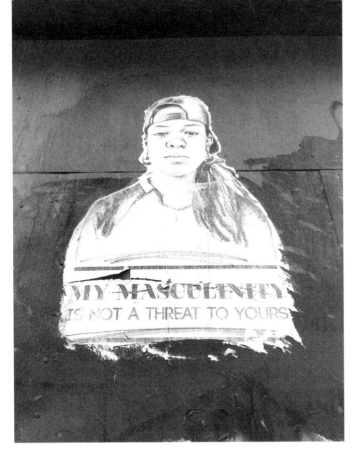

MY MASCULINITY
IS NOT A THREAT TO YOURS

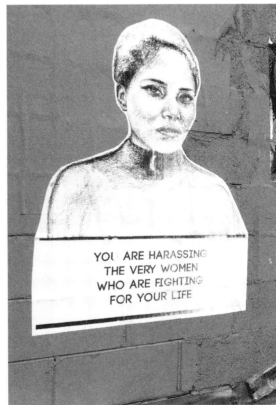

YOU ARE HARASSING
THE VERY WOMEN
WHO ARE FIGHTING
FOR YOUR LIFE

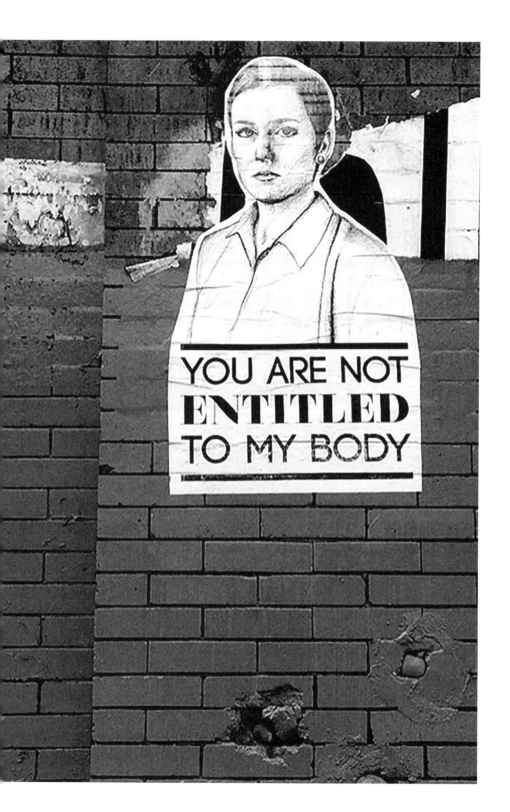

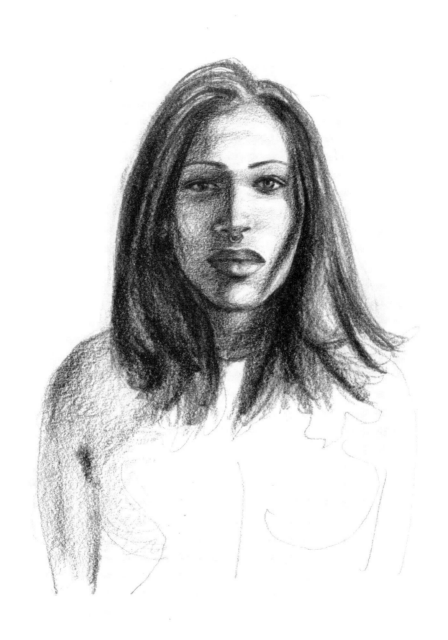

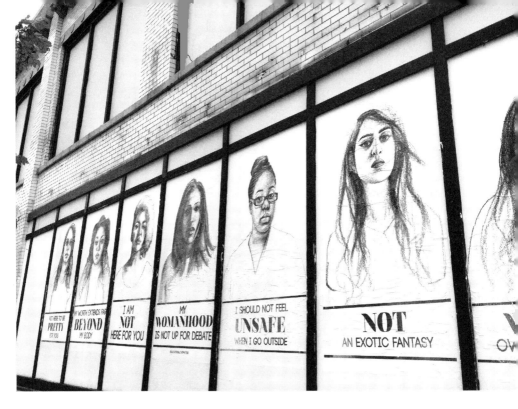

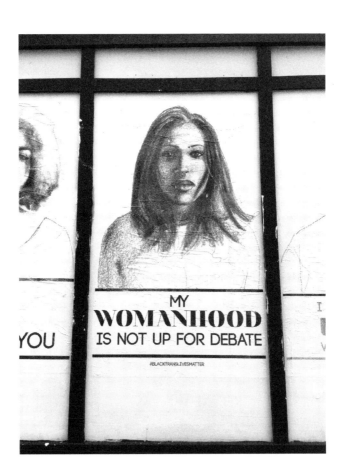

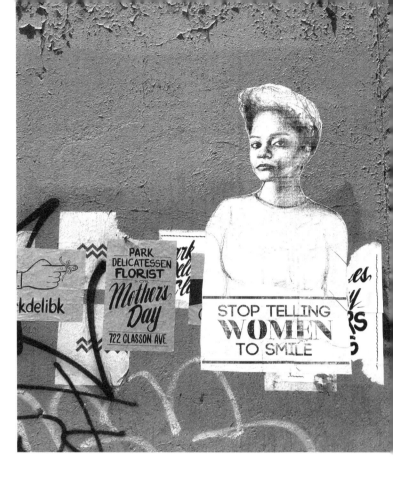

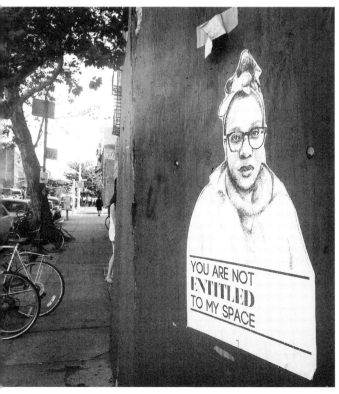

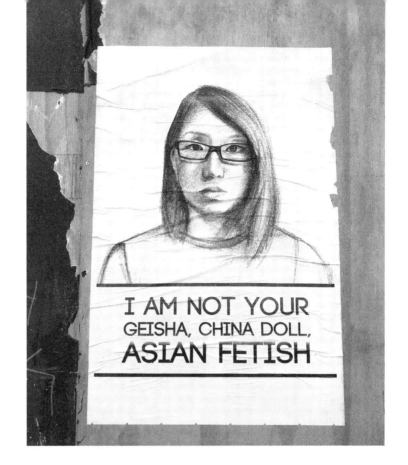

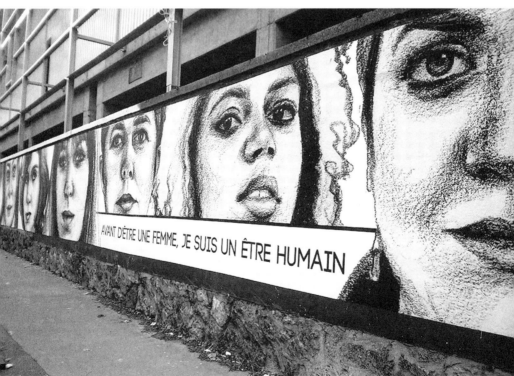

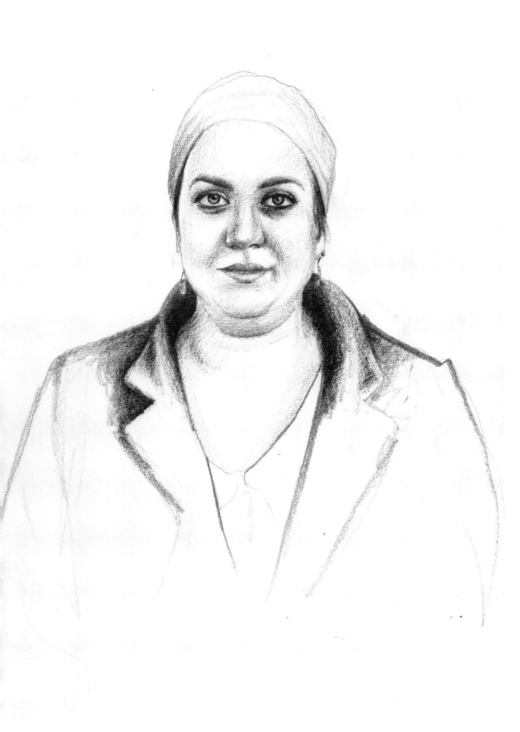

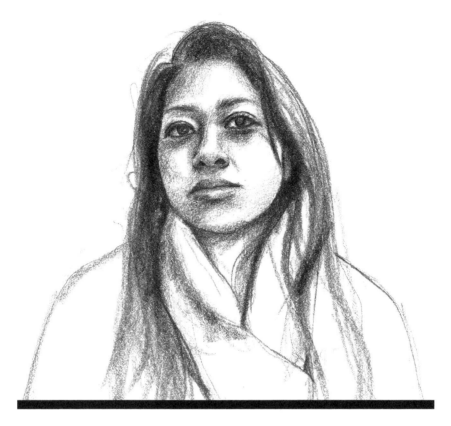

NO ME LLAMO

MAMACITA

CHIQUITA, PRECIOSA, CHT CHT

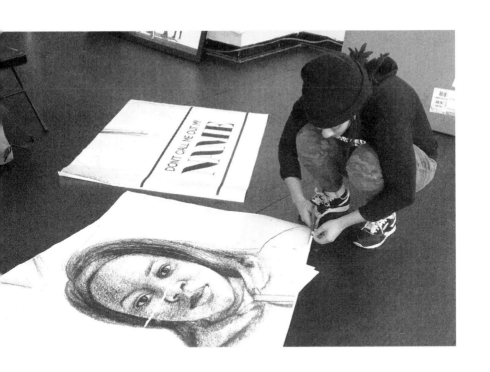

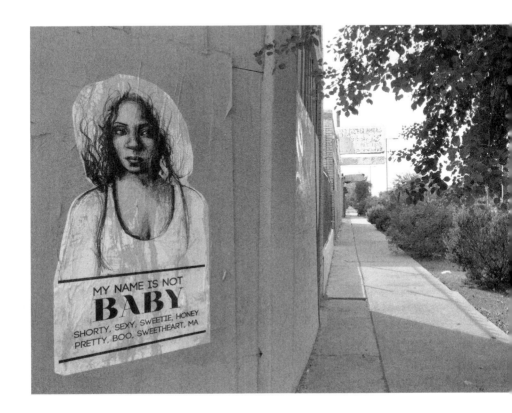

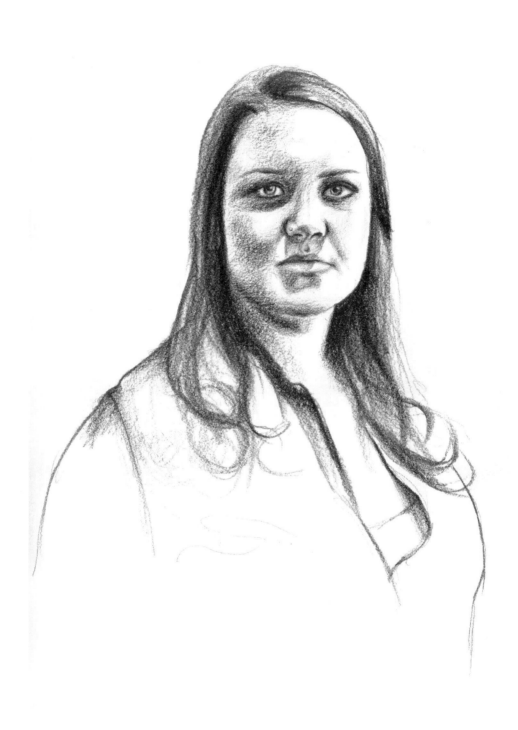

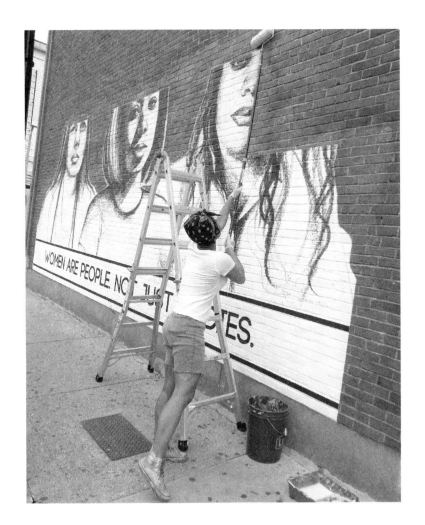

Chapter 13

ART AS ACTIVISM

Why I Do the Work

Over the years, I have heard from many women about how the project has affected them and their lives. Sometimes it's in person, often it's via the internet. Sometimes they tell me their own story. I cherish these responses because with a project like Stop Telling Women to Smile, it can be difficult to measure the impact.

And I am definitely trying to have an impact. I see Stop Telling Women to Smile as combining three types of art: social practice art, activist art, and public art.

Social practice art attempts to have a real-world effect. I am not pushing for legal change or policy change but for cultural and social progress. For some artwork, the point is self-expression or aesthetic beauty, and the work itself is the goal and purpose. When you're making social practice art, the purpose is to engage with the audience, whether as a community or as individuals.

Then there is activist art, which is created specifically to tackle social and political issues, as a means of activism.

And public art is exactly what it sounds like—art in any medium that is created or placed in a specific location, usually outdoors, with the intention of being a part of the public space. Public art can be political or not.

I'm sure it's obvious how Stop Telling Women to Smile is a public art series. As a social art practice, the process of involving individuals and communities is crucial. And the goal, in addition to making good art, is to tackle the social issue of street harassment through the act of placing the pieces in the street, which makes it activist art. It is ultimately attempting to change something, to provide something to the world.

These types of art put as much emphasis on process as on product. Sometimes, the process is actually more important than the finished object. And plenty of social practice art does not even involve a final, tangible piece. It does not always end in a painting or drawing or sculpture. In those instances, the process is the work.

That's true of Stop Telling Women to Smile. Although there is a final piece—the posters—the process of getting there is just as important, if not more so. That is because the work is about real people and their lived experiences, and to make the final object, the process must include these people. And it does.

The Importance of the Process

The conversations that I have with women are the most important aspect of Stop Telling Women to Smile. Even though I don't even start to draw the women when I'm talking with them, the creation of the artwork begins when I sit down with someone and have a candid conversation about their life. My hope is that the conversations provide some sense of relief to them, allowing them a safe space to talk about experiences that have greatly affected them.

I know that it provides something for me. Having a space to talk with women about shared experiences makes me feel just as much in solidarity as it does for them. (Or, at least, I hope it does that for them.) It cultivates a community around a shared experience.

Though the work ends with a drawing, the point is not just to draw any woman. If it were, I could imagine a woman and draw from my imagination. Instead, I choose to draw real, everyday women, because I want passersby to see a real person, and a genuine story. These are women and nonbinary people from all walks of life, ages, backgrounds, colors, gender presentations—regular people who are tired of being treated badly. Who want to tell their story.

Just listening to them tells them that they matter and their experiences matter. And so, the act of bearing witness and documenting their stories is when the art-making begins.

The archiving is also essential to the project. When we tell our stories and record them, whether through art or other media, we have a reference to look back on and say, *This is what happened. This is how we were treated and how we took our power back.*

Even just providing the space for the conversation to happen at all feels important to me. Before I started this work, the only time or place I'd talk about street harassment was when I would vent to my best friend on the phone (she lives in Oklahoma). And that was it. Before STWTS, I had never really had a chance to sit with a group of women and speak candidly about this huge, dark, hurtful part of my life and to hear others describe their similar experiences and feelings.

In that communal space, we feel heard, understood, and empowered. In that space, we are able to learn about and from each other and see that our different experiences stem from the same larger issue. That is how the work engages a community of people. For me, as the artist, creating that space for

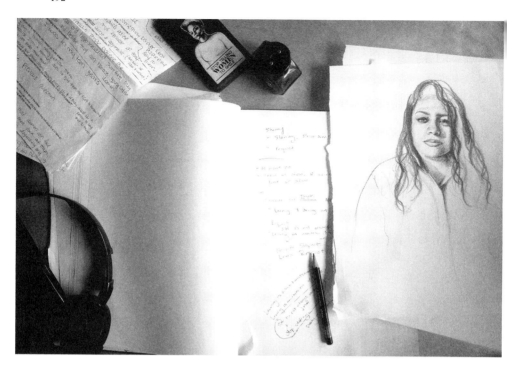

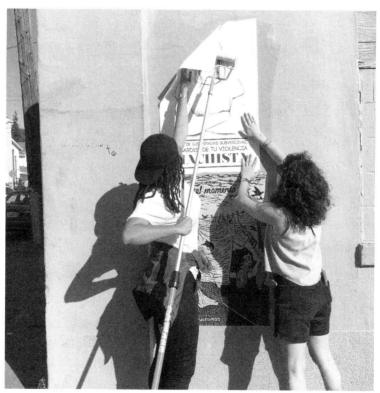

other women and for myself, where we feel safe and comforted, is a huge and crucial part of this project.

It might seem slightly strange, then, that the conversations usually go unseen. That is part of my goal with this book: by including the interviews, I want to portray my subjects in more depth and particularity, to deepen and specify the conversation. When so much of the process is the work rather than the product, how do I and other social artists actually see the effect it is having on a community?

The Big Picture

Art has long played a pivotal role in activist movements. Art can function to evoke emotion, to tell stories and amplify voices, to reach masses of people with beauty and truth, and to inform people of social injustices. It's a means of reaching the public in ways that may not be available to activists and organizers. And in doing so, it makes activist work visible and helps to grow and strengthen movements. Art serves as a rallying cry and tells the truths of our times.

Look at Migration Series by Jacob Lawrence, one of our greatest visual artists, which depicted the great migration of Black people from the South to the North during the Jim Crow era. Or the Guerrilla Girls, a group of protest artists who have been telling the truth about and challenging discrimination against women and people of color in the art world since the eighties.

When I think of the Black power movement, I envision the artwork of Emory Douglas, who created the imagery for the Black Panther Party. And of course there is the music of the civil rights movement—Mahalia Jackson's soul-stirring voice; Nina Simone's intensely powerful "Mississippi Goddam."

After the 2016 presidential election, artists like me felt the fierce need to use our art as protest, resistance, and weaponry. We have used our particular skills to create work that tells the stories of the vulnerable and of those whom the current political landscape is pushing ever farther out into the margins. Artists' groups, institutions, activists, and organizers immediately began creating art that would reach eyes and emotions. In the current political moment, I want my work to give women back power and ownership of public spaces.

And I'm dazzled to see that very thing happening. Stop Telling Women to Smile not only provides people with the opportunity and means to speak

and amplify their truths about street harassment but also gives weight to the issue. As mentioned, in response to the series I often hear some version of "Men complimenting you on the street is not a big deal." Many, many women I've interviewed and met over the years get this same response when they express anger about their mistreatment by unknown men in public.

And more than one of those women has told me that when men make that argument now, they have the perfect retort: someone has made an entire art project about this problem, over many years, involving hundreds of women. Upon hearing that, it becomes much harder for doubters to sweep the issue under the rug. Lone women are no longer pleading their case in isolation to an indifferent world. STWTS is hard evidence of the huge impact street harassment has on women. It provides proof that these micro- and macro-aggressions matter.

There's another way I can see with my own eyes how the art is making a difference: There has been a small but definite change in the street harassment culture in New York City, especially in certain neighborhoods. I'm experiencing less of it myself, and multiple women have told me how STWTS has changed their experience of New York. I'm hearing about more men who are aware that it's an issue that needs to be addressed, both in their own lives and in the wider culture.

Other factors are at play in the visibility of Stop Telling Women to Smile: all the social movements that have grown over the last several years—Black Lives Matter, #MeToo, trans rights activism, immigrant movements—have brought attention to groups of people and social injustices that had previously been ignored. I started my project alone, and for years I cultivated and grew it one interview and one poster at a time.

Now, and for the last few years, I have become part of a huge group of people fighting together for common goals. I have relationships with feminist activists as individuals and in networks. I've had the privilege of collaborating with the organizations like Girls for Gender Equity, the YWCA, the organizers of #MeToo, Time's Up, the Women's March, the Movement For Black Lives, and other similar groups, who now know and share my work, and I theirs. There is so much more conversation and collaboration among these kinds of groups than when I started the project. It's grown into a big community of like-minded activists, artists, and other kinds of media makers focusing on related issues.

And an accompanying development has had an equally big impact on the profile of STWTS and many other political art projects: all those flourishing social justice movements have truly changed the art world. For a long time, the art establishment didn't see political art as real art, or as good art. It was rarely deemed museum quality.

Now, there is great demand for art that addresses social justice issues. Not only does STWTS get even greater visibility because of that, but I like to think the project played a part in changing what the art world deems worthy. One of the reasons the project succeeds, both on the street and in the art world, is that the work is aesthetically pleasing. It's good art.

It comprises these lovely drawings of women, and it's clear a lot of effort and talent and thought and skill have gone into them and into the poster design, as well. When I first started the project, before the art world had fully embraced political art, particularly political street art, it was very important to me to prove that it could be beautiful in addition to sending a political message.

It still sometimes fills me with awe and surprise when I consider how quickly these social justice movements gained mainstream prominence, and

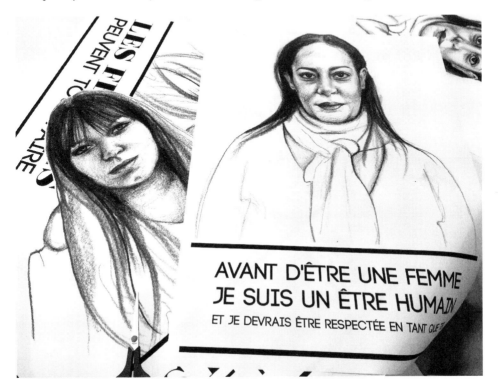

how that has dovetailed with the change in the art world and art market, and how my art is positioned in that convergence. I feel so lucky that my work is a part of this very specific moment in time. Years from now, when we look back at this period, it will be about all of these political movements and what women (among other people) were doing in response to injustice. As visual artists, we have such an incredible opportunity to make arresting work that says something important about the world and does something to make it a better place.

Putting Art in the Streets

STWTS functions as activism in that it takes a rigorous action to stop sexual violence against women in the streets. When I display the posters in the street, I invite other women to participate with me. It moves beyond the bounds of a drawing or poster and provides women with an action to take against street harassment. We are able to go into the streets, wheat-paste a poster on a wall, and know that it will make a difference in how passing women feel in the street. The actual activity of wheat-pasting is invigorating, as is knowing that you are standing up to your street harassers in a clever, safer way.

This was most apparent to me in 2014 when I took the project to Mexico City to interview, draw, and make posters of women there. I do not speak Spanish, so there was something of a language barrier. Even so, the eagerness to actually go out into the streets and do something about harassment was palpable.

The women ranged in age from early twenties to mid-fifties. One woman, Andrea, spoke about how she had been experiencing harassment for most of her life—and was still getting it at age fifty-four. I made a poster of her that read *"Yo Merezco ser Respetada"* (I Deserve to Be Respected), and then she went out with us to put it up in the streets.

There is the act of telling your story, your rage, your heartache, your exhaustion, out loud to a room full of people who understand. And then there is the extended act of using your words and an image of your face as part of a public action to stop the very behavior that enrages and exhausts you and breaks your heart. I hope and believe that for these women, participating in STWTS—speaking about being harassed, being listened to, and taking concerted action to combat it—makes their experience less lonely and frightening.

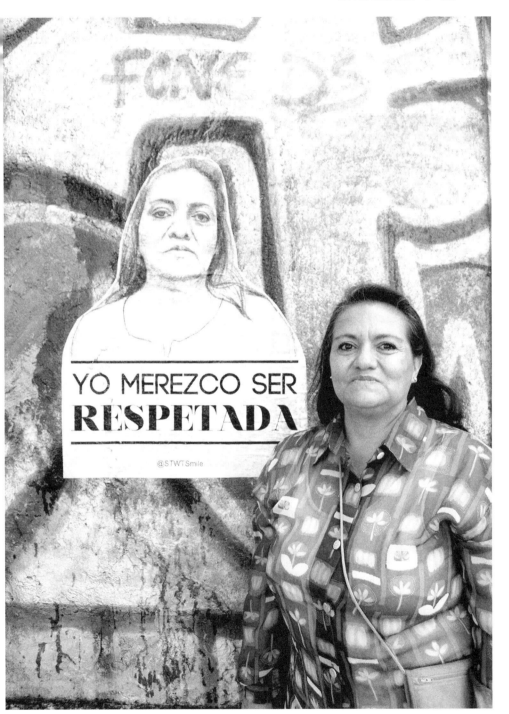

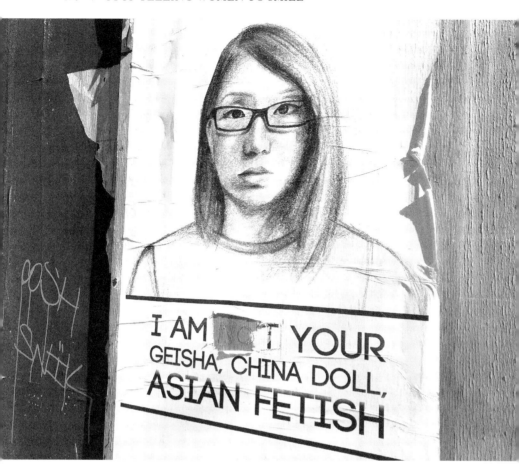

I know that for me, as the artist, I am very lucky that I get to feel useful in my work. Leading the action, and using my art as the tool, is incredibly satisfying and empowering and has become something of a survival mechanism for me as I walk around in public bracing myself against harassment.

International Wheat Pasting Night

In an effort to make the series even more international, I have set up an annual event called International Wheat Pasting Night. It's part of the efforts around Anti-Street Harassment Week, which includes all sorts of events and actions around the world organized by the nonprofit Stop Street Harassment.

During International Wheat Pasting Night, people all around the world are invited to download STWTS posters, go out in groups, and wheat-paste

them in their neighborhoods. It's my way of opening up the series as an international community–based project. I want people to have access to the work and to use it for their own activism efforts.

Countries from all over the world participate. I have seen images from Trinidad and Tobago, France, Spain, England, Canada, Mexico, Switzerland, Australia, Brazil. The posters are being placed in cities that I've never traveled to. It feels incredible to be in solidarity with people across the world and to see my art travel in ways that I never expected.

I love imagining communities all around the planet waking up the next day to find posters plastered everywhere. People have put the posters on their college campuses and in their community centers and community group spaces. Teachers have used the pieces in their classrooms, and people carry the posters during marches and protests.

To make it easier for people to wheat-paste pieces on their own, several days before each International Wheat Pasting Night, I send out files for people to download and print posters. I encourage folks to map out the sites they want to paste, go out in groups, and have fun.

It's a thrill and a joy—for me, and I hope for other participants—to know that as we're putting up posters, people across the country and around the world are doing it too. It's another step in creating a community around this project, making it a collective effort to fight street harassment.

And just like when I get personal responses to the series from other women, when I encounter one of the posters that someone else has put up on the street, it energizes me and inspires me to keep doing it. Recently, I was walking in Brooklyn, after having not received any street harassment in what seemed like a long time. Maybe it was just a few days, but even that can feel like a break when you are used to being harassed almost every day.

Of course, the break from harassment was short-lived. A man I passed said something to me that I didn't quite make out, but I could tell it was about my body. I kept walking. And a little farther down the block I saw one of my posters, the one that reads "You Can Keep Your Thoughts On My Body To Yourself." It was surprising—I hadn't known the poster was there because I didn't put it there myself.

And I thought, "Oh! This must be how women feel when they come across this work!" It was so on point to what had just happened to me, and so heartening to encounter it in that very moment. For that poster to be there, alone on that wall, meant that there was someone else nearby who had gone

through a similar experience of harassment. It felt like they were still there, in a sort of omnipresent solidarity with me and every other woman who walked by.

Responses to the Work

When I bring Stop Telling Women to Smile to a new city, I stay for a few days, meeting with women, shooting their photos, drawing their portraits, creating the posters, and putting them up in the street. And then I leave.

I don't always get to see how the work is resonating with the community. I don't always get to see or hear people's reactions. The act of creating it and putting it up is the art and activism. How the series permeates the environment, permeates a specific city and the national conversation—that is not a tangible thing that can be held and quantified.

So, when someone comes to me in the street and says, "This is how your project has affected my life in a very real way," that is a fundamental, crucial way I get to measure the impact and see how my work is operating in people's lives. Over the years, I have received many messages from women showing gratitude for STWTS, asking to be involved, and offering their own personal stories about street harassment.

In these messages, it's evident how the personal becomes political—how a project that started out as me telling my own experience of street harassment quickly reached thousands of other women who had had the same experience and offered them a way to share their own story. These messages show how so many of us live quietly with these daily violences against us.

I make this series because I really do want women, femmes, and non-binary people to be treated better, and I believe that is possible. The steady stream of welcoming responses is not a perfect measurement of the impact, but it absolutely encourages me to continue doing it.

Because in truth, it is difficult. Hearing so many stories about sexual harassment and abuse is a lot to take on. It can be emotionally and mentally taxing. I often have days when I spend hours and hours listening to stories of street harassment, discussing my own stories, and making art about it, only to walk outside and get harassed on the street.

Nonetheless, I'm grateful for this work, and I do it with purpose. The notes I get from women also show that we want to speak, and to listen to one

another speak, and to feel encouraged and galvanized by coming together with other people who endure similar things. Many messages that I have received over the years demonstrate this desire for rallying around a common experience, and I share some of them with you, in the interest of always expanding the communal nature of this project:

> I just want to say thank you for coming up with this idea and risking your safety and freedom to do it. I always felt uncomfortable when men would catcall me, but I never completely understood why. I just knew it felt wrong and all I wanted to do was go yell in that guy's face to "never speak to me again! your attention is unwanted!" but I never had the courage to say that much.
>
> —Jackie

> I want to thank you for giving this issue a voice. This is a source of endless frustration for me, I find it extremely offensive and intrusive though I struggle to convey this to most of my friends and colleagues who deem it relatively socially acceptable behavior. Taking a look at your website was a lovely reaffirmation of my own beliefs and I can only hope that we start to see similar posters on this side of the world sometime soon.
>
> —Bianca

> As a Brooklyn girl who is harassed and yelled at all the time, who has been told to smile, I really appreciate this. Even if harassers aren't hearing the message, it still shows solidarity among those who are affected by street harassment.
>
> —Anonymous woman

> As a feminist I applaud your work, but as a woman I thank you. Thank you for sharing women as they are, for sharing women as they feel. I think it's important that women don't need to be strong, or weak, or anything. They are themselves, and they feel how they feel, and your project has captured the human nature of this beauty.
>
> —Caitlin

> When I was in my early twenties and working in NYC I used to get nervous leaving my office for lunch because it meant that I usually had to walk by a construction site where a bunch of men would be sitting around on their lunch break. Walking through the limited sidewalk space, I felt exposed, angry, and, most disturbing to me, afraid . . . at twelve in the afternoon in Midtown. I still rage about it today and fantasize about all the things I wanted to say (and sometimes did). Thank you for doing this important work. It's powerful, it's meaningful and it's inspiring.
>
> —Jennifer

For me, both personally and as an artist, it is important to know that my work is doing what I intended it to do—having an effect on people's everyday lives. I created STWTS to be a defense for women. When I am reminded that the project is in fact helping women feel less alone and more empowered to stand up to street harassment, I feel a sense of responsibility, and I am also fueled to keep going.

Art Under Attack: Defacing

Sometimes, though, the project receives a different type of response. Because the message of STWTS is so uncomfortable for a lot of men, I've gotten pushback. And because it's a public artwork, many responses have been written directly onto the work. This was, at first, alarming to see. But it happens so often that I expect it now, and it has become a common part of the life of the work. The comments written on the posters usually display one of two reactions.

There are the negative remarks. People, I assume men and boys, frequently deface the pieces by scratching out the text and writing crude words and insults. In a way, these reactions highlight and help empower the messaging of the posters.

Often, then, another type of response is written. People cross out the negative comments and rewrite the original text, or write new words that reinforce the intent of the poster. Sometimes, long, multiperson conversations will unfold, with one person responding, then another, and another, and so on.

The first time I saw this layering of responses was in Brooklyn. Two pieces sat next to each other on the corner of Halsey and Tompkins for a few months. By the end of those few months, they were covered with numerous handwritings. It showed me that this work can and will spark a dialogue among neighbors, which is one of the goals.

More important than seeing the work in an online or international platform, I want it to have a local impact. I want the men in a city, in a neighborhood, or on a residential block to see the posters and interrupt their harassing behaviors. I want the women in those same places to feel safer and advocated for. The writing on the work is a visual measure of that. It shows me on a street level, an in-person level, how community members are seeing and reacting to it.

At times, the defacement of the work goes further and depicts graphic violence against women. On some pieces put up in Edmonton, Canada, a few years ago, someone drew a man decapitating a woman. There have been many crude drawings on the work, particularly gendered slurs.

I don't want my work to add inadvertently to media that depicts violence against women. I don't want women to walk by this work and see such hurtful comments or drawings written on the pieces. I still feel some responsibility to

the aesthetic of the neighborhood that my work is placed in, and what women see and feel as they see these pieces.

But what I've also come to see is that women take ownership of this work, as well, and protect it. When the work is written on or defaced, women respond. They defend it. When the text on the pieces is crossed out or cut out, it is soon written back in by someone in the community.

Changing Culture

I've spoken a lot about how the project aims to provide women with a voice and with solidarity. But, of course, I'm also trying to bring about drastic change in a culture that we have all been socialized not only to accept but also to believe is the only way. We have been taught that sexist and disrespectful behavior from men and boys is just the way they are. Crude language is just locker room talk, and mistreatment of girls and women is just boys being boys. We expect so little of men. And we expect women to just accept and deal with how men treat us.

What I'm doing with this work is capturing the moment of street harassment from a woman's perspective. This art for me has been less about the study of how and why street harassment happens (although this book does that), and more about the emotional and physical reaction to it.

I've tried to capture that rage you feel when a man says something so crude to you on the street that it's almost unbelievable. Or the fear that fills you when someone begins to follow you. The laughable absurdity of some of the comments. And the stern faces of women who just won't take it anymore. Because capturing those moments and then putting them out into the world is an act of public acknowledgment that leads to holding men accountable for their actions.

Changing culture means providing a consequence for bad behavior, not changing people's hearts or minds. STWTS does this by calling out the bad behavior in a public form. Like social media, the medium of public art pulls the behavior into the light for other people to see and recognize.

Harassers, too, see the posters and are forced to recognize their own behavior. They are confronted with the words they have said to women or the things they have done to women in the street. Here is a piece of work that is saying to them that their behavior is unwanted and unacceptable.

Gradually, more women feel compelled to call out the harassment, telling their own stories publicly, and more men will have to face the consequences of how they treat women.

For harassment that happens in the workplace, the consequence is very tangible: men can lose their jobs. For harassment that happens in social settings, the consequence may be public shaming and the loss of relationships and friendships. For harassment in the street, the consequence could be that the target snaps back at harassers or a bystander intervenes, both of which also entail public shaming.

Art's unique position in social change is that it has the ability to stop people and hold their attention. Some art creates empathy, something I've tried to do in my work. It has the power to ignite actions and engage communities of people. This particular art project makes a difference in the world because it calls attention to the daily oppressions of women. It calls out men for how they treat women, and it gives women a place to have their voices heard. This art is also important in that it works as a defense for women in the moment of street harassment. There are many times when we do not speak back to our harassers in the streets out of fear of physical harm. Having a poster on the wall that says the words we want to say but often cannot is significant.

The art also takes action, and provides others with the chance to do the same. The role of action is important in any political art. It must involve an action.

When I lead workshops at colleges on art and activism, I emphasize the power of using individual talent to address societal issues as a way to make change. The goal is to get the students to take who they are as individuals, their talents, passions, interests, and skills, and apply those to the things they care about in the world, the things they are angry about, the things they want to see change. That is how you can make your unique contribution to the world: by being very clear on who you are and what you do.

Street harassment and the fight against it had been happening before I created Stop Telling Women to Smile. But my unique addition to that movement involved street art and the perspective of a Black feminist woman. Those elements were not part of the anti–street harassment movement before, and they have proved to be essential to it. The project has provided the movement with a powerful, important lens and has broadcast the message to the world.

It has greatly affected not just the conversation around street harassment but also how women are actually experiencing the street now.

And it all began because I took what I was good at, visual art, and applied it to my real-world experiences based on my identity as a Black woman. For anyone who is looking to create something in the world that makes a difference, I would tell them to do the same: Take what you are good at and enjoy doing, and combine it with who you are and what matters to you. Come up with a great idea (don't get discouraged—remember that it took me several years!), and then find a way to execute it.

That is the second point I emphasize to students: Execution is key. You can have a great idea, but unless you actually do it, it will remain only an idea and will not have any real consequence.

Using the resources and relationships that are at your disposal is the first step. What materials do you have right now, and who do you have right now who can help you? Start there, using what you have to begin the project.

Here is what I would say to women and anyone who is part of one or more marginalized communities: Tell your story. Disrupt the mainstream narrative that places cis, white, hetero, and male points of view at the center. Demand that your story be heard and recognized and believed. When you do that, you open up a new space for other people to tell their stories too, to demand better treatment, to change the conversation, and to change the world.

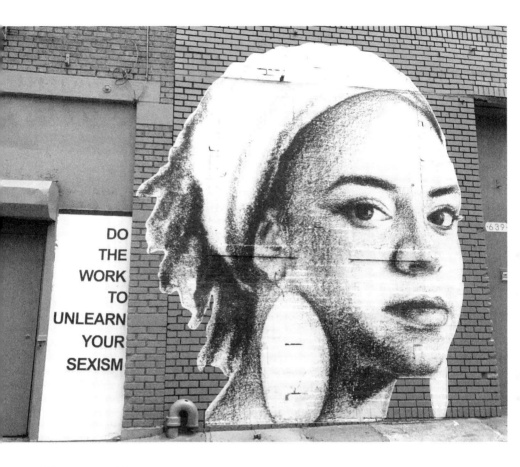

Chapter 14

A MESSAGE TO MEN

I talked earlier in the book about how I don't want the responsibility of worrying about what is in cis-het men's hearts and minds and that Stop Telling Women to Smile is about telling you to stop your mistreatment of women, not saving your souls. But in 2017, for the first time I made a piece that addressed men about what you carry inside; it's called "Do the Work to Unlearn Your Sexism."

I know that saying "do the work" seems abstract, and though I do not want to bear the weight of changing men, and I do not have all of the answers, having studied and learned about street harassment and sexism for years now, I do have some good ideas for you. (My cis and trans women and nonbinary readers might find this chapter helps them talk to men about all of this—but only if they want to.)

To begin with: Choose to see women as subjects, not objects. Recognize your sexism, then work every day to undo it. That means paying attention to lots of things: the language you use to talk about women, the jokes you tell, the way you address women, the weight you give to a man's opinion versus a woman's, the expectations you place on women, your sense of entitlement to a woman's body.

Imagine if you listened to women and believed them, consistently. It would change the way you understand and empathize with what women and girls go through, what we have always gone through. It would give you pause before you commented on a woman's body, before you assume you have her consent to touch her. It would make you reconsider before feeling entitled to her conversation or time.

Frustratingly, and sadly, men do not often listen to or believe women. When women come out publicly with their stories of sexual assault or harassment, they are belittled, called liars, threatened. We've seen this time and again in the mainstream news and media.

We saw it when Dr. Christine Blasey Ford bravely told a Senate judiciary committee her story of sexual assault at the hands of Supreme Court nominee Brett Kavanaugh. We saw it when Anita Hill blazed a trail when she testified about receiving sexual harassment from Justice Clarence Thomas when she worked for him. We saw it happen when dozens and dozens of women accused Bill Cosby of rape, and still many people did not believe them. And we see it every day when we simply try to speak up for ourselves.

I have seen it even with this work. Men have told me that I'm making a big deal out of nothing, that I'm wrong to describe these behaviors as street harassment.

I understand it's hard to integrate new information when your behavior is part of how you've been taught to be a man. I get it that men resist these conversations because, if what women are saying is actually true, it means that you yourselves have likely hurt people. That you are, and have been, *that* guy. Many men—probably most men—have deeply held beliefs about their own character and behavior: "I'm a good man. Only immature men yell at women."

Hearing that even "good" men are sexist and abusive requires you to investigate your own lives. It's not easy to confront how you may be complicit, and even more difficult to accept all of these things that go against what you've been taught about manhood and women since childhood. It's not easy to confront when you're empowered and emboldened by a patriarchal society every day.

Speaking with Men

Over the course of this project, I've come into contact with many people who have questions, comments, and anecdotes to share. As expected, the positive feedback comes mostly from women, gender-nonconforming individuals, and queer folks. Also expectedly, the negative responses come from cis-het men.

I also see men responding in another way that I wouldn't necessarily consider negative but that demonstrates the overarching problem: you have a difficult time listening to the experiences of women when those experiences might implicate your own behavior. More often than not, men get defensive.

In some of my conversations with men, where I try to explain the seriousness of street harassment and the general mistreatment and perception of women's bodies, you are taken aback by the stories I tell you. You have sometimes tried to pin the behavior onto "immature" or "crazy" men. Men who, for whatever reason, are not like you. And perhaps there is a marked difference between some men and others.

But in these conversations, it is not your job to tell me that this behavior could only come from a particular type of man. That is not the point. The point is not that all men are perpetrators, though I do believe that all of you hold some sexism and that all of you hold responsibility for sexism (more on this later, you can be sure).

The point is that most, if not all, women have experienced some form of sexism or sexual harassment. The purpose of relaying stories of harassment is not to heap accusations onto men—it is to call attention to the treatment that

women endure all the time. As men, your job is to listen, understand, and then go check your male peers and/or yourself. You do not get to disassociate yourself from the problem because you are "one of the good guys."

I believe that men hold the responsibility for sexism in the same way that I believe white people hold the responsibility for racism. Sexism is an oppression that was built to put you in positions of power. It is structured so that women and other marginalized people suffer. As a member of the group that benefits from it, it's your problem. Even if you think that you don't perpetrate it, you do.

The fact that you may not be the jerk who yells at women or the creep who whistles at them does not excuse you from responsibility for the problem of sexism and violence against women. Every single one of you bears that responsibility. The responsibility to listen to women, trust their realities, find your role, and help shift society to a place where it is not acceptable for men to be violent toward women.

I talk about men taking the steps every day to recognize your sexism and to undo it. To begin that, though, you must recognize that, even as "good" men, you are in a privileged group that is and has historically been violent to women. And that that violence does not look only like physical violence but also shows up as systemic, verbal, and emotional violence. What are seen as harmless banter, sexist talk, and violence against women are correlated. A real thread runs through every sexist comment, sexist interaction, and act of physical violence.

Some men I've spoken with don't get actively defensive but instead position their opinions over women's actual lived experiences. Even the well-intentioned among you often respond in a way that centers your own interests and perpetuates male dominance. Many of you ask, "Well, how should I approach a woman I find attractive in the street?" You need to understand how this response glosses over women's experiences and jumps to a conversation that benefits you.

When this happens, I know you don't truly understand what I'm talking about. You don't know what it feels like to have someone hiss at you like you're a dog or grope you on the train. Male privilege affords you the freedom not to understand these experiences. The reality of moving through public space is drastically different for men and for women. Even Black and brown men, who well understand being targeted on the streets and in other public spaces, are not subject to sexual harassment, assault, and violence the way that women are.

I do want to point out that my conversations with men have been going better in the last two years, probably thanks to the national conversations and movements around sexual harassment, including my own work. More men are a little more aware, more willing, and more able to listen and empathize, taking it more seriously, calling yourselves feminists, and so on. Sure, sometimes that can seem kind of easy and even self-congratulatory. But I'll take it; it's better than it used to be.

Frustratingly, however, most of those same guys still seem to have an ingrained sense that they are removed from the issue, that it's not really their problem. I wish you would see that the situation belongs to all of us and that you are implicated in it.

For those of you who want to understand street harassment and sexism better, here are some thoughts.

What to Do

Don't harass women. Leave them alone. Hesitate to approach strange women on the street. Be aware of your surroundings and a woman's surroundings and how she may be feeling vulnerable.

Sometimes when I find myself walking a few steps behind a woman, I pause to give us distance. Or I make some noise to announce myself and then speed past her. I do this because, as a woman, I understand the nervousness when you sense someone behind you on the street, and I don't want to make that woman feel unsafe. Men should be thinking about and doing these same sorts of things out in public.

Be hyperaware of your thoughts and actions in regard to gender and sexuality. Be vigilant in learning about sexism, listening to women, and interrogating your own lives, behavior, and history with women.

I also believe that men should sit with the idea that you are very likely sexist, even if you are thoughtful and progressive. Cis-hetero men exist in a patriarchal society that gives them the power in terms of gender. It's similar to how white people in this white supremacist society should be cognizant of and diligent about dismantling racism every day.

But how exactly can you men do this? I don't have all of the answers, but I also understand that simply expecting you to undo everything you've been taught is a large ask.

Maybe you have never catcalled a woman on the street. But you have likely witnessed it and not intervened. Maybe you have excused the behavior by saying, "Men are just like that," perpetuating the idea that manhood is defined by sexual aggression. But you are still complicit in the problem.

Listen

Instead of excusing yourself, listen to women when they tell you about the times they were insulted by a man as punishment for not accepting his advances. Ask yourself if you've ever used the same language to or about a woman. Ask yourself if you've witnessed that behavior and not done anything about it. This work requires vigilance when you're looking outward at society and also when you're looking inward at your own beliefs and behaviors.

Instead of trying to speak with authority about an oppression you have not experienced, first, listen to women when they talk about what they go through, and then believe them. I believe that by listening to women and believing their stories, a lot of you men will be able to comb through your own lives and experiences and realize that this is behavior you have seen before, and maybe you've even committed it yourselves.

One of the positives of the recent national wave of brave women outing high-profile abusers and harassers is that it has forced men to listen, and that alone has caused many of you to look at and question your own actions. Christopher, a thirty-seven-year-old Black man I spoke with in Philadelphia, says that he's recently revisited situations in his life when women might have been uncomfortable.

> I've gone back and thought, "Have I ever put someone in an uncomfortable position?" You go back and examine it. I don't think I've sexually harassed anyone, but it definitely made me question certain situations in my life where I wondered if the other person was uncomfortable. I think I did ask one woman about that, and she said no. But I wanted to be sure.

I wondered about how someone like Chris experiences the street, and what or if there are any social norms for him. He says that on the street, he tries to look people in the eyes to acknowledge them, to have some human

connection. He says that other men tend to look back and make some nod of acknowledgment, whereas women usually avoid making eye contact.

> Slightly less women make eye contact in general. There's another layer to that—with men, if they don't make eye contact, it's seen as a weak move. With women, I'm sure it has to do with the misconception that eye contact is an invitation for an interaction. They try to avoid that altogether, which shouldn't have to be the case. But sadly some men do think that a smile or eye contact is an invitation.

Stop Your Behavior

Once you've truly listened, and absorbed, and empathized, men's work is to stop your old ways. Figure out exactly how you are complicit in a society that allows this to happen and what you can do to help stop it.

Be conscious of your actions and how they might harm women, how they might perpetuate a masculinity that is detrimental to everyone. When you see an attractive woman on the street, remember that she might be exhausted and triggered by a slew of leers and catcalls, and rethink approaching her to lay your sexual desires onto her. In every interaction with a woman or girl, be mindful of her experience of the situation.

Seriously, take no for an answer. This is something that has been a part of discussions on sexual violence for a long time. No means no, and only yes means yes. But it's amazing that it still needs reiterating. On the street, when a woman says no to you, it is not an invitation for you to be more persistent. For you to wear her down with your "charm." It means for you to fall back and leave her alone.

From there, take rejection as an emotionally intelligent adult would: with respect for that person's boundaries and wishes.

I've developed some prompt questions that could facilitate men and boys seeing themselves within the overarching problem of sexism, gender inequality, and violence against girls and women:

How do I define masculinity without its relation to femininity?
What social cues can I use to determine whether a woman wants to
 interact with me?

Am I taking up space that could be given to someone with less priv-
ilege than me?

Am I taking up too much physical space?

Could this woman's smiling and nodding be a sign that she is actu-
ally uncomfortable?

Am I projecting my own desires over someone else's boundaries?

Would I treat this person differently if they were a cis-het man?
Would I give them more respect?

Stop Your Friends

And your work goes beyond stopping your own sexist behavior. It has to ex-
tend to the men around you. Check your friend when he uses language that
is violent toward women. Step up when a man hassles a woman on the train.
Interrupt your coworker who's going in for a rape joke. Teach boys that they
are not owed anything from girls and to respect people's autonomy over their
own bodies and lives. Get deeper in your group chats by challenging your
male friends on your and their definitions of vulnerability and masculinity.
Call each other out when you are being shitty romantic partners.

So often street harassment is a performance of the manhood you think
other boys and men want to see. It's not to impress women or girls but to im-
press the dudes around you. This is why masculinity as it is currently under-
stood can be dangerous. It is defined too often by aggression and violence.

You must remember that street harassment does not begin and end on the
street. It is part of a wide spectrum of sexism that is bred in many male spaces.
So much of rape culture is allowed because it is passed off as locker room talk
or men just being men. It's in these male spaces, when there are no women
around, where it's crucial to address misogynist and sexist talk.

When Donald Trump's private comments about grabbing women by
their genitalia were made public, so many people dismissed them as locker
room talk. But if more men, particularly the one man he made the comments
to, had denounced that type of talk, called it out for what it was—bragging
about sexual assault—it would have gone a long way toward denormalizing
this sort of sexism.

You men must do the work when only men are around. In locker rooms,
in barbershops, at home. The conversations that you have and allow when you
are with other men seep out into what you do and allow to happen in public.

Teach your children how to be good people, not how to perform gender roles for the allotted gender binary. Allow your children, especially girl-identified children, to have agency over their own bodies. Teach them to have boundaries for their physical selves. And teach boy-identified kids, especially, to be respectful of those boundaries.

Intervene, Even with Strangers

This one is difficult but critical: when you witness street harassment, intervene. So far, this is a rare occurrence. In Chapter 2, Candice talked about being grateful when a man stood up for her and her woman friend as they were being harassed in the street, and how before then, she'd never had a man intervene. Now it's time to make intervention a common and normal response from male bystanders.

Take another look at the discussion of bystander intervention in Chapter 2. It's especially important for men to follow these guiding intervention steps to stop street harassment. Most times, men will listen to other men before they will listen to a woman. If you see a woman being harassed in public, find a safe way to intervene. If you see a woman being physically assaulted on the street, find a way to stop it. Call for help. Get others involved. While still considering your own safety, do something.

Do the Work to Unlearn Your Own Sexism

I understand that dismantling sexual harassment is a very complicated thing that requires more than just stopping a particular behavior. It means unlearning and undoing an entire system of socialization that has been taught to us since we were children. Even as a young girl, I was socialized to look at my own body a certain way and to expect predatory behavior from men. Anyone can absorb the toxicity that is traditional masculinity.

Misogyny and sexism hurt everyone—not just people who identify as women and girls—in some way. All genders lose when femininity is seen as a weakness and something to be preyed upon.

Self-reflection is necessary for undoing normalized sexist behavior. I hope that the current national movement against sexual harassment is making you consider your own behavior—not as a means of protecting yourselves, but as a

means of protecting women and holding yourselves accountable for how you might have hurt women. Ask yourselves every day: How might I have been complicit? How have I enacted damaging behavior simply because it is what I was taught to do?

The responsibility to end street harassment and the dangerous treatment of women belongs to you. It is a huge task, but men are the ones who overwhelmingly are the source of violence against women, so you have to be the ones to end it. And that includes every person who identifies as a man or masculine person. You have to figure out how to cast off the violent and toxic traits of traditional masculinity you've internalized and in their place create a new model of masculinity that is kind, equitable, and respectful.

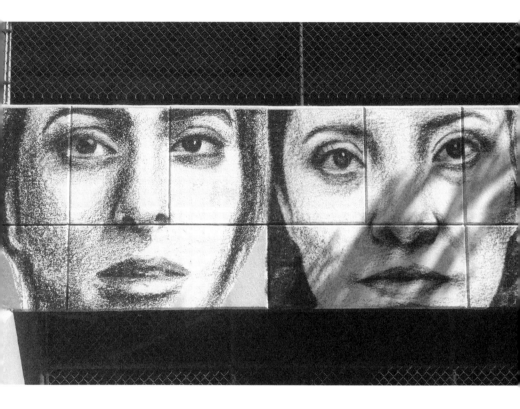

Chapter 15

<u>THE FUTURE</u>

What would happen if men did change? If the consequences of the anti–street harassment movement, of these larger national conversations and organized efforts to hold men accountable actually shifted society to a place where street harassment and sexual violence against women were taboo? What would an America free from rape culture look like?

As I continue to make work that foregrounds women's current experiences, I'm also wondering about what we might experience in the future. What would my days be like if I didn't have the emotional, mental, physical toll of street harassment to bear? How would our society at large be different?

A brilliant friend of mine asked me one day, "What kind of conversations do you want to be having ten years from now?" Maybe I was feeling discouraged in that moment because I answered with what I've become habituated to talking about and thinking about—race, gender, and oppression.

But then I thought about it and realized that I absolutely don't want to be talking about oppression ten years from now. I don't want to have to think about street harassment or sexual harassment or racism in the future, because I'd like to be free from those things. For us all to be free.

If we look at our world and allow ourselves some idealism, it opens up space to create new ideas, a new world. If society were to completely change, and we actually became free, then what?

And so I'm looking at my work and other anti–street harassment work not just as documentation to raise awareness of a longstanding problem but also as the foundation for a future world we want to live in. A world that is almost here.

When I ask the women I interview what a future without street harassment would look like for them, most of them talk about freedom and safety: the freedom to wear what you want without fear. The freedom to take up space on the sidewalk without worrying about being attacked.

One answer in particular has really stuck with me, from Victoria, in New York:

> Not only would women walk down the street feeling safer—I think it's so much deeper than that. I think about when you're getting ready and you're putting on your outfit and you're just thinking, *This is what I want to wear,*

but am I willing to take the street harassment today? Am I a strong enough version of me today? Can I handle that? All of these questions enter women's minds and determine their confidence level for the day.

I think if street harassment ended, it would reprogram all of that. Like many instances of oppression and harassment in our society, if it were removed, it would be granting women a piece of their identity back that is denied to them because of all the emotional labor they have to do to try and defend themselves from the inevitable harassment.

The thought of getting our identities back resonates with me so strongly and fills me with longing. Street harassment takes away so much of our ability to simply be who we are without anxiety. A future without street harassment would mean more than not having to hear catcalls; it would mean the elimination of an oppression that chips away at who we are.

It makes a lot of sense that many women also mention their children in response to this question. They try to imagine a world that would be safe for their daughters and feminine-presenting children to grow up in, free from sexualization and abuse of their bodies. Free from having their identities dismissed by other people and their humanity questioned and denied.

I went a long time without asking myself this question that I've asked so many other women. I was focused on the moment when street harassment and its layered oppressions occur: The casual and gratuitous assertion of dominance by a strange man; the fear, pain, and rage of the woman he targets. For years, I've concentrated on arresting and illuminating those fleeting acts and reactions.

But I feel more ready these days to look up from my work and wonder what might be possible, to allow myself to consider what I actually want.

So: What would a future without street harassment look like for me?

As with many of the women I've interviewed, my immediate thought is that it would feel freeing. I'd be less anxious, less fearful. I am on guard anytime I leave the house, and without street harassment, I wouldn't have to move through the public space in that way. I wouldn't have to be suspicious of the intentions of men who talk to me on the street.

Lately, in thinking about what I want my work to say to the public, I've been thinking about the role identity has always played. My work, and my

general sense of myself as a person, has always been so much about identity—about being a woman, a Black person, a mixed-race Black woman.

Now, I sometimes think beyond that. Who am I as a person that doesn't have to do with those identities? It would be fascinating to learn about who I am and what I have inside me that is apart from my Blackness, apart from my womanhood.

I'm not saying I would actually want to live without those identities; they're integral to who I am on the inside as well as on the outside. As Sonia said, they are my home. And I like very much being Black, being a woman, and being a part of the cultures and communities of these identities.

But in a lot of art-making and media, the focus on these identities is usually about the struggle, the challenges. Rightfully so, of course. These identities, particularly race and gender, were constructed to keep certain groups above or below one another in the societal hierarchy. So it makes sense that artists within marginalized groups make art about that oppression. So much of my identity as a woman is linked to the particular mistreatment of me as a woman. This project, Stop Telling Women to Smile, is particularly about oppression faced by women and femmes.

But what about the celebration of ourselves outside of oppression? What are my identities if they are not defined by oppression? Am I creating art that centers the male gaze or the white gaze, or does it center ourselves? I think there is room to answer these questions while also recognizing the present reality. I should be able to define my own gender or race beyond the framework of white supremacy and misogyny, but simultaneously I must also recognize the fact that I could easily be killed when I walk out of my door—because I am a woman; because I am Black; because I am a Black woman.

While I contemplate a future where who I am is not predicated on violence against my body and my communities, to get there, I must continue to document and reflect who and where we are today. Art is about telling the truth. And the truth for myself and so many women is that we live in a constant state of danger. Telling that truth about our world today is the way to create that future.

Of course, a world free of street harassment would have broad societal implications, too; it would mean a world without a lot of other forms of sexism and oppression and violence against women. That's a world where girls' bodies aren't sexualized before they even know what to make of them.

And that makes me hopeful, for everyone in general. If I can walk down the street freely as who I am, then perhaps that means that a femme queer

man who wants to dress in a feminine way can also walk down the street without being harassed. Black girls and boys and nonbinary Black kids should be able to wear sagging pants and hoodies without fear, just like they should be able to wear miniskirts without fear. The world would be a safer place not just for me but for all kinds of people who express themselves and their gender (or their rejection of gender) in all kinds of ways.

I'd like to live in a place where gender, sexuality, masculinity and femininity, and appearance are not rigid, binary constructions. Rather, I want those things to be states that people can fluidly move through, over, and in between. Any person should be able to live in this world inhabiting a true, full expression of who they are.

It would also mean a world with a different idea of masculinity. And for sure, society's understanding of masculinity is getting better and more open. It's no longer only understood in this narrow way, as a macho, violent, sexist thing. This is partly because trans and nonbinary folks are redefining masculinity for themselves.

A lot of street harassment is cis-het men believing this is what it's like to be a dude; they're performing something. If they stopped performing this thing, it would mean masculinity had shifted into something else, something more open-hearted, more kind, more expressive. It wouldn't have to be about accruing and displaying the most power.

Who knows what the world would be like if women were able to move freely and to be more expressive in the outdoor space? It's almost impossible to imagine.

Try to imagine feeling that free on the street. What would it feel like if we were free to make eye contact with anyone without worrying that it will be taken as a sexual invitation? What would we be able to do outside, what spaces would we be able to create? What would it do for city structures and urban development? What would it do for women's sense of our place in the public space? I know I would feel safer, calmer, and more confident when I leave my house. And I wish that for all of us.

For now, though, the work continues. I will keep telling the stories of how women and nonbinary people experience the public space by inserting images of us into that space, as a way of taking it back. I'd like to see Stop Telling Women to Smile expand to include other artists from around the world and other actions that use different forms of art.

I'm moving forward with the help of people from communities all over the world to continue to take back the streets. I'm moving forward as part of

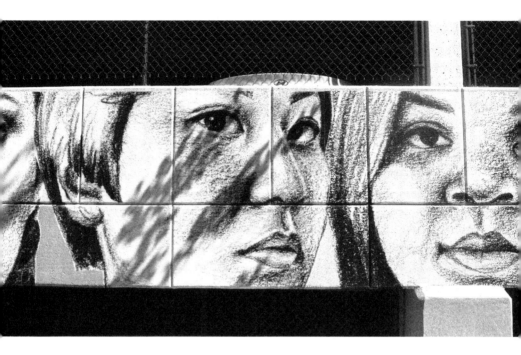

a huge wave of anti-sexist activism. I'm also moving forward bolstered by the work of other artists who have long been creating work that tells the truth about our lives. Work that does not shy away from the uncomfortable, that forces people to pay attention to the lives of marginalized groups, and that forces our society to treat these groups better. So much beautiful art out there is illuminating so many urgent political struggles.

I'm proud to be part of the anti–street harassment movement and of the lineage of political art. And as street harassment becomes more and more taboo over the coming years, I'll take heart knowing that this work has had something to do with it.

I know I've already been fortified by doing it, and even a little bit healed. I hope you find it fortifying and healing, too.

Many experiences of harassment have left me feeling stuck, shaken, and scared. At times I've been distraught and near tears because of something that was said to me on the street. If you sometimes feel the same way, I'd like to say in closing, you are not alone. What has happened to you is not okay. Your experiences are valid. Your voice is important. Tell your story boldly and with urgency because, in doing so, you allow others to do the same.

ACKNOWLEDGMENTS

Thank you to every person who has lent me their words and faces as a part of Stop Telling Women to Smile. There are many of you, and each of you has made this work what it is. I wouldn't have a book, nor an art series, without your portraits and stories. Every woman and femme I have interviewed, from Newark, New Jersey, to Paris, France, thank you for sharing your stories, your anger, your voice, your experiences with me. Thank you to everyone who has helped organize an STWTS event, discussion, or mural over the years. For challenging me. For making me think deeper and harder about the intentions and impact.

To Sonia, Rakia, Fanila, Widad, Chanel, Sarah, Candice, Madeleine, Deyanira, Christiana: thank you for allowing me to share your stories with the world, and for being gracious throughout this entire book project.

I'd like to acknowledge Seal Press for picking up this book and for all of the team's hard work on this project. To Laura, my editor, and the entire publicity team, thank you. Thank you, Rayhané, my literary agent, for believing in this work and working so hard to get it published. I also want to acknowledge Wylie, who came in at the end to help me get over the finish line.

To Alana, my best friend and soulmate, who has been right there through the entirety of Stop Telling Women to Smile, the project and book: I guess I could if I had to, but I definitely would never want to do any of this life shit without you. Thank you.

I'd like to acknowledge the friends who provided love and support for me in numerous ways over the course of this book project: Lance, Mychal, Gbenga, Tanya, The Jerk Store, Natalia, Lisa, Donald, Hunter, Texas Isaiah. I love all y'all, for real.

I want to acknowledge the many people, particularly women, who are doing the work for gender equity. The artists, activists, writers, who use their work to make this world better—I see you, I thank you, and I'm happy to be in this with you.

Lastly, I'd like to acknowledge my mother, whom I write about a lot in the book. I often don't know what to do with all of the love I have for you. Thanks for being my first example of an artist, of a Black woman, of a person not afraid to speak back.

Tatyana Fazlalizadeh, a native of Oklahoma City, currently lives and works in Brooklyn, New York. She is the Public Artist in Residence for the New York City Commission on Human Rights. She is a 2015 *Forbes* 30 Under 30 recipient and has been profiled by the *New York Times*, NPR, *Time* magazine, and *Brooklyn* magazine, where she was listed as one of Brooklyn's Most Influential People. She has lectured at the Brooklyn Museum, the New Orleans Contemporary Arts Center, the National Museum of African American History and Culture, and a number of universities, including Stanford, Brown, University of Southern California, and the Pratt Institute.

Tatyana's work crosses between the gallery and the street, positioning issues where they will best reach intended audiences. Her street art series, Stop

Telling Women to Smile, tackling gender-based street harassment through portraiture and storytelling, can be found on walls around the globe. In addition to her street art work, she has exhibited her oil paintings and wheat paste installations in galleries and museums such as the Mills College Art Museum in Oakland, the Oklahoma Contemporary Arts Center in Oklahoma City, the Long-Sharp Gallery Project Space in New York, and many more.

In 2016, film director Spike Lee took inspiration from Tatyana's Stop Telling Women to Smile project and asked Tatyana to be the art consultant for the TV adaptation of his first movie, *She's Gotta Have It*. Tatyana created all of the paintings for the show's main character and served as the art consultant to the writers' room.